Travelling Still **Rob Carter**

cover *Long Beach II* Barbados 2005

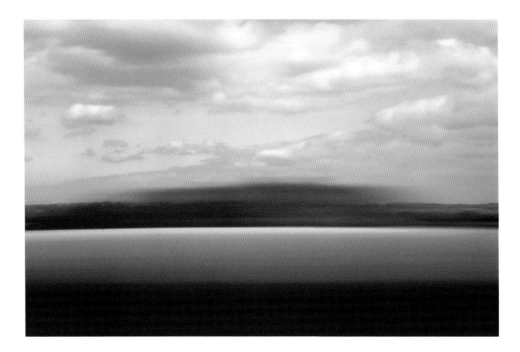

Eurostar
France 2002

Eurostar
England 2002

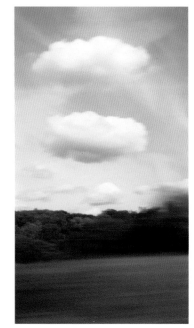

Travelling Still is an ongoing series of photographs I've been working on over the last five years. As the name suggests, *Travelling Still* is all about creating the feeling of movement within a still image and tries to represent the experience of travelling itself. The photographs stretch the 'moment' both literally—in that the camera shutter is held open—and visually, as the details of the subject blur out horizontally.

Rob Carter

2008

For as long as I can remember I've been taking long exposure photographs while on the move. I've always loved the painterly quality of light when colours bleed into each other in the photographic image.

All the photographs contained within this book have been shot using a revolving-lens camera—the movement is created 'in camera' on to film, with no digital intervention—and are subsequently printed directly from the original transparency on to Cibachrome paper. The prints are in editions of 12 with two artist's proofs.

for Nicky, Jessica and Saskia

Travelling Still ›

1 *Hotel du Cap* Cap d'Antibes, France 2007

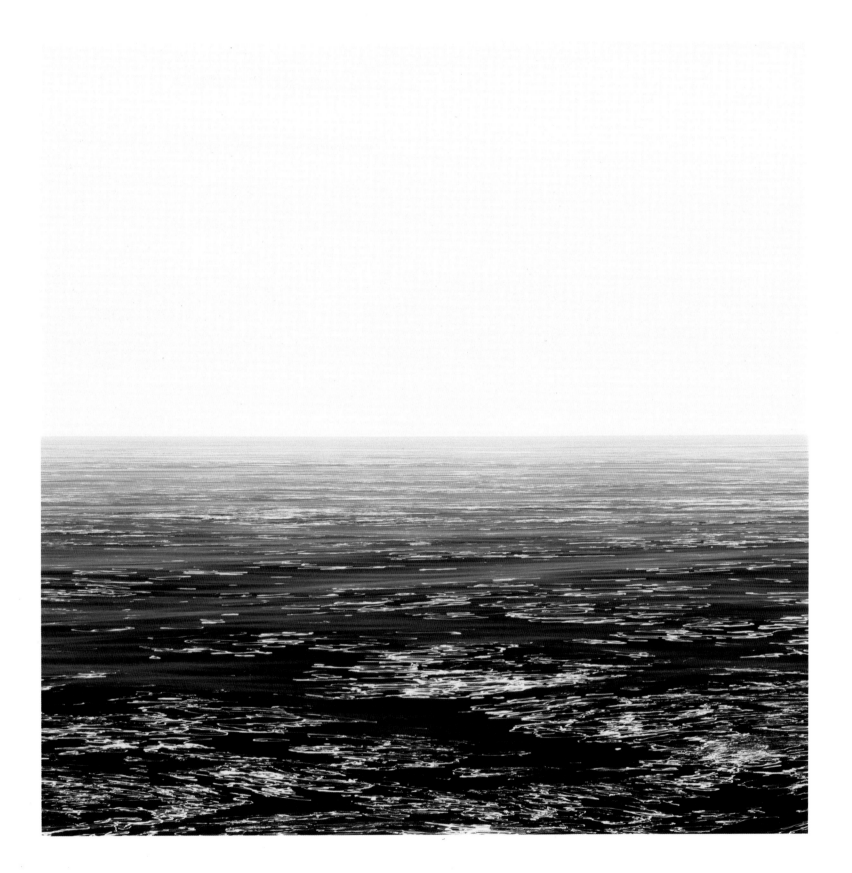

2 *Fundu Lagoon* Pemba Island, Tanzania 2003

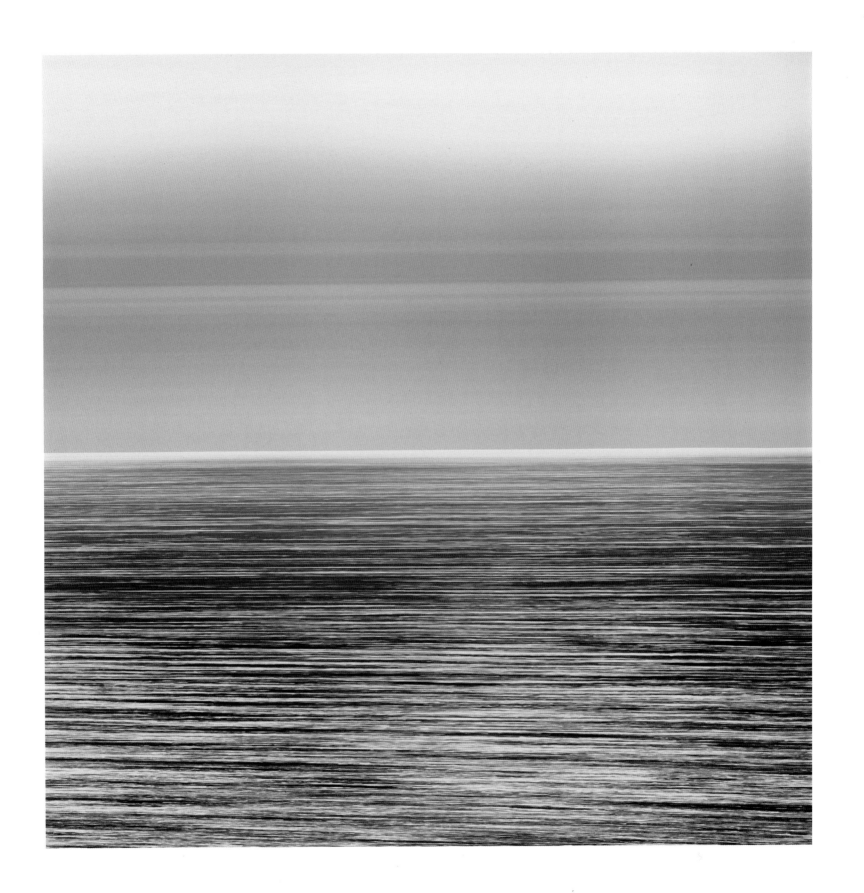

3 *Coral Reef* III Barbados 2007

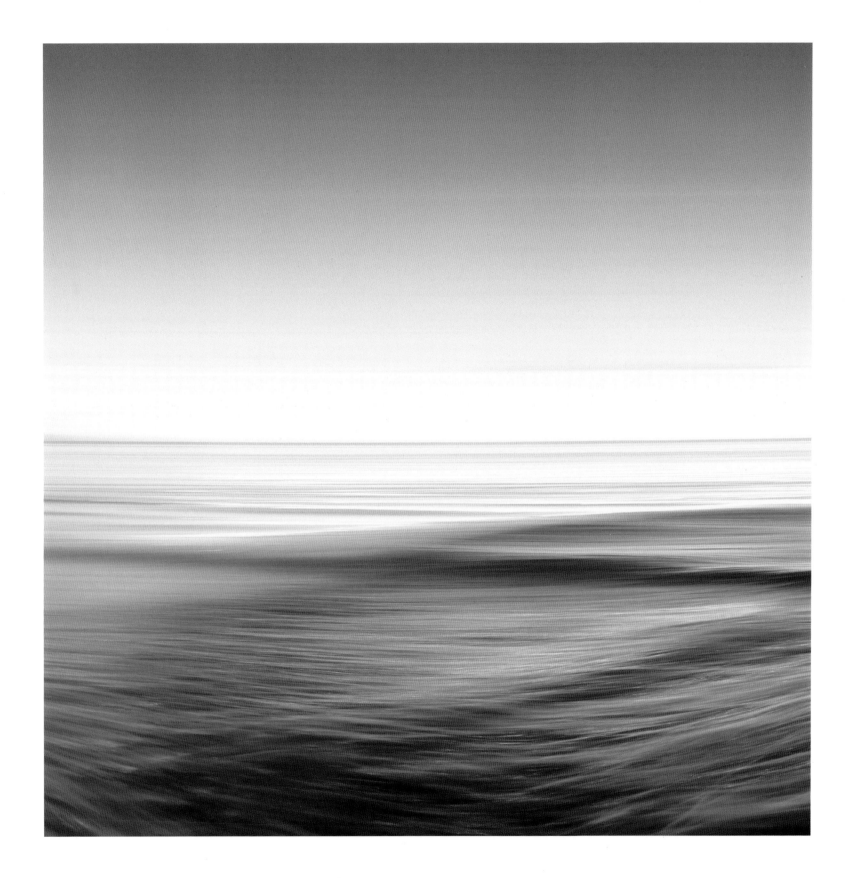

4 *Nice* France 2007

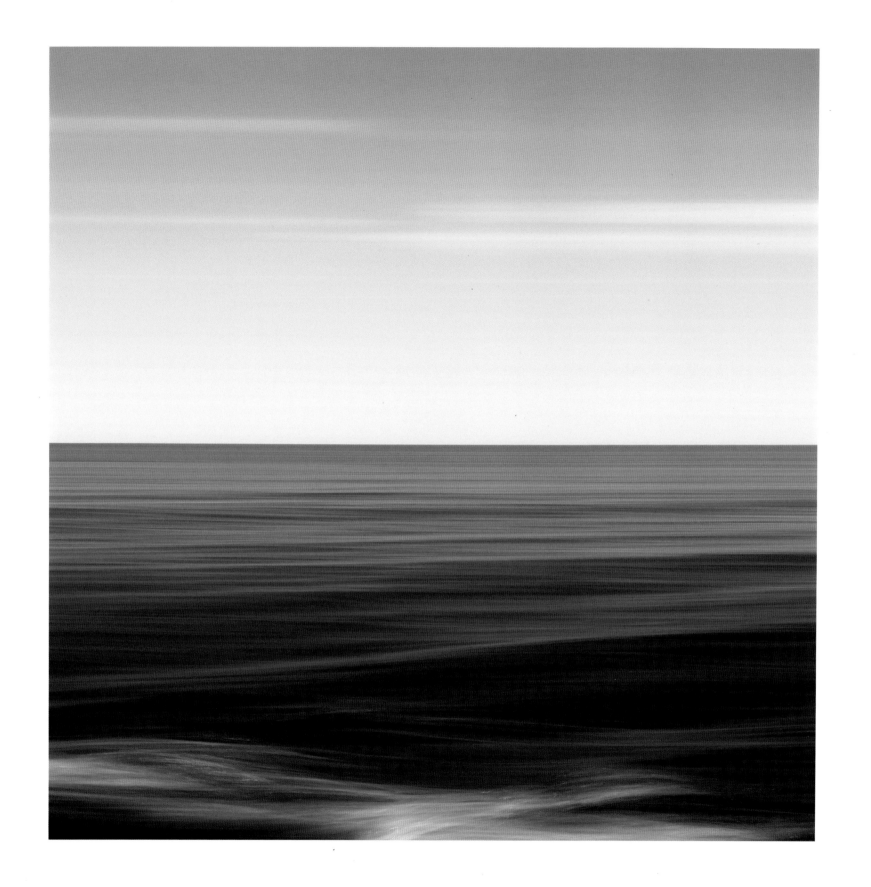

5 *Valle della Luna II* Capo Testa, Sardinia 2007

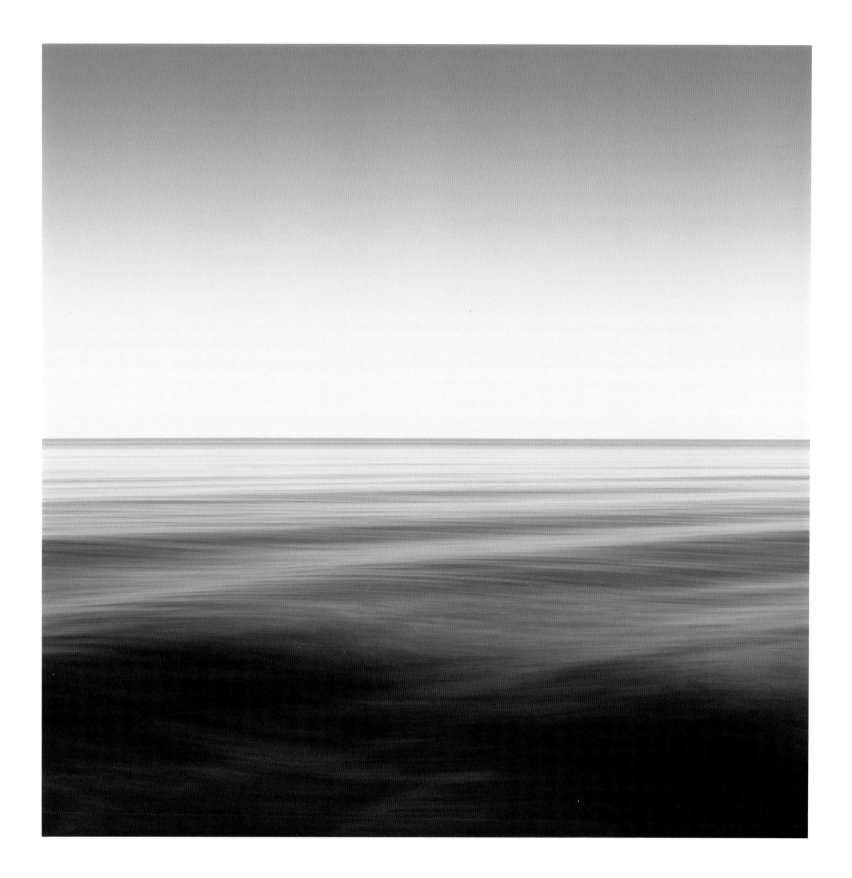

6 *Valle della Luna I* Capo Testa, Sardinia 2007

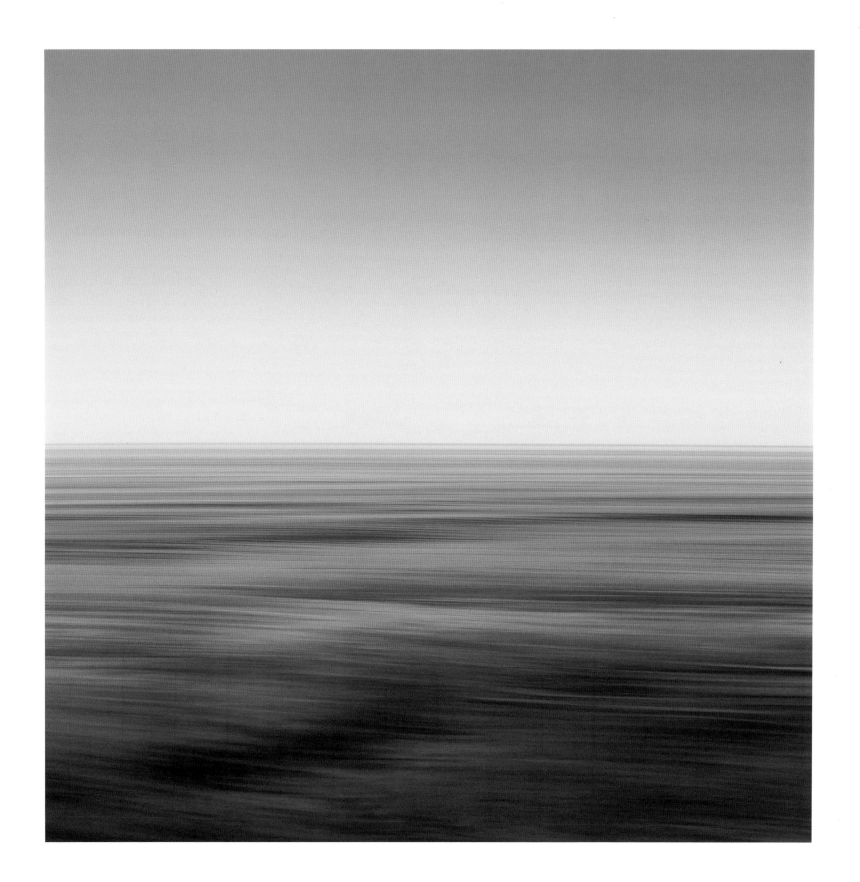

7 *Cala Granara I* Sardinia 2007

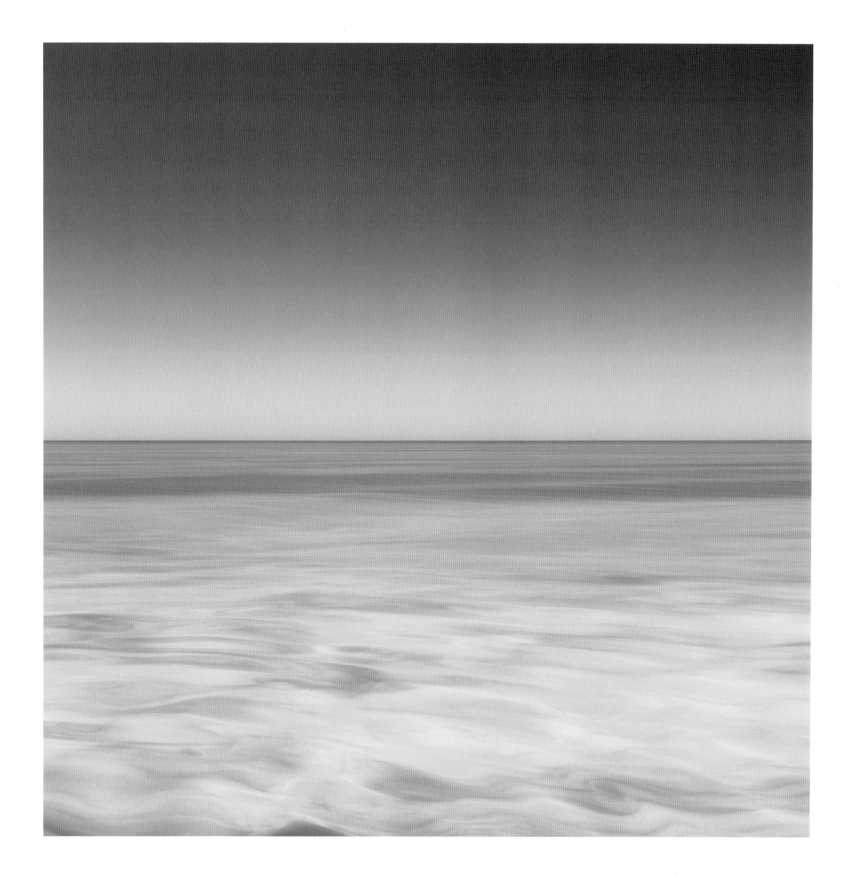

8 *Cala Granara II* Sardinia 2007

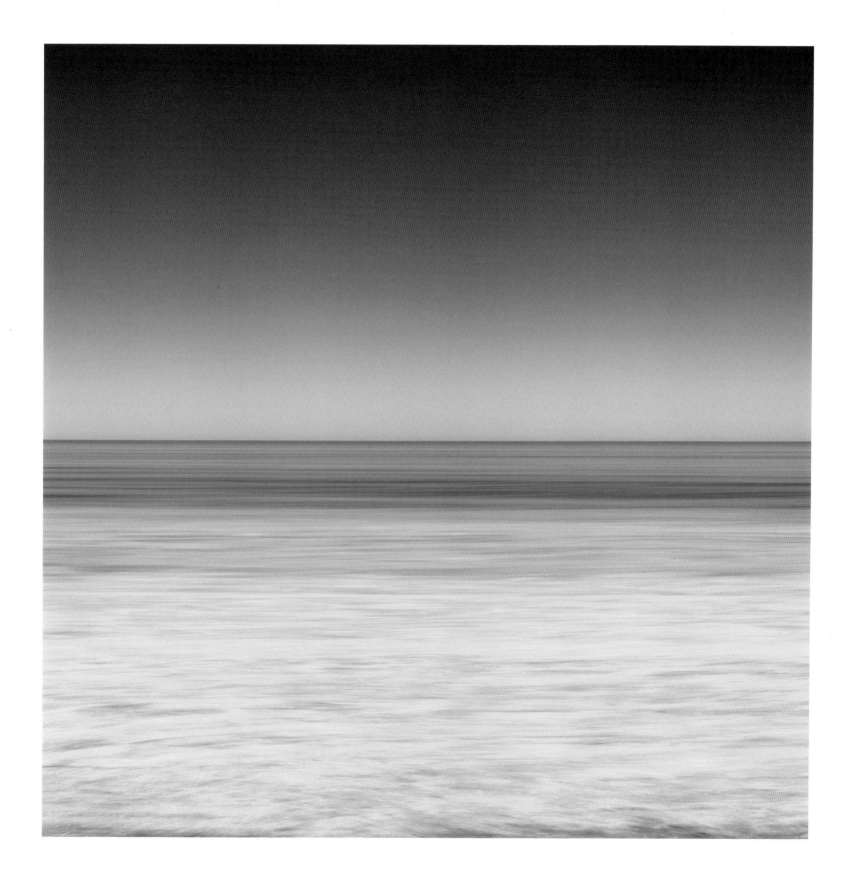

9 *Spargi Island I* Sardinia 2007

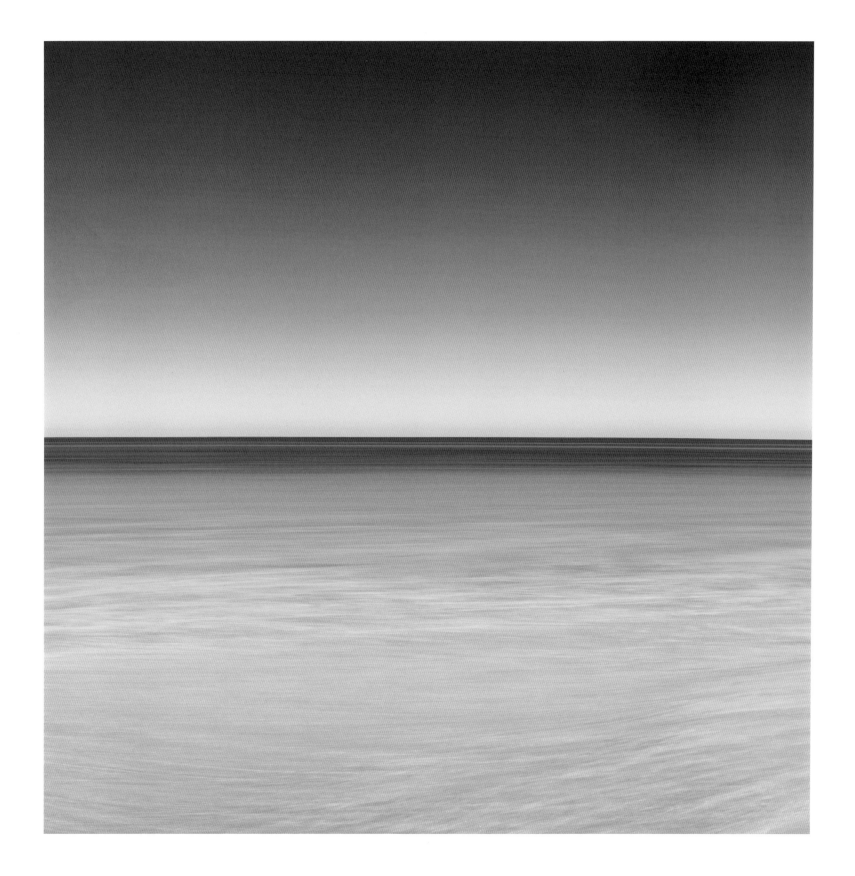

10 *Spargi Island II* Sardinia 2007

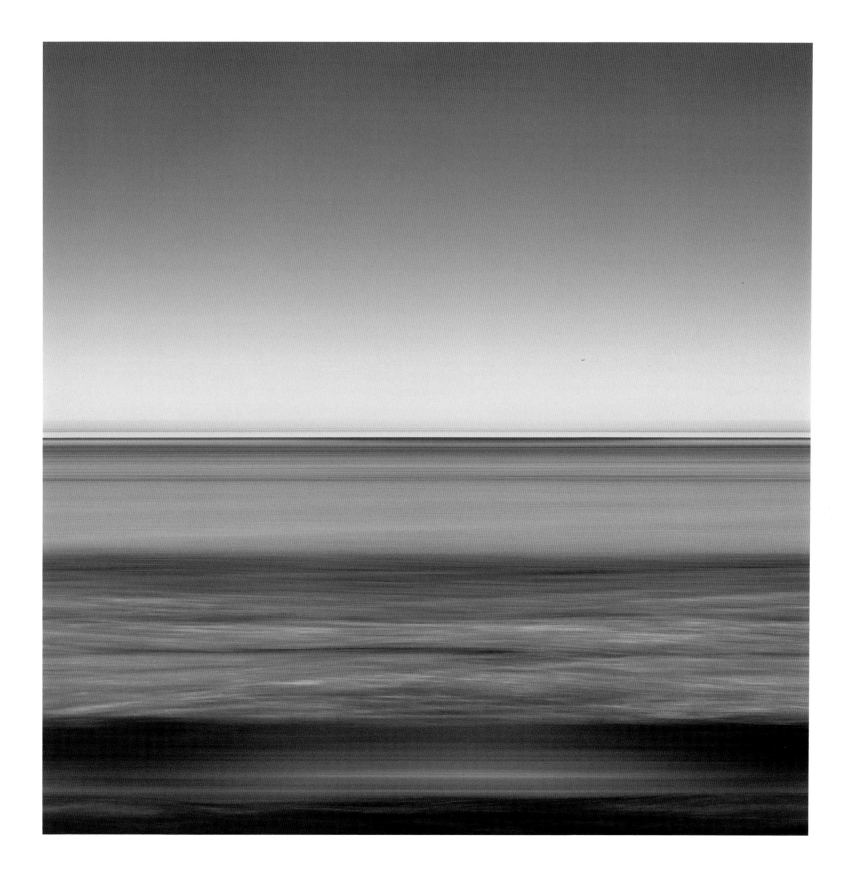

11 *Spargi Island III* Sardinia 2007

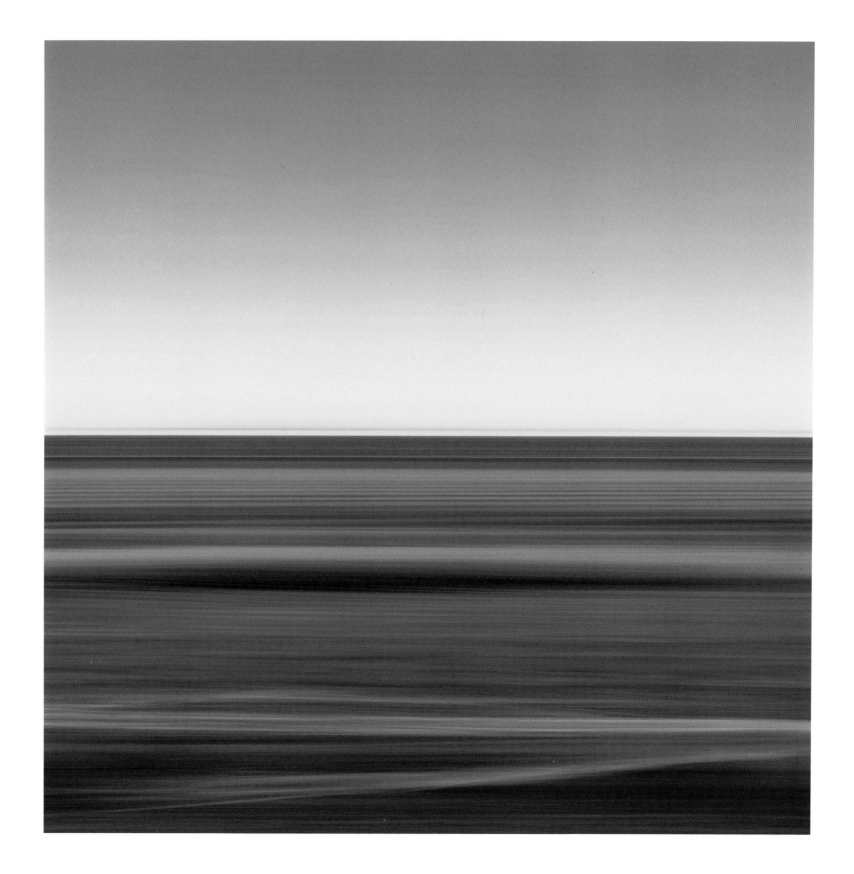

12 *Spargi Island IV* Sardinia 2007

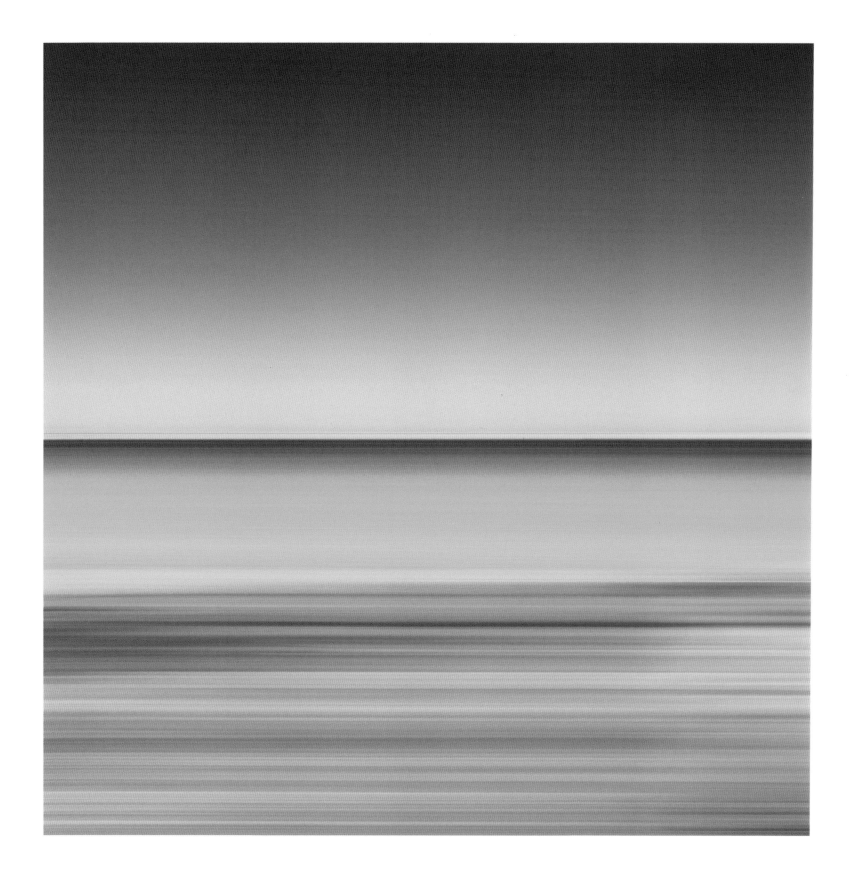

13 *Rena Bianca* Sardinia 2007

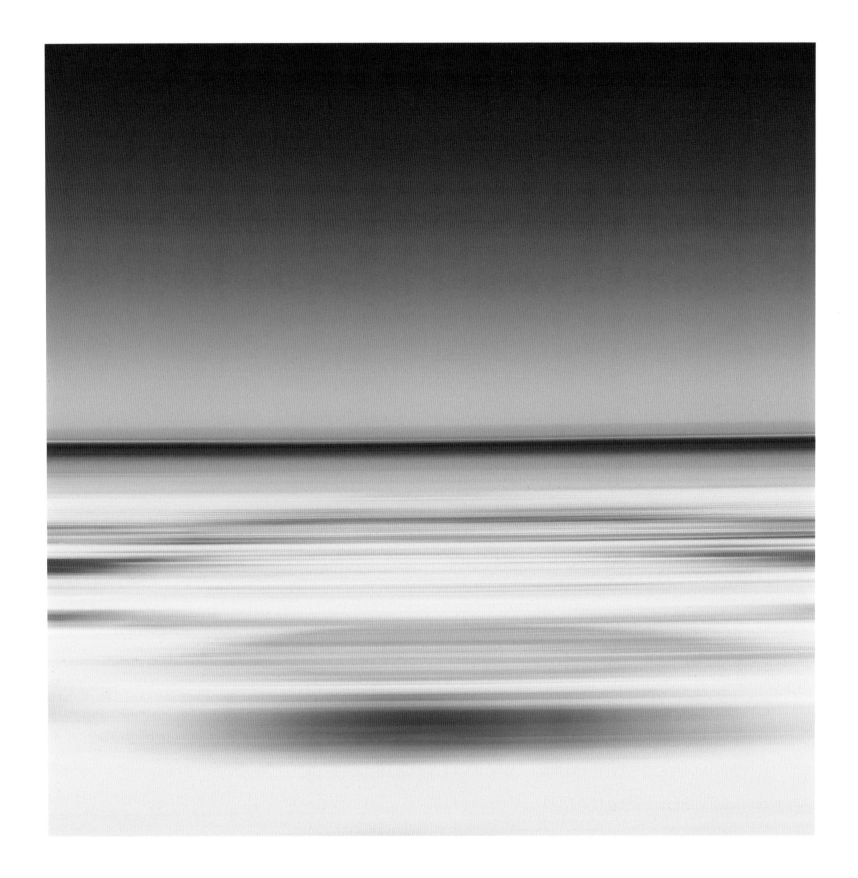

14 *Brancaster Beach* Norfolk, England 2003

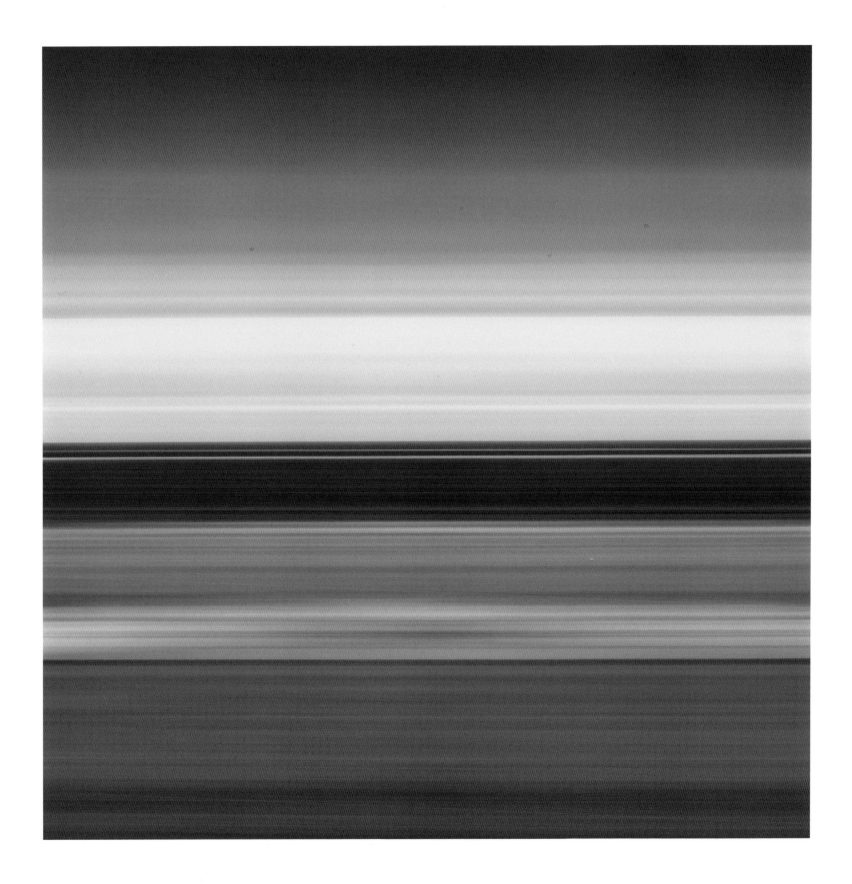

15 *Promenade des Anglais* Nice, France 2007

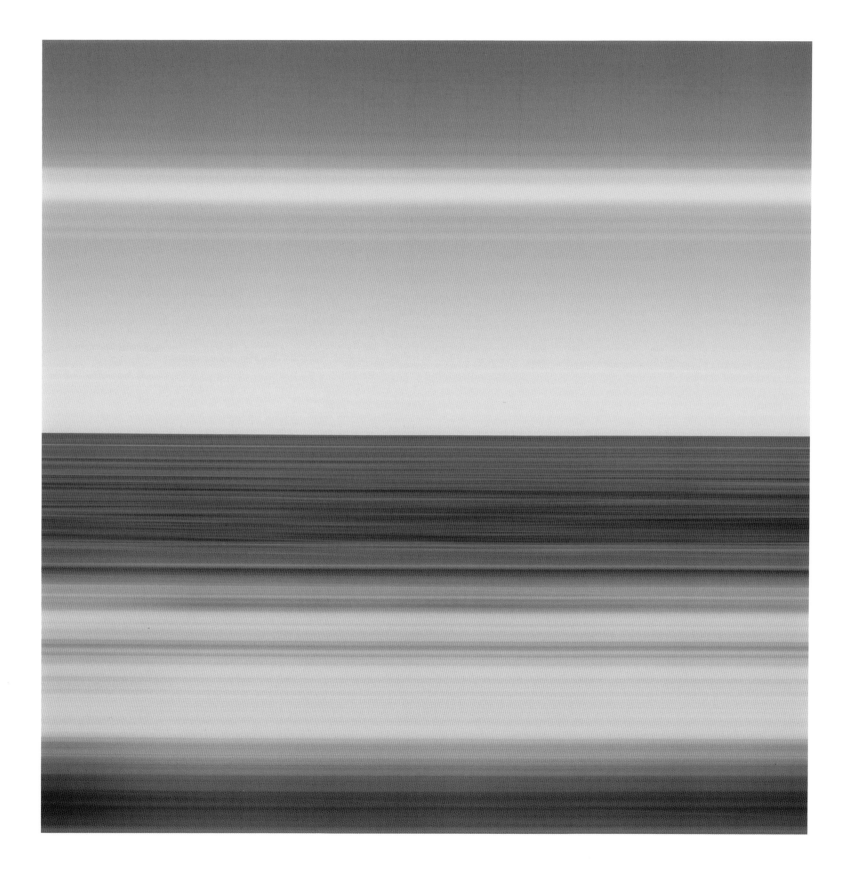

16 *Holy Island* England 2003

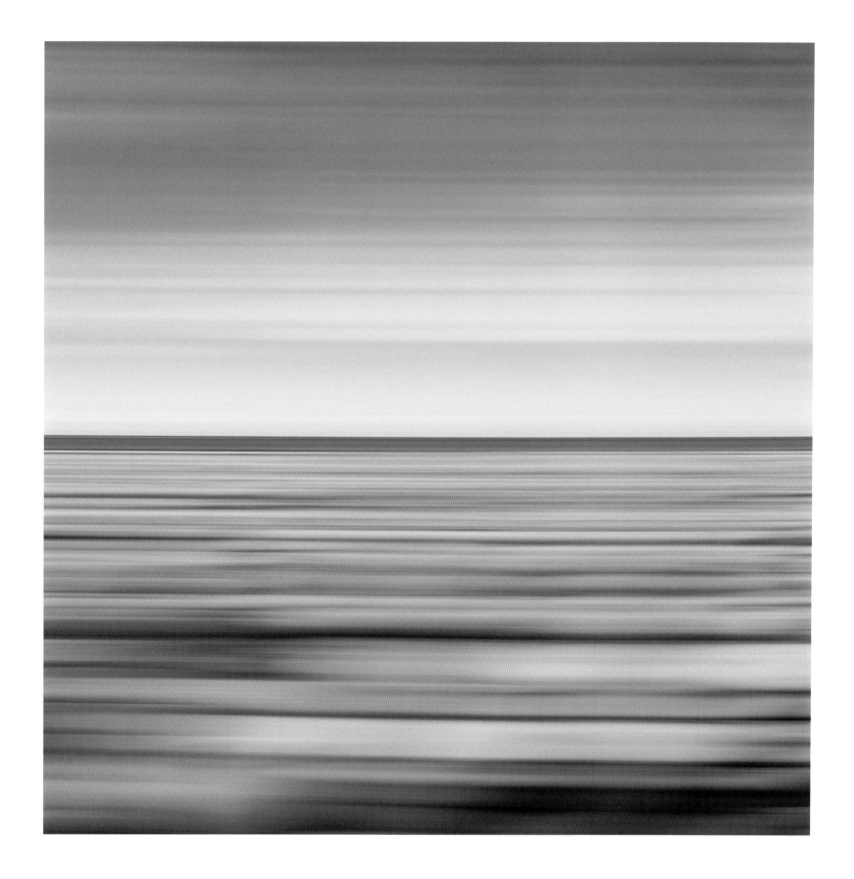

17 *Soliman Bay* Mexico 2007

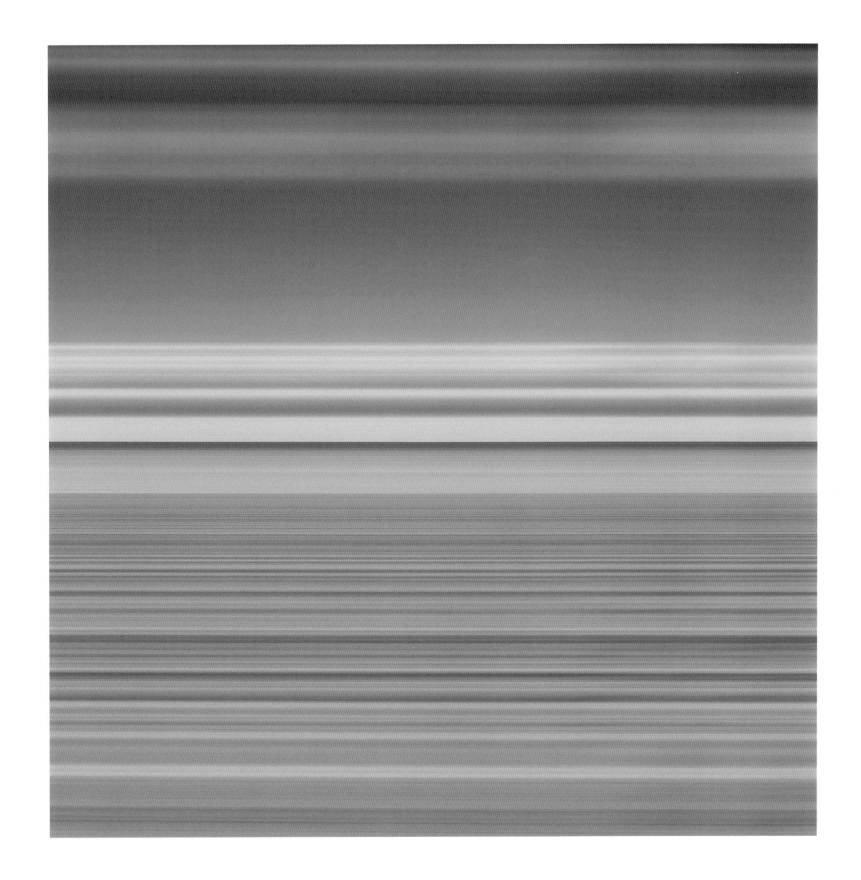

18 *Mesali Island III* Tanzania 2003

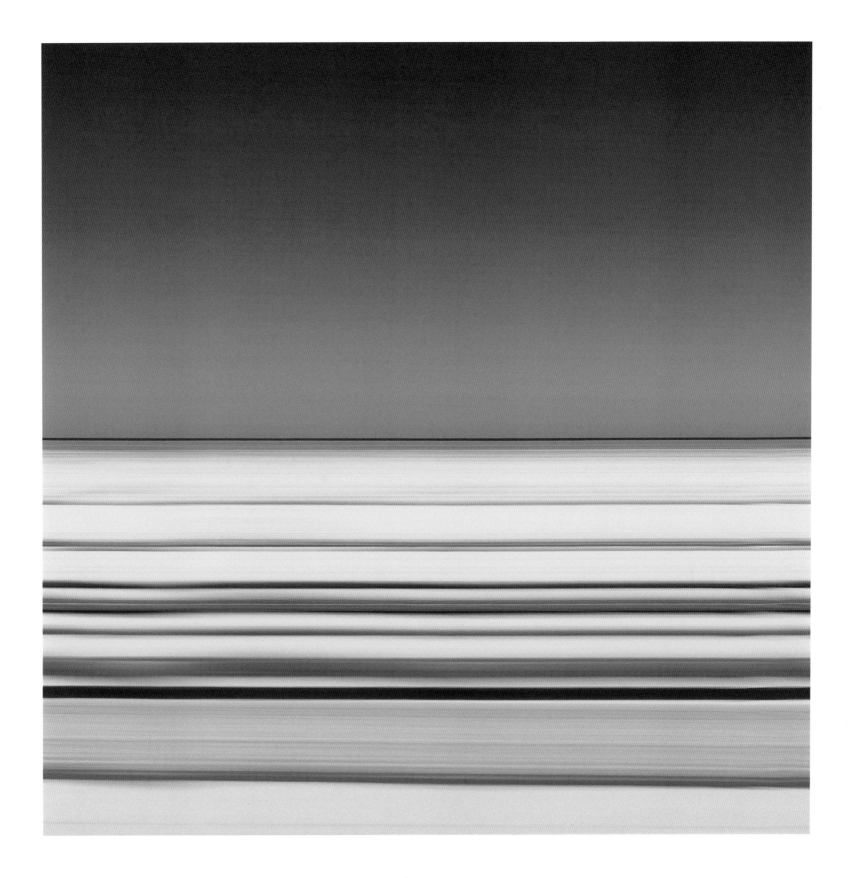

19 *Cancun Public Beach* Mexico 2007

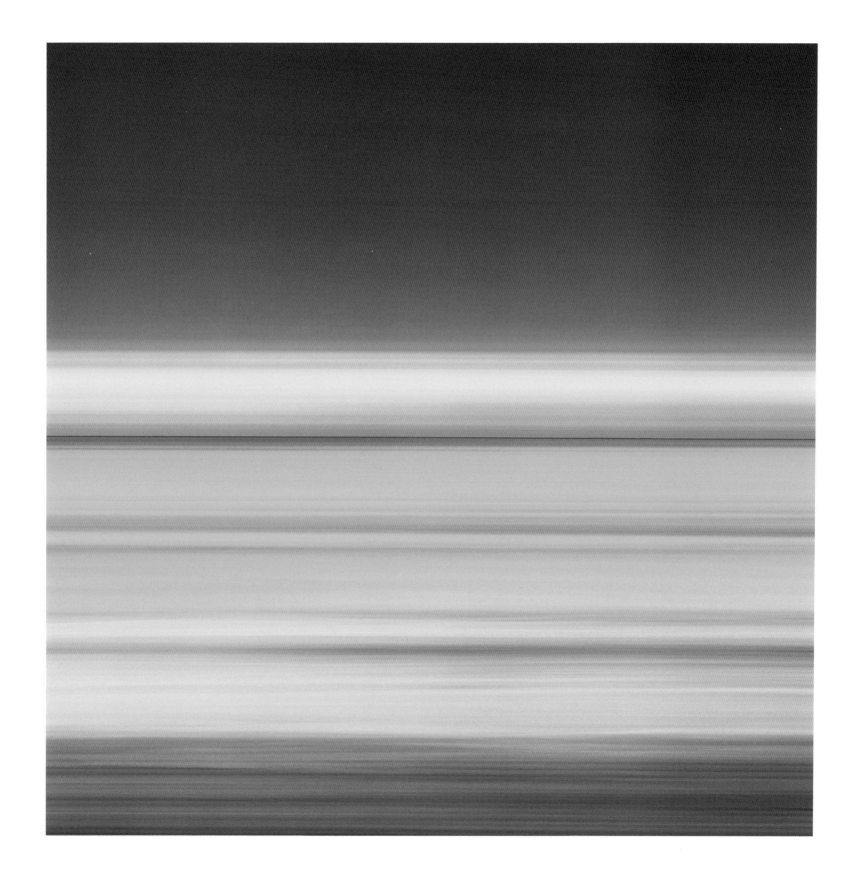

20 *Xpu-ha Beach (with red boat)* Mexico 2007

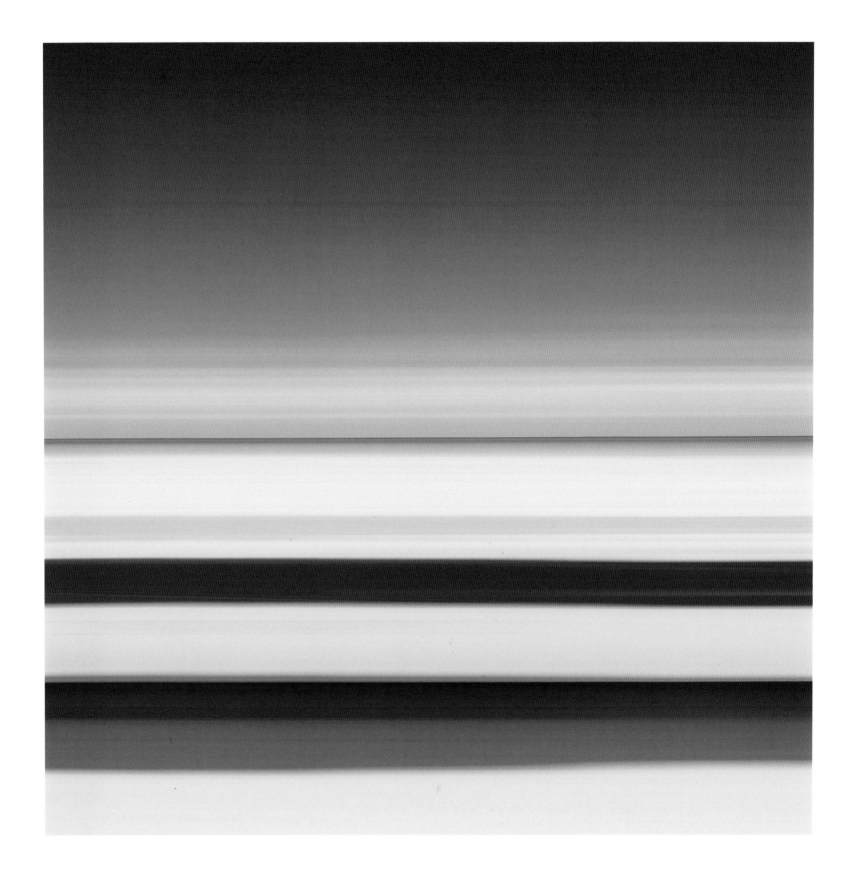

21 *Chac Mool II* Mexico 2007

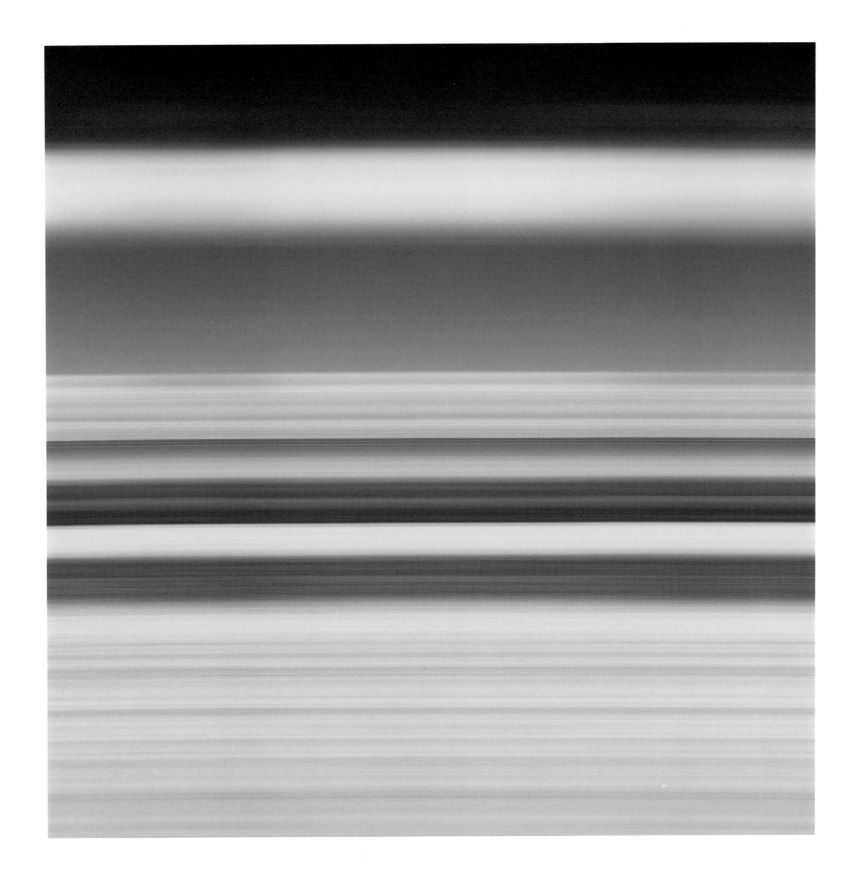

22 *Chac Mool I* Mexico 2007

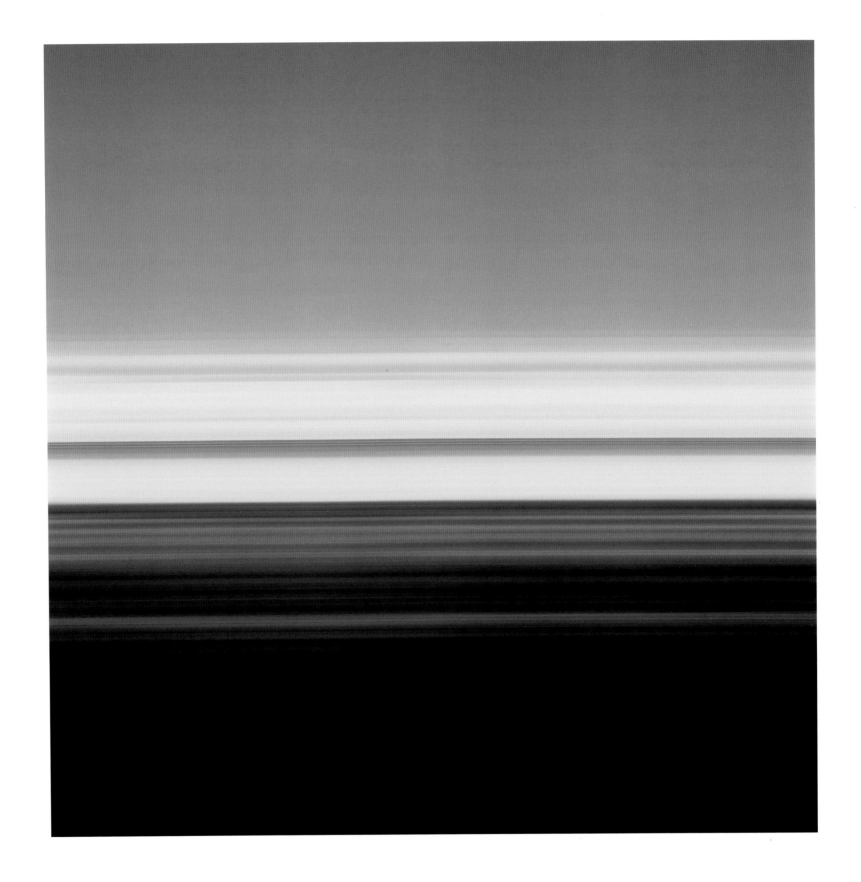

23 *Tulip Fields VI* Holland 2004

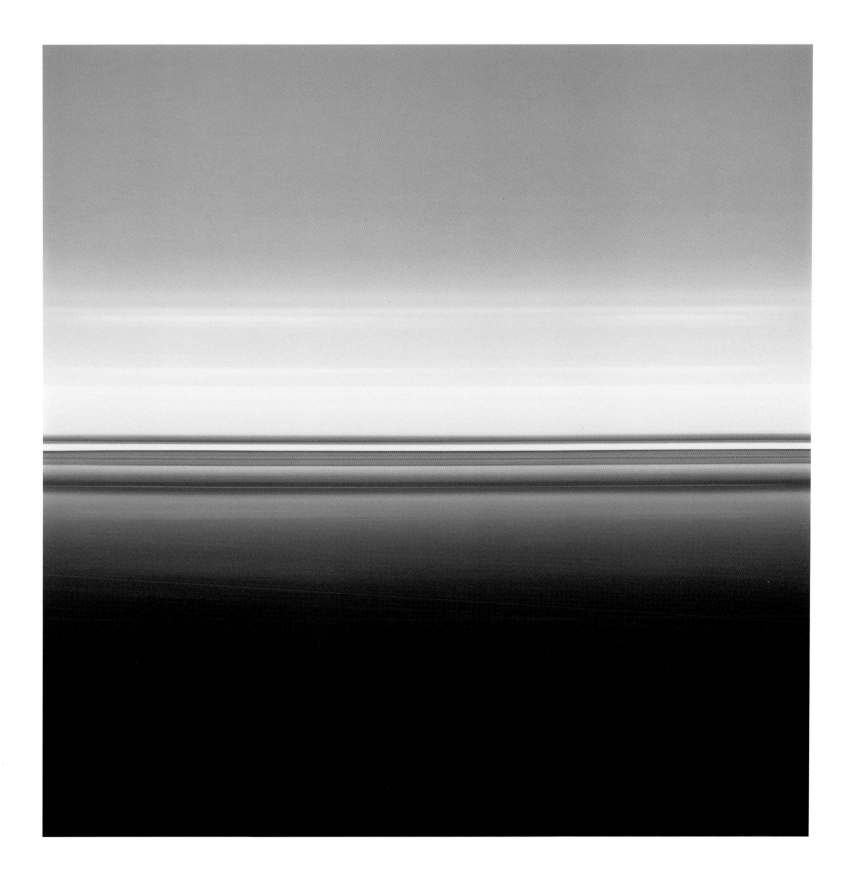

24 *Tulip Fields VIII* Holland 2004

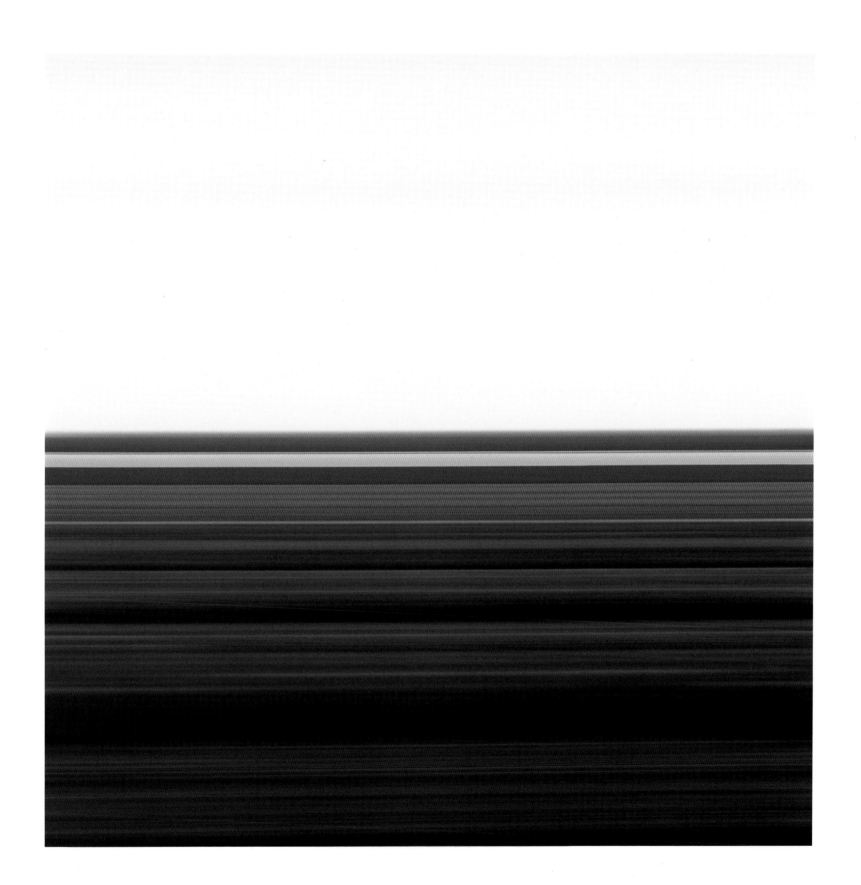

25 *Tulip Fields XXIV* Holland 2006

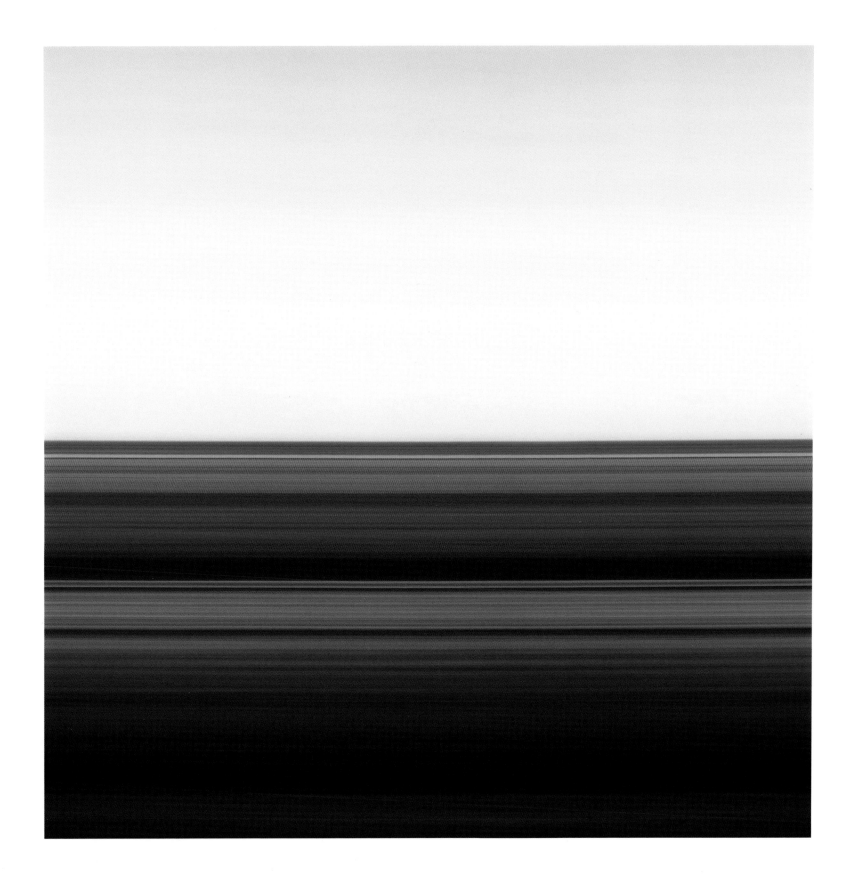

26 *Tulip Fields XVIII* Holland 2006

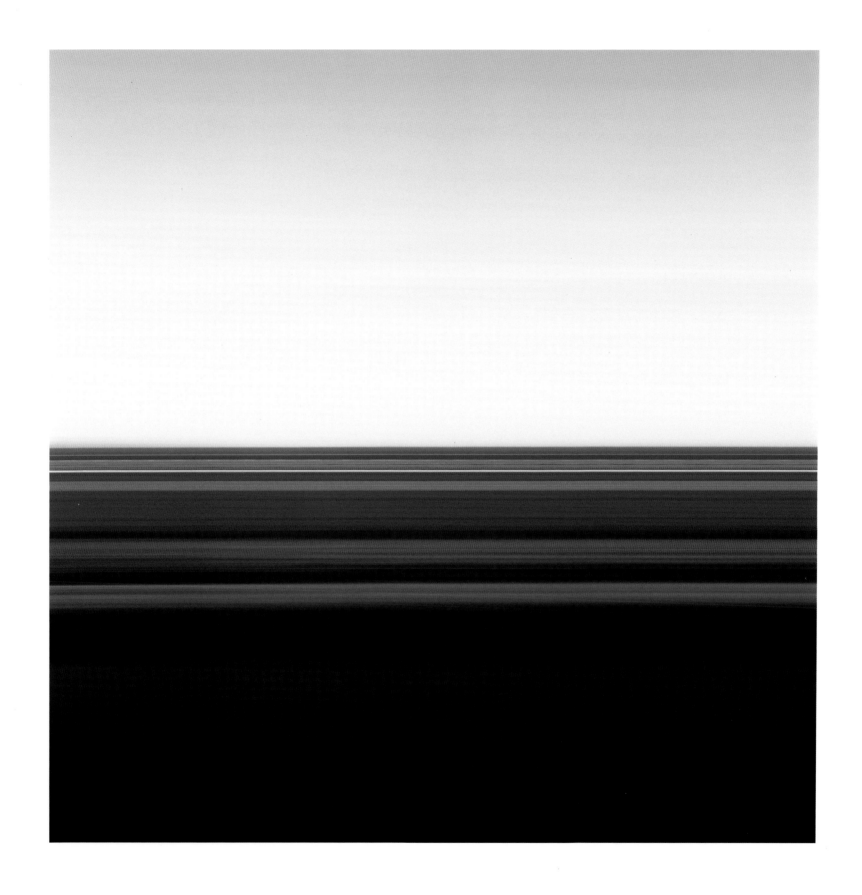

27 *Tulip Fields xxv* Holland 2006

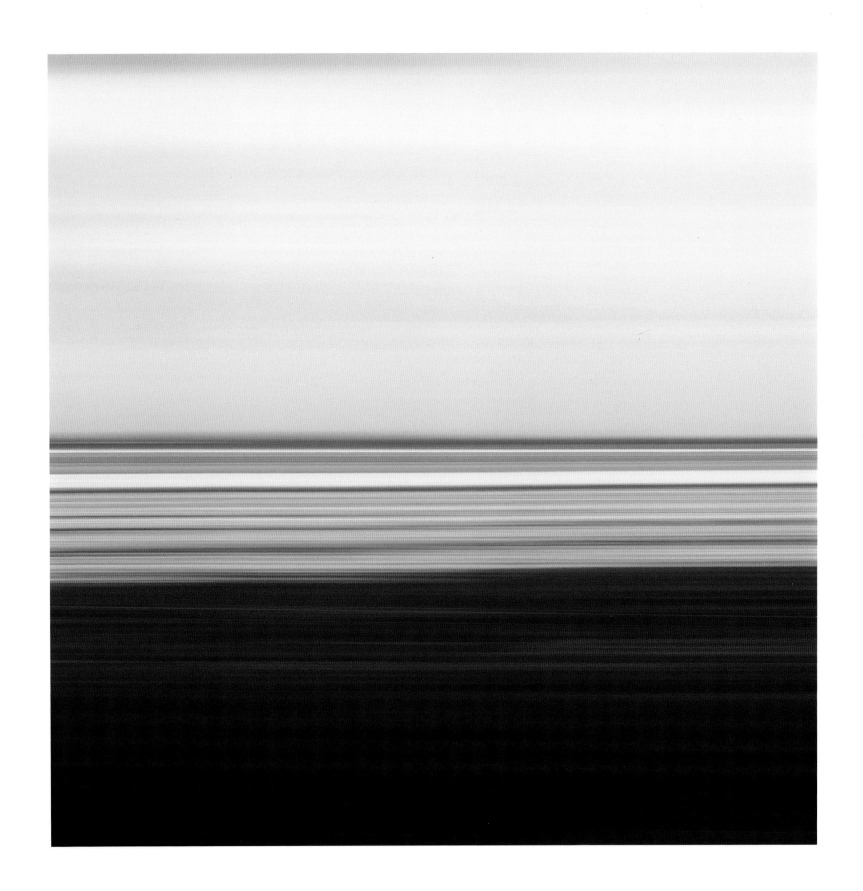

28 *Tulip Fields* x Holland 2004

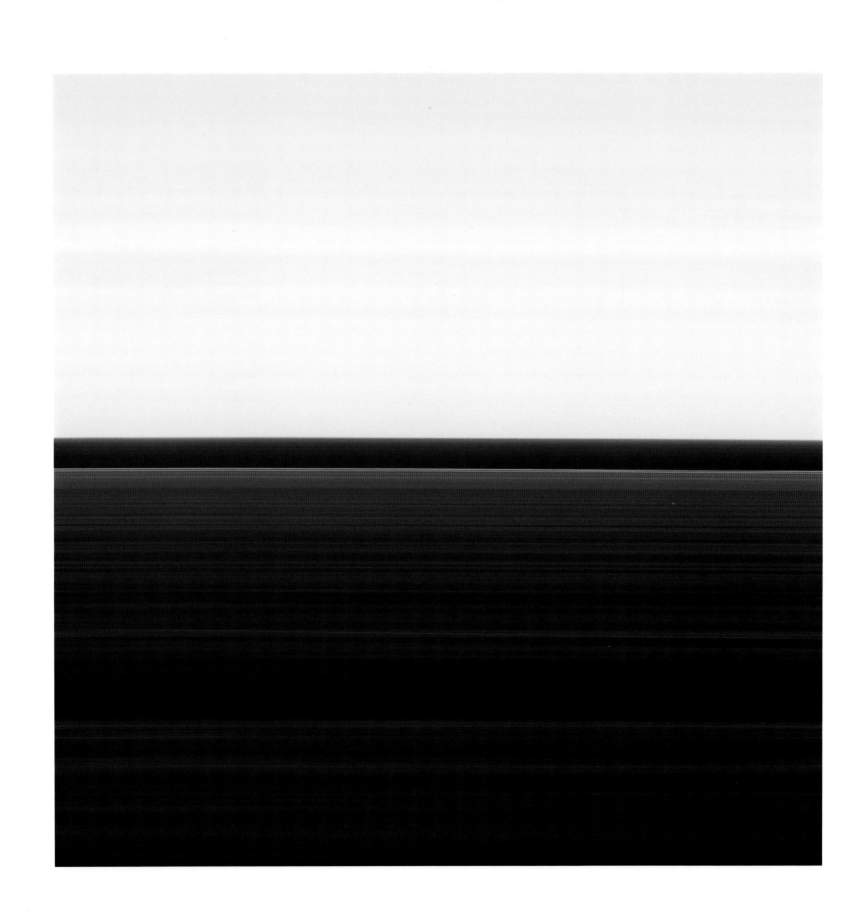

29 *Tulip Fields III* Holland 2004

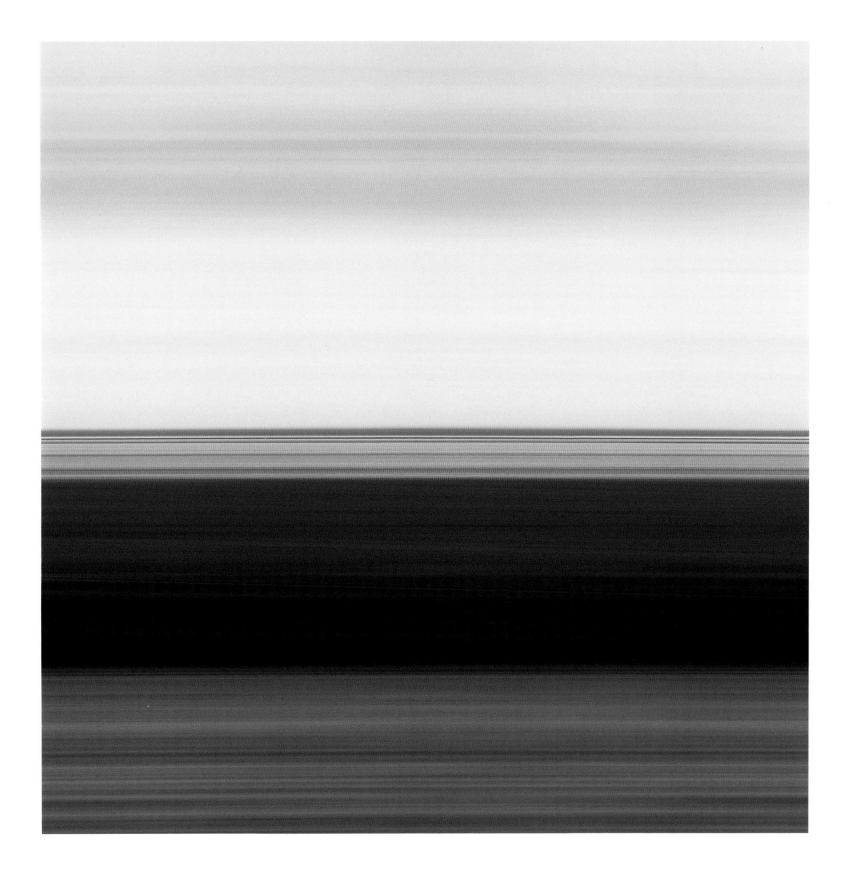

30 *Tulip Fields XVII* Holland 2006

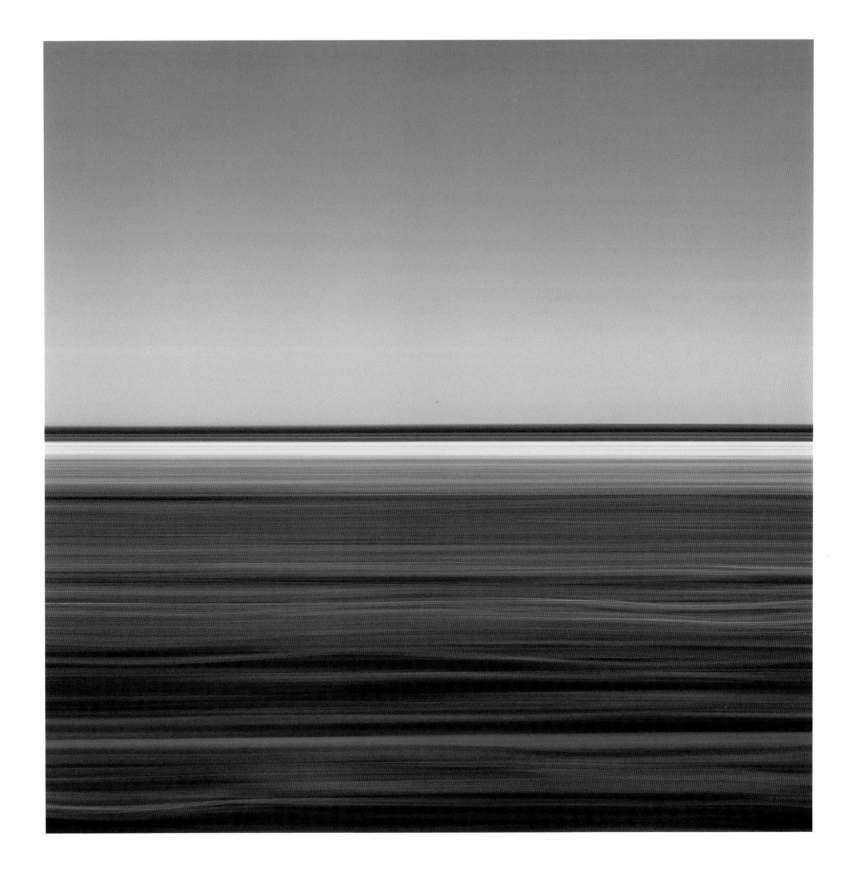

31 *Tulip Fields XIII* Holland 2004

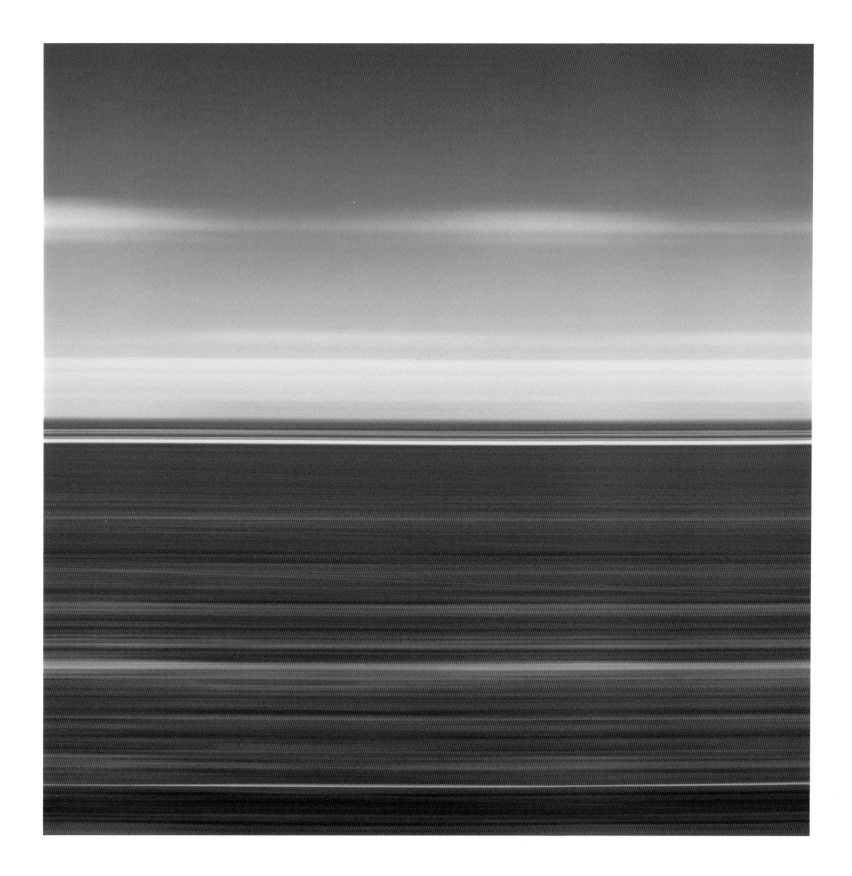

32 *Tulip Fields* xxx Holland 2007

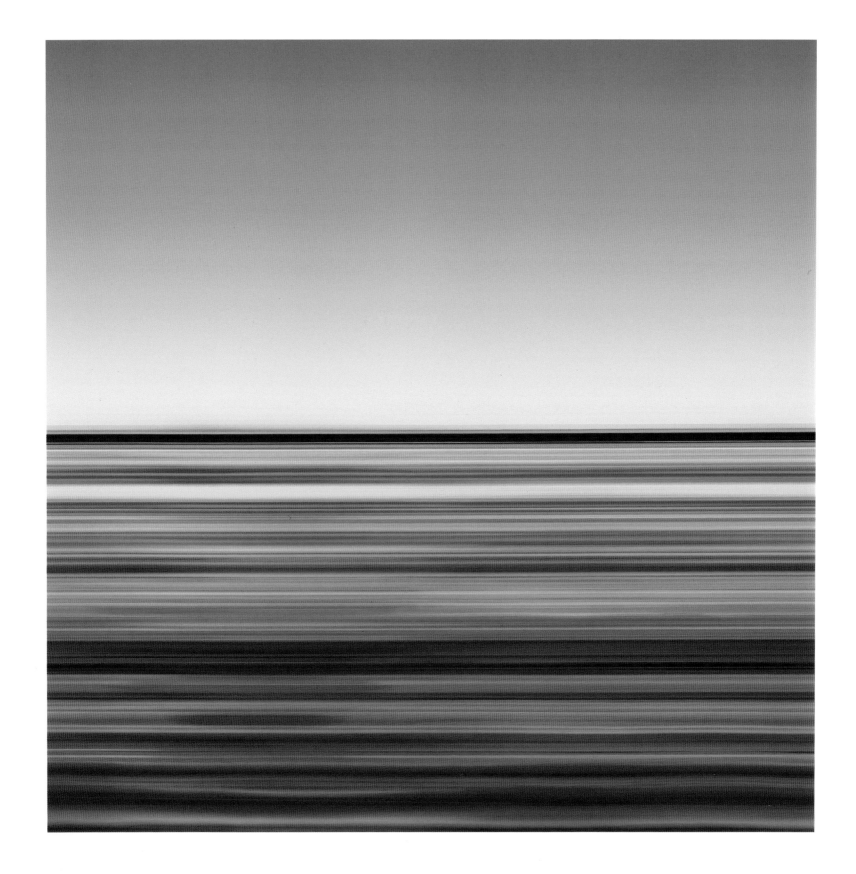

33 *Tulip Fields IV* Holland 2004

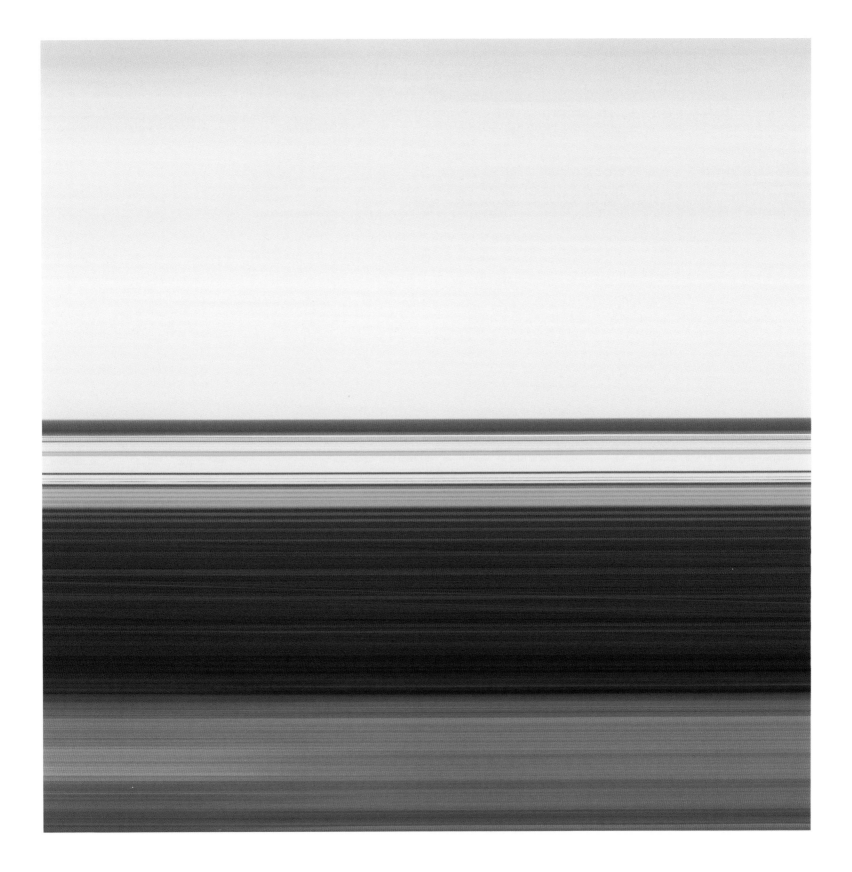

34 *Tulip Fields XXVII* Holland 2007

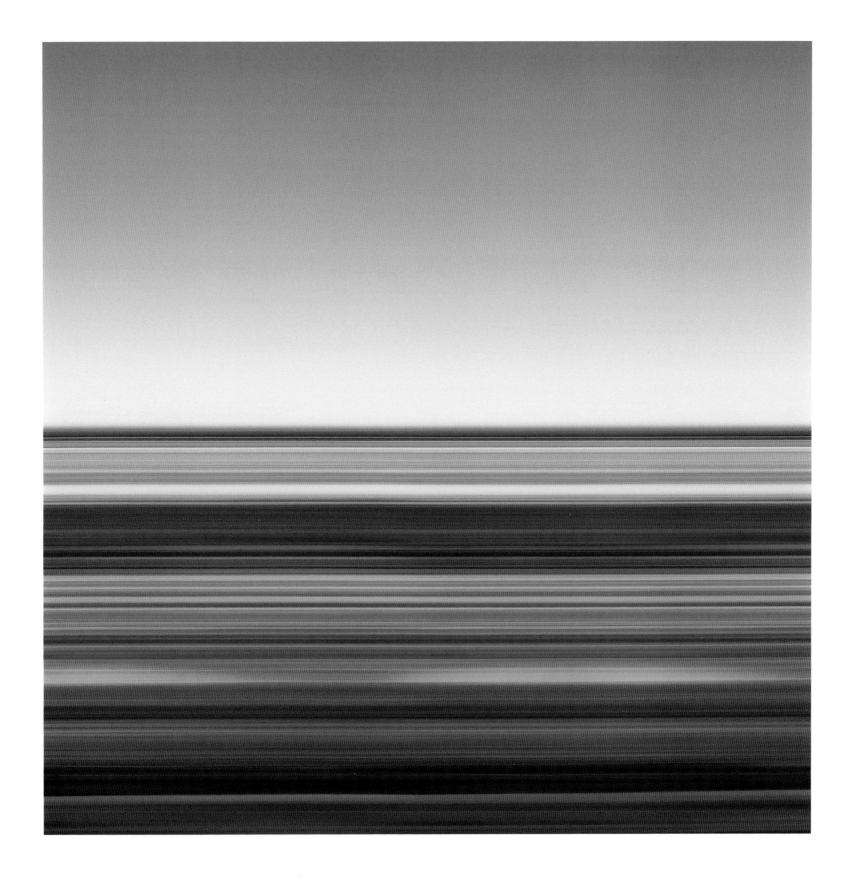

35 *Tulip Fields xxxi* Holland 2007

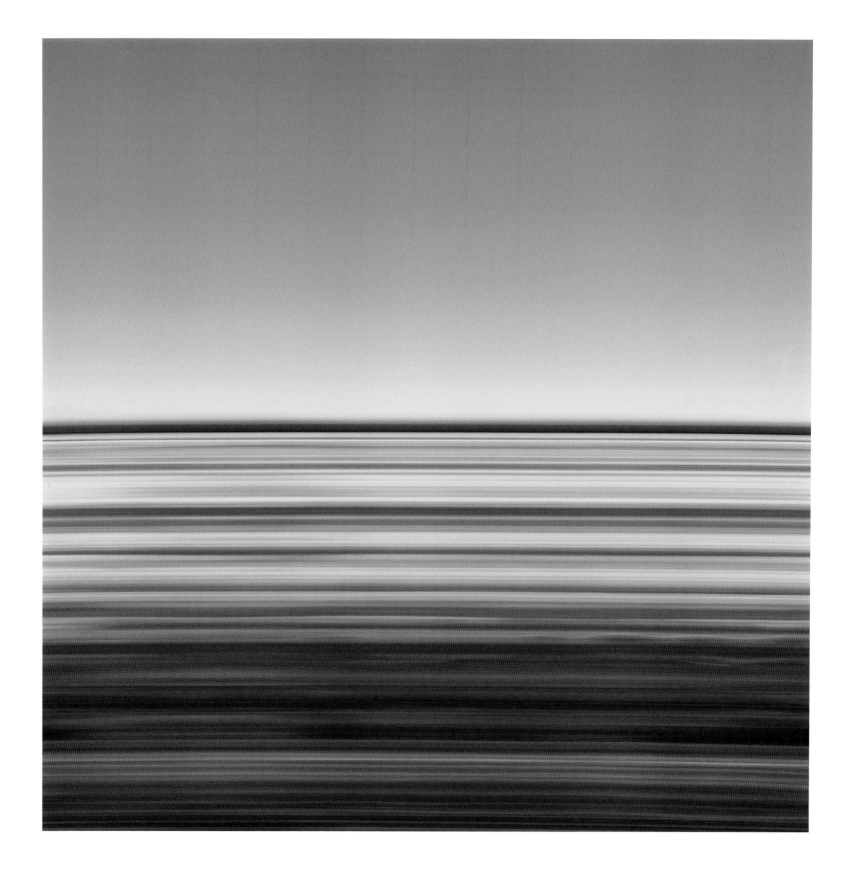

36 *Tulip Fields* XI Holland 2004

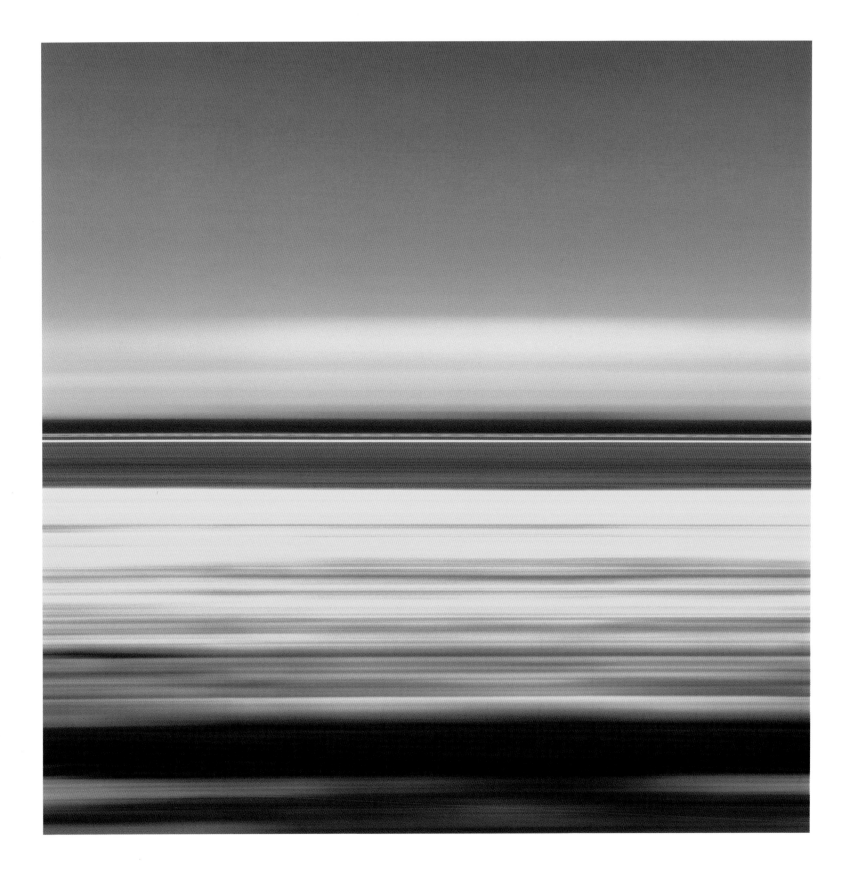

37 *Tulip Fields xxix* Holland 2007

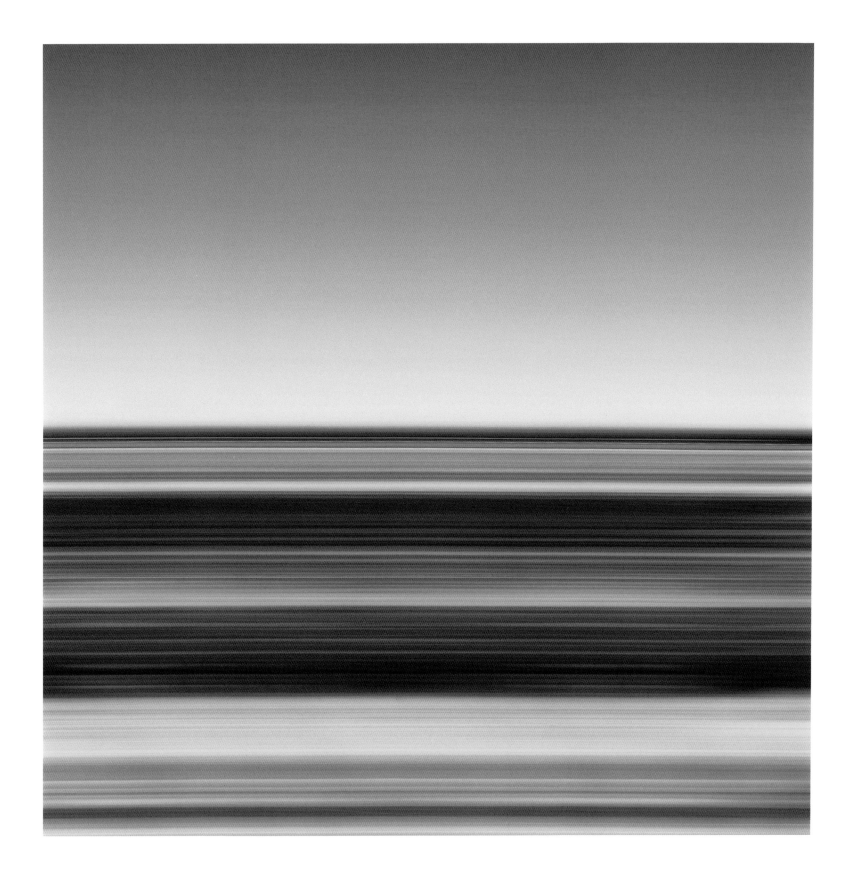

38 *Tulip Fields XIV* Holland 2006

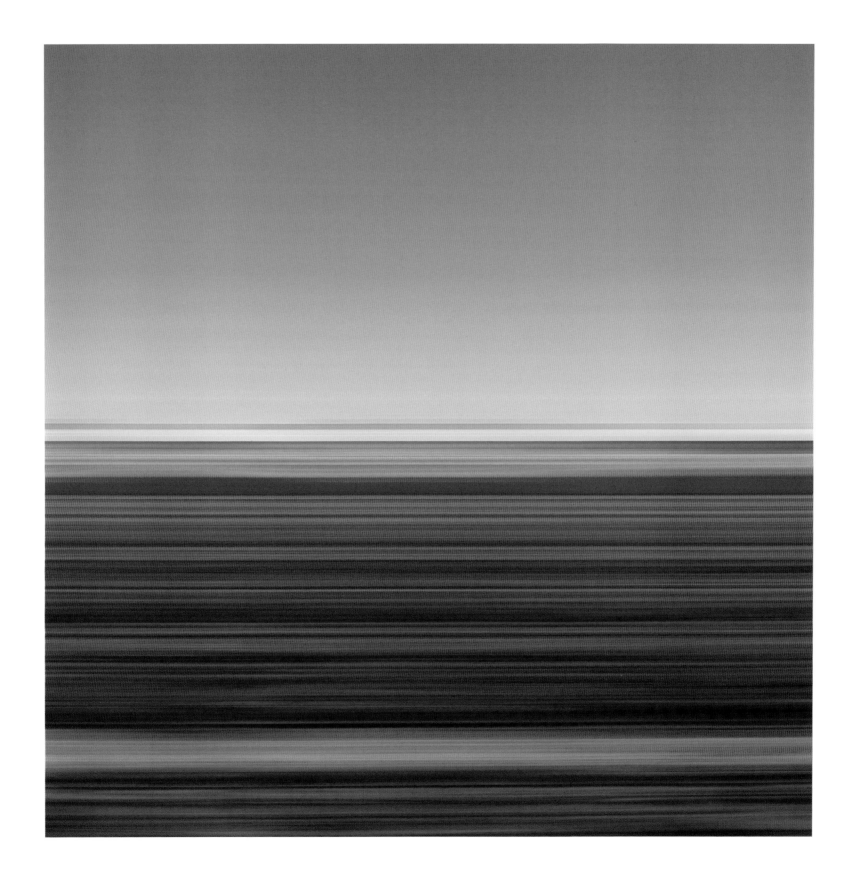

39 *Tulip Fields XIX* Holland 2006

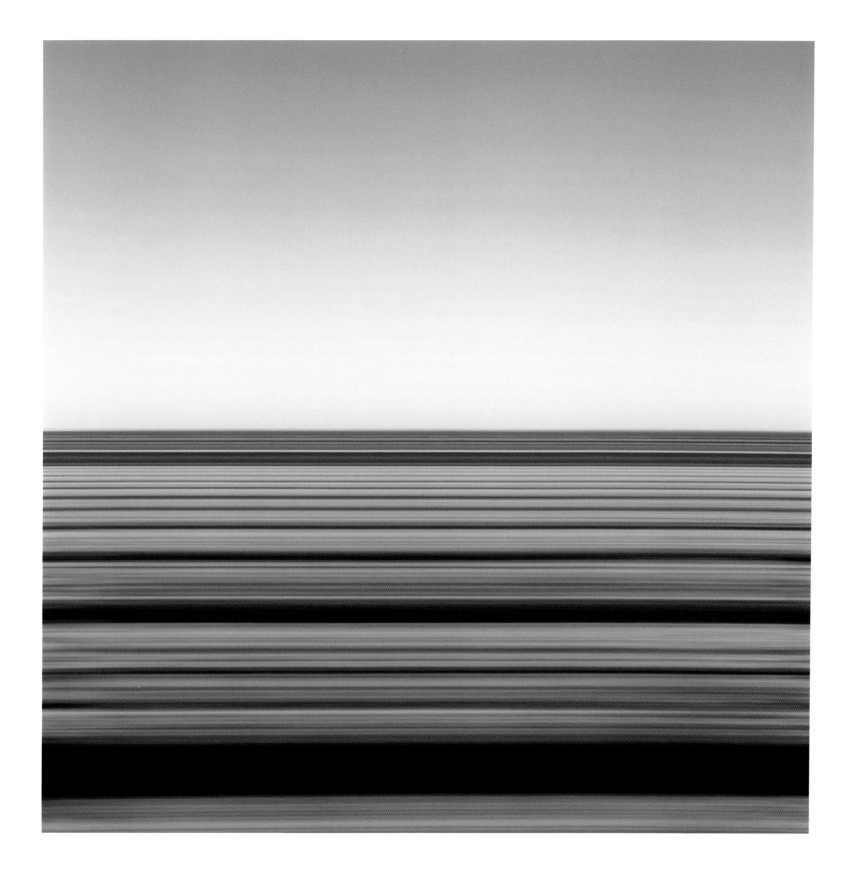

40 *Tulip Fields VII* VII Holland 2004

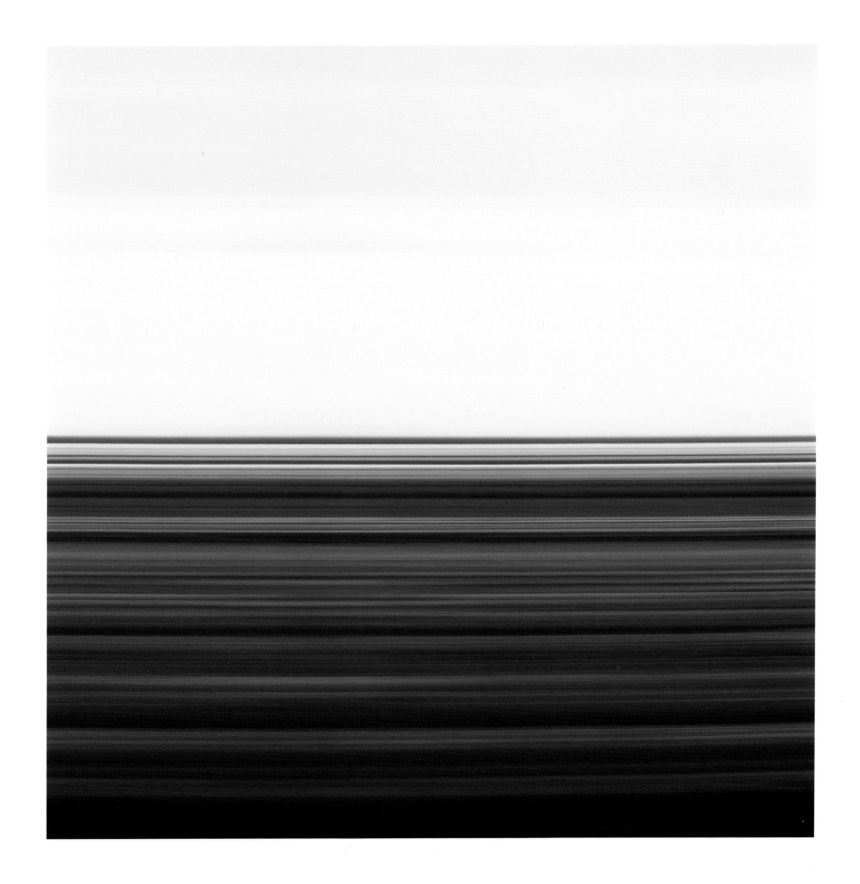

41 *Tulip Fields II* Holland 2004

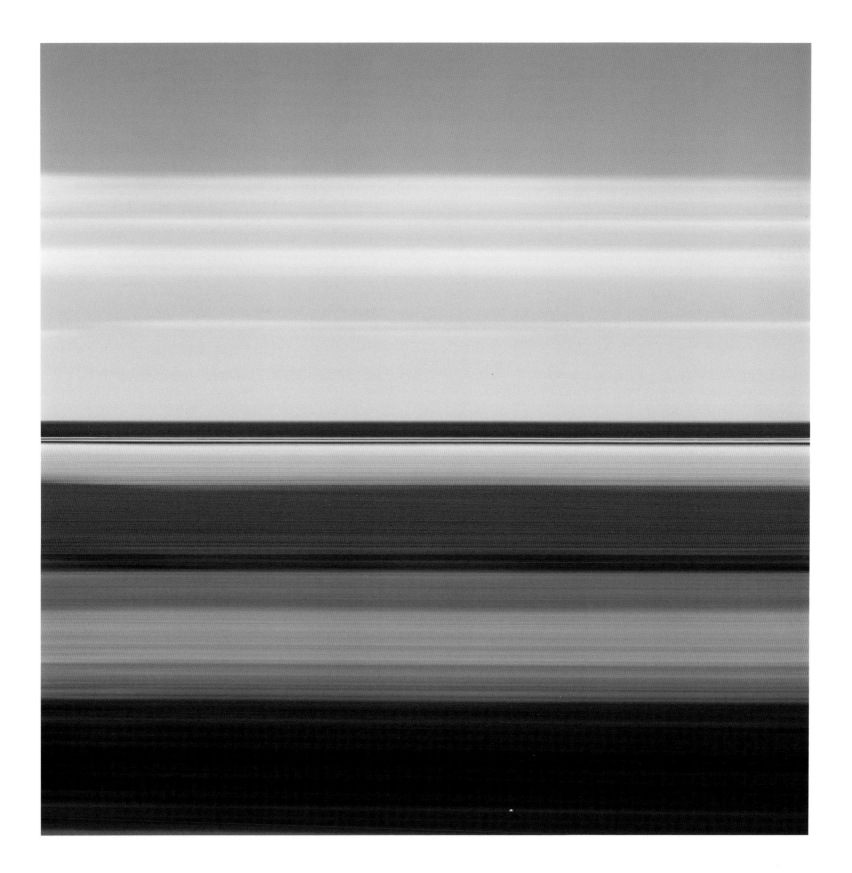

42 *Tulip Fields XII* Holland 2004

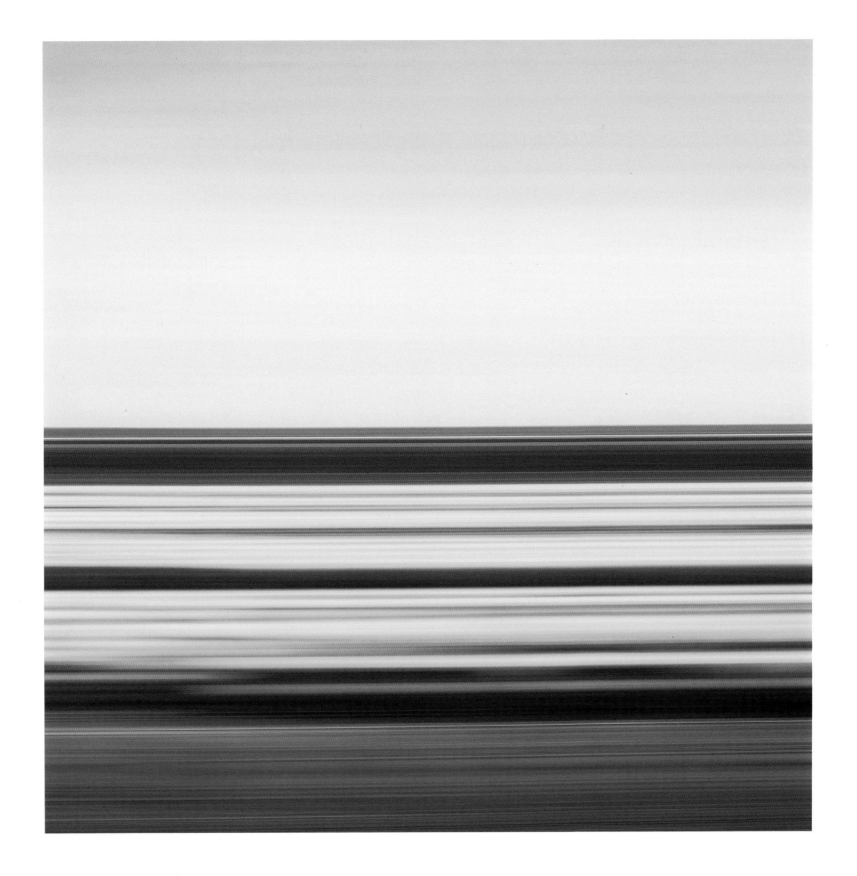

43 *Tulip Fields xxi* Holland 2006

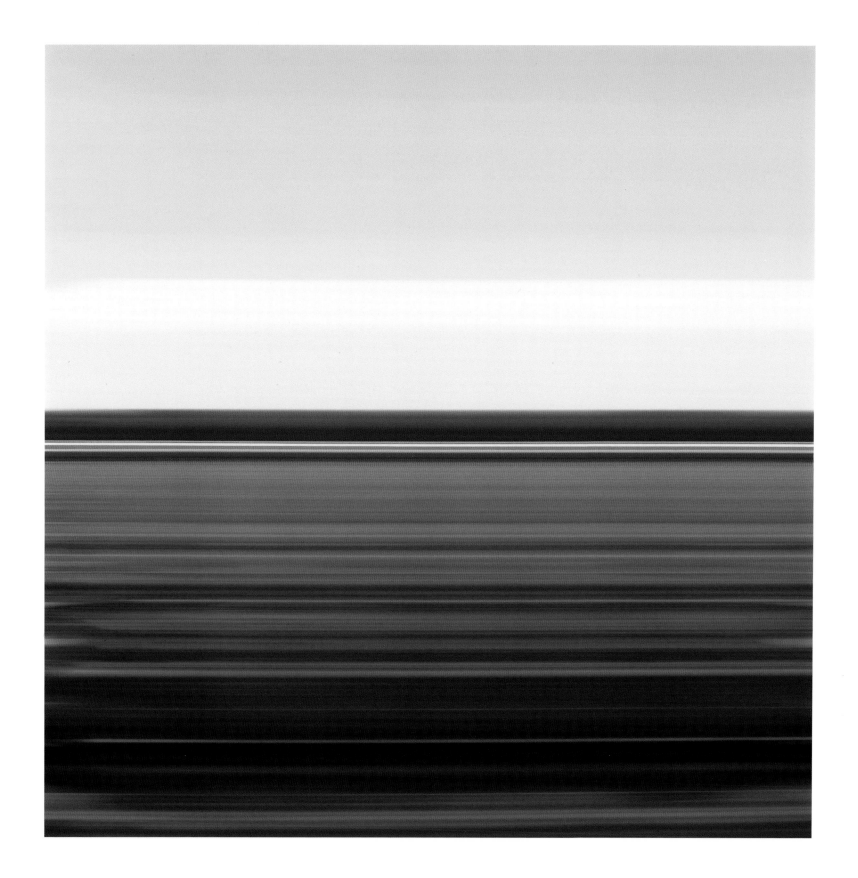

44 *Tulip Fields XXIII* Holland 2006

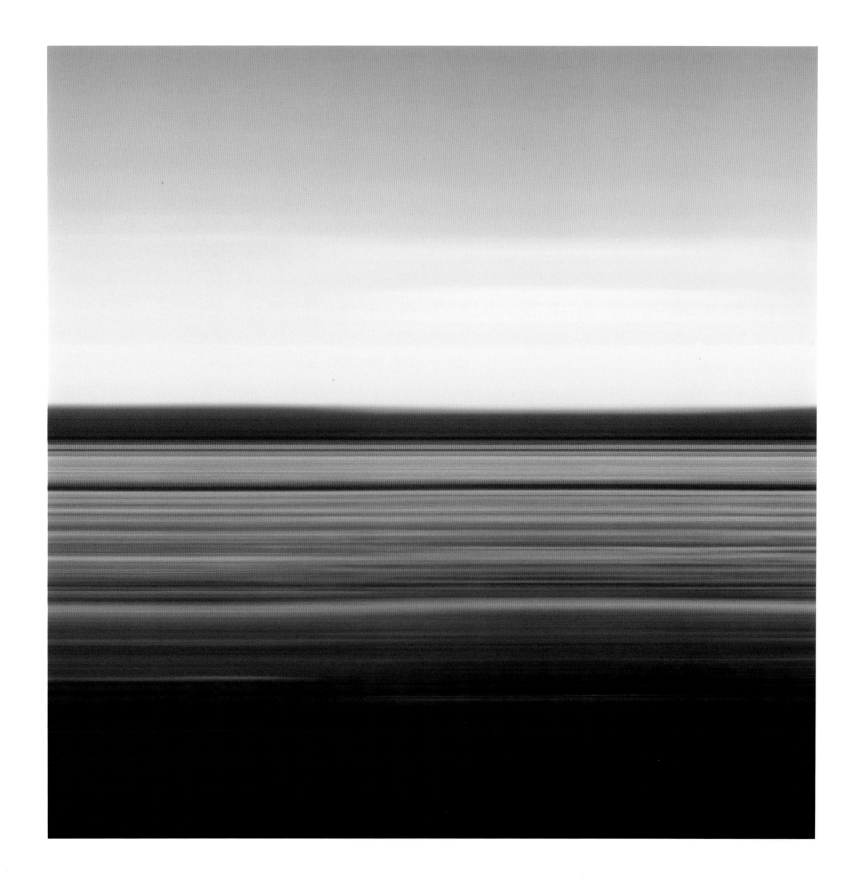

45 *Tulip Fields* I Holland 2004

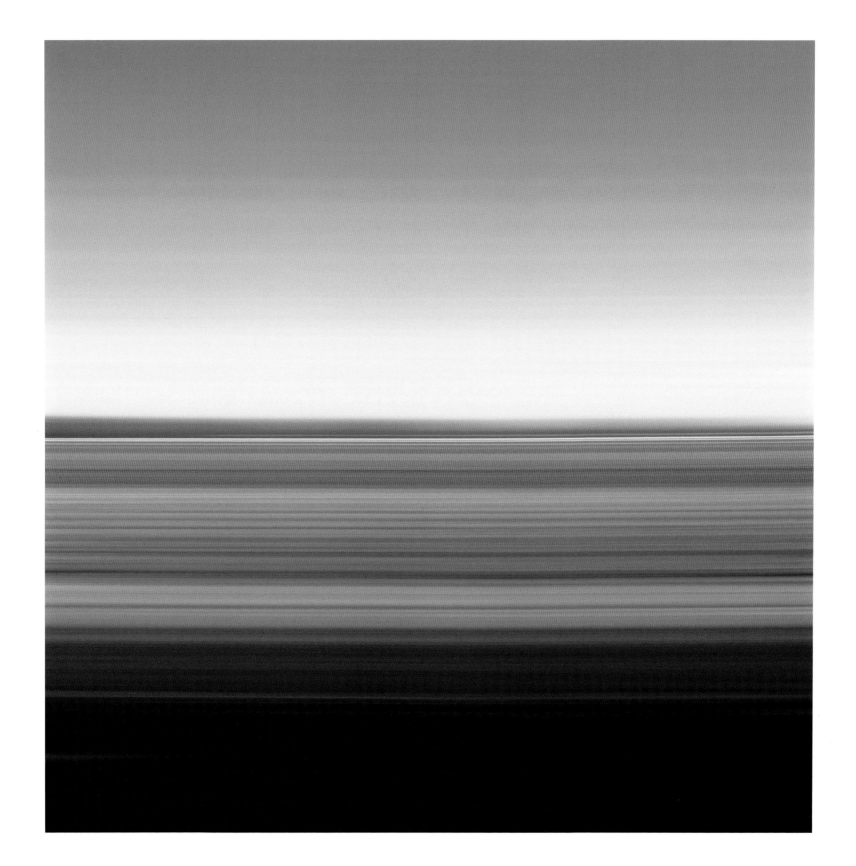

46 *Tulip Fields IX* Holland 2004

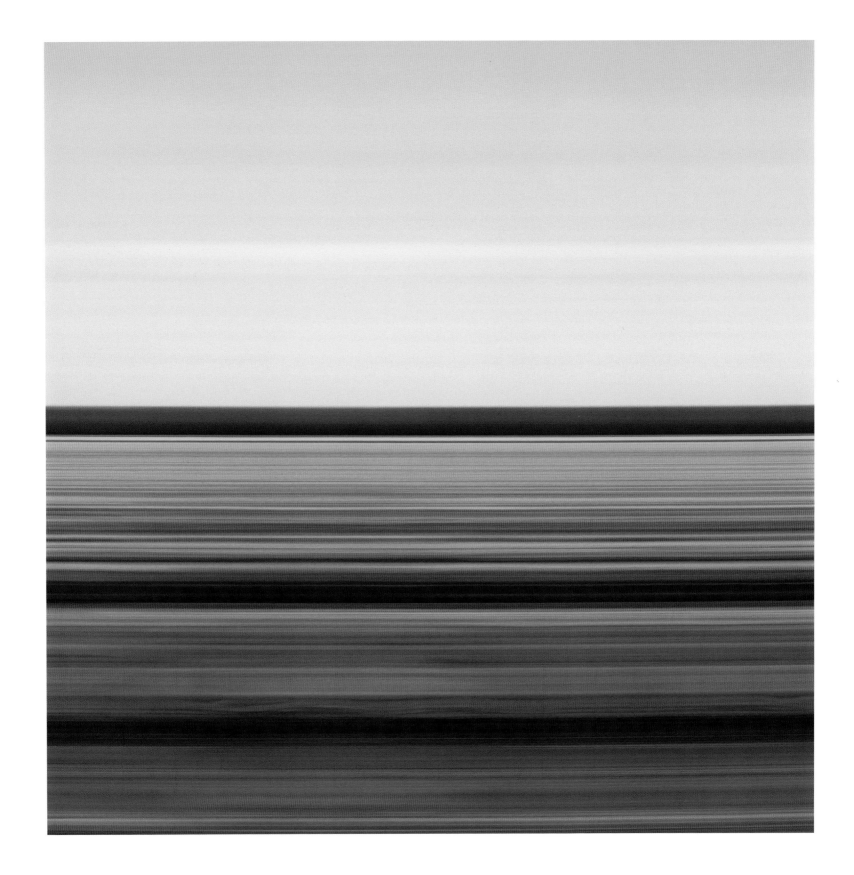

47 *Tulip Fields XXII* Holland 2006

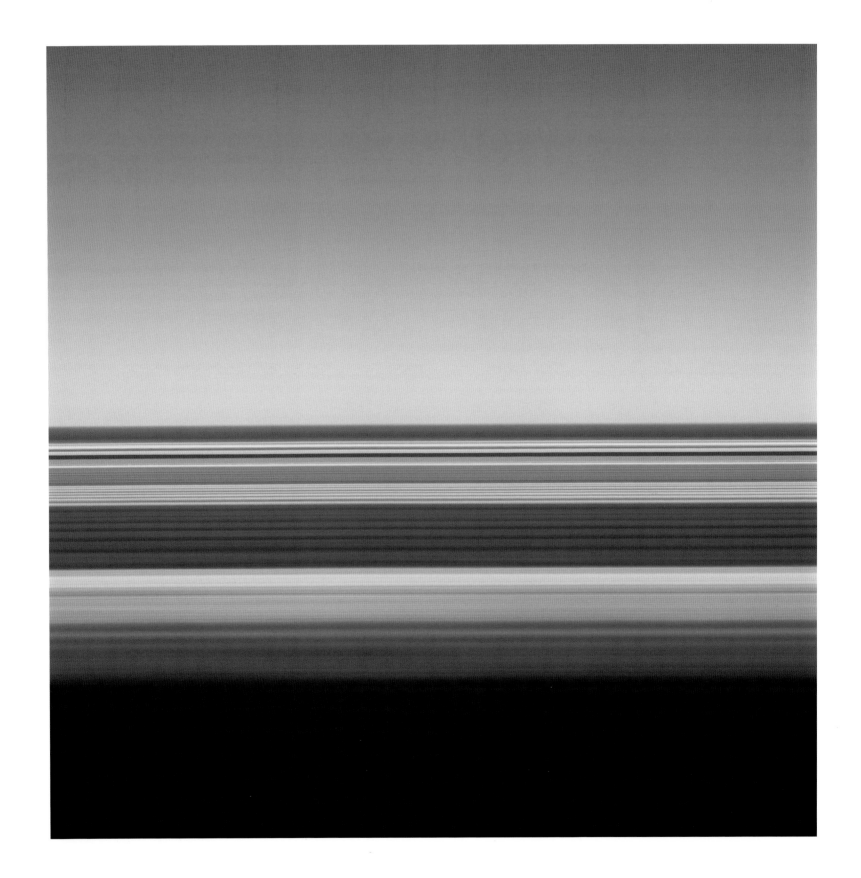

48 *Tulip Fields XXVIII* Holland 2007

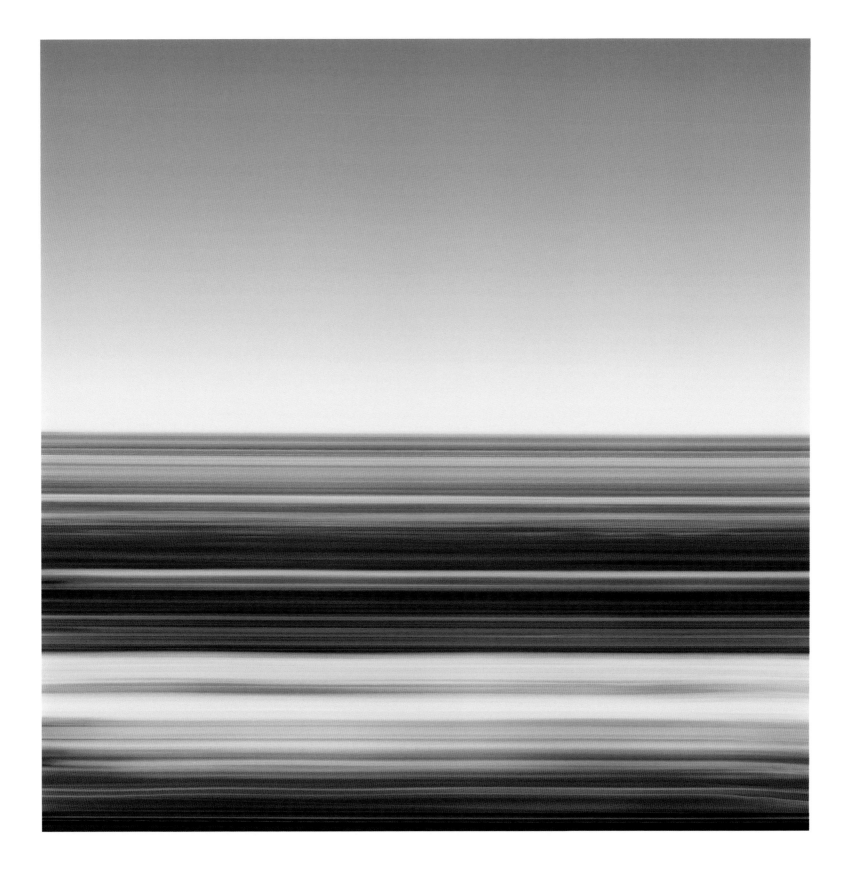

49 *Tulip Fields XV* Holland 2006

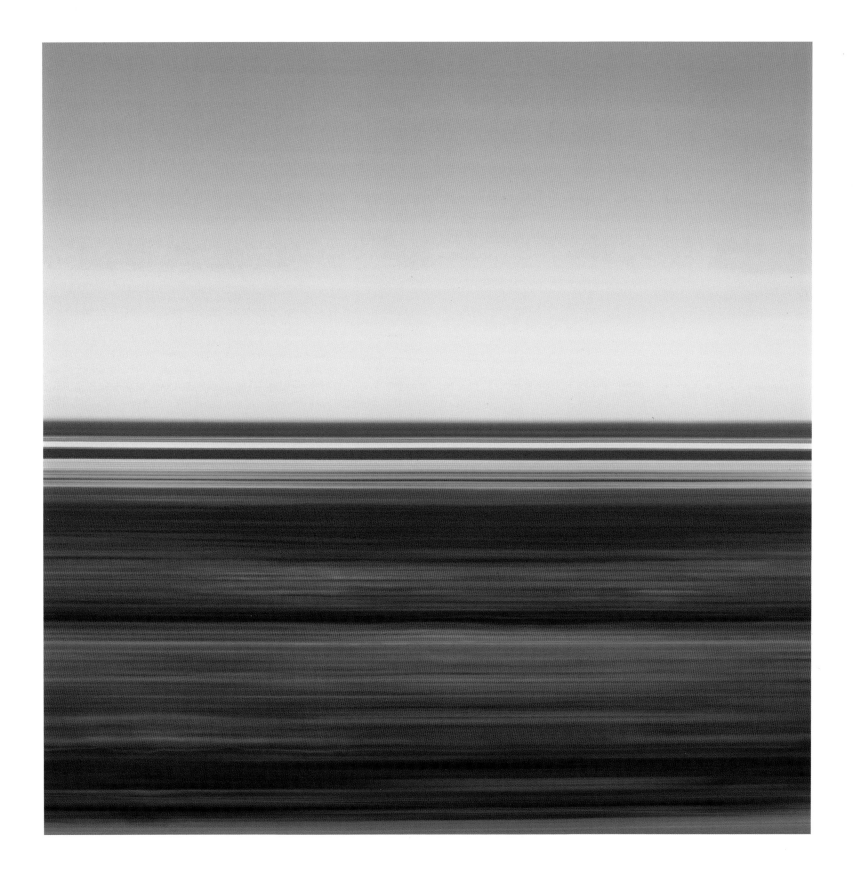

50 *Tulip Fields xx* Holland 2006

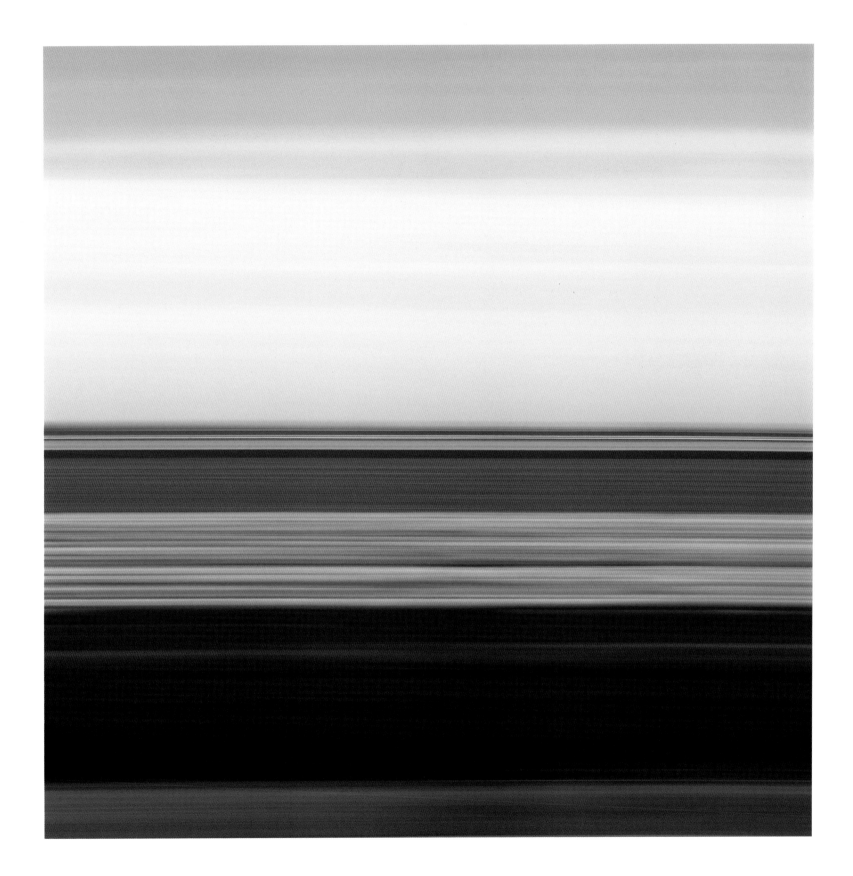

51 *Tulip Fields XXVI* Holland 2006

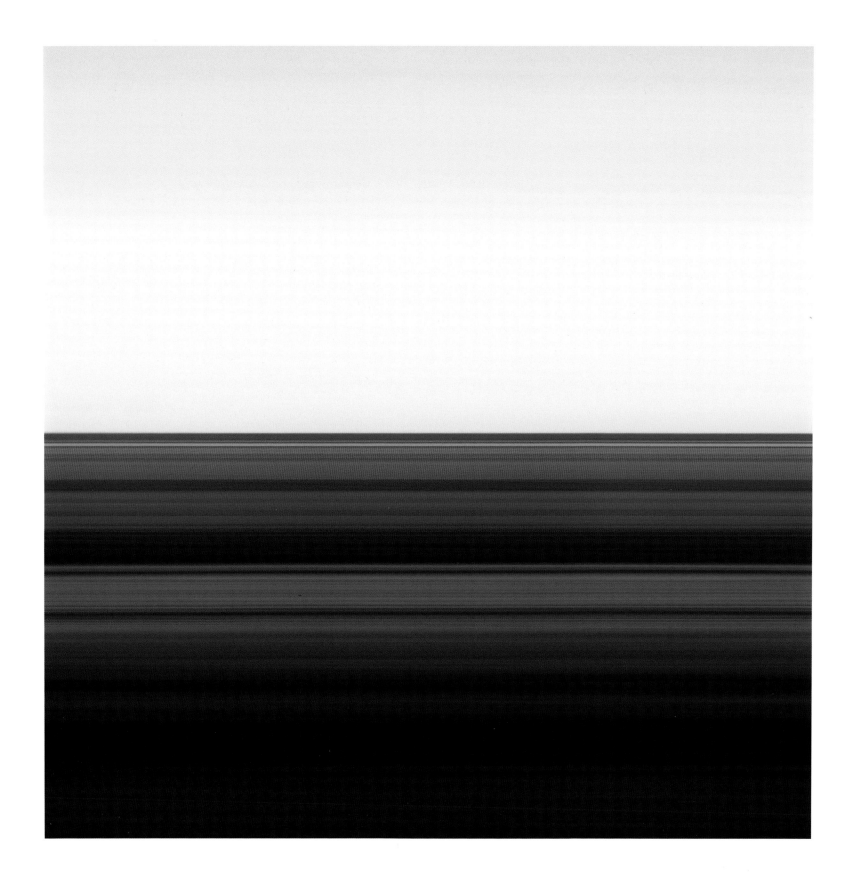

52 *Tulip Fields XVI* Holland 2006

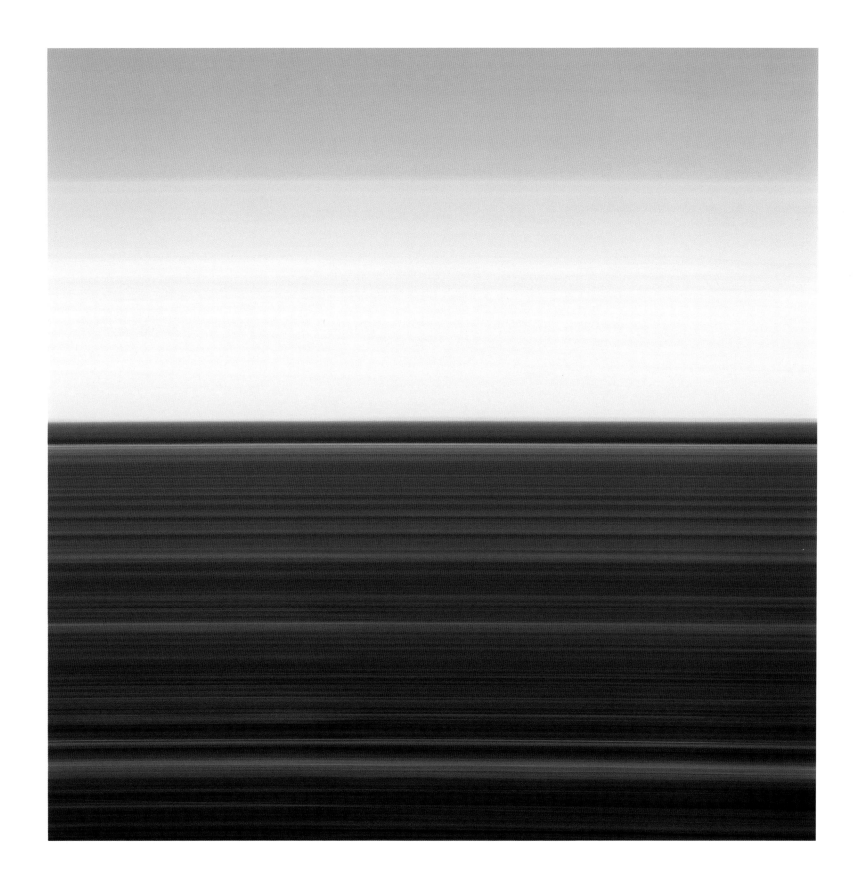

53 *Tulip Fields V* Holland 2004

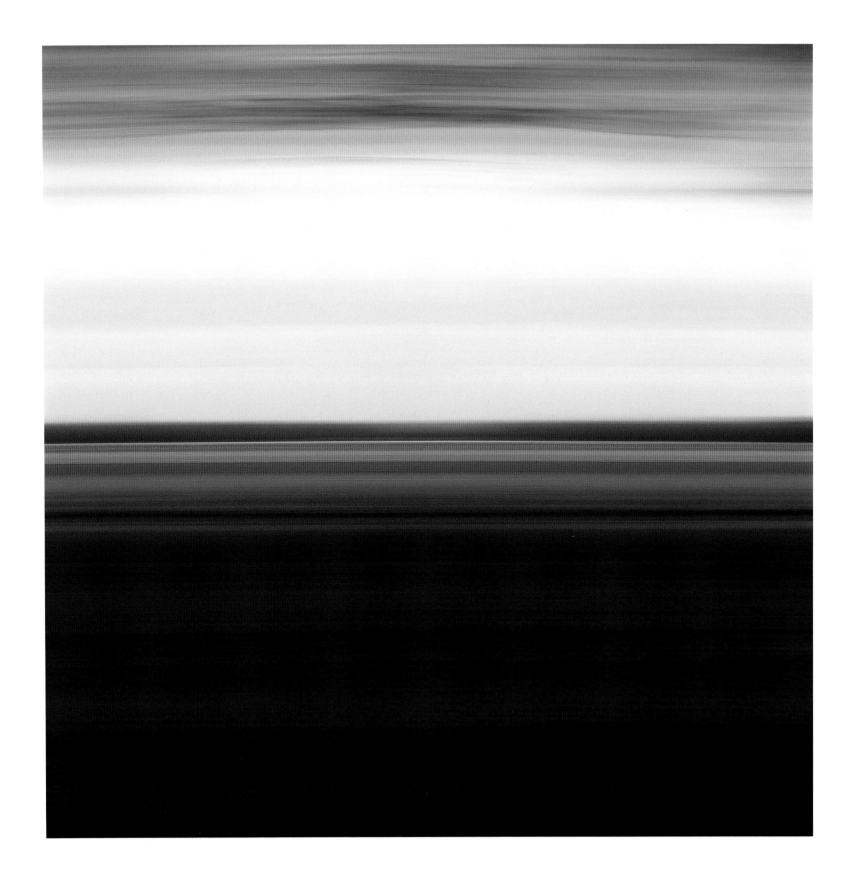

54 *Sunset IX* Mauritius 2006

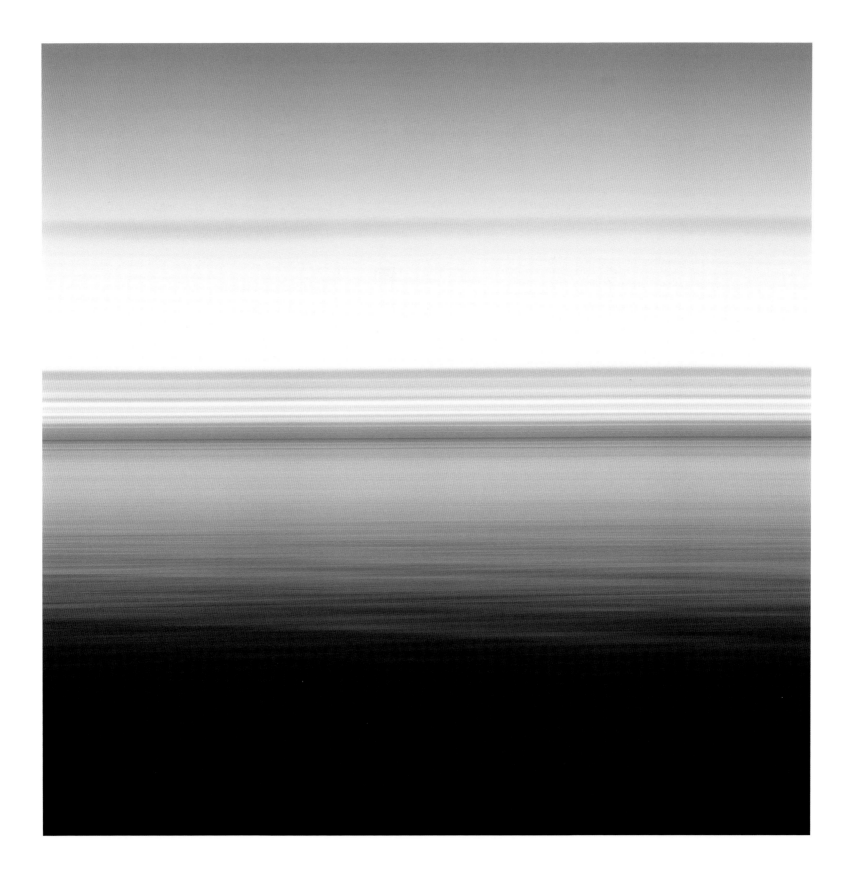

Sunset IV Mauritius 2006

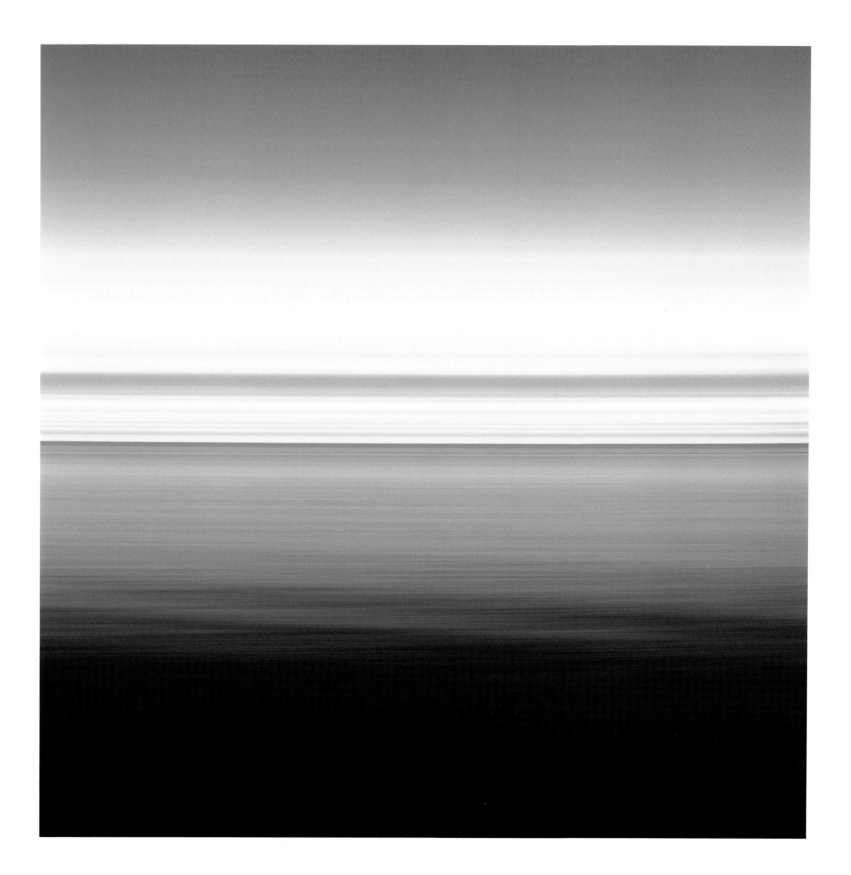

56 *Sunset III* Mauritius 2006

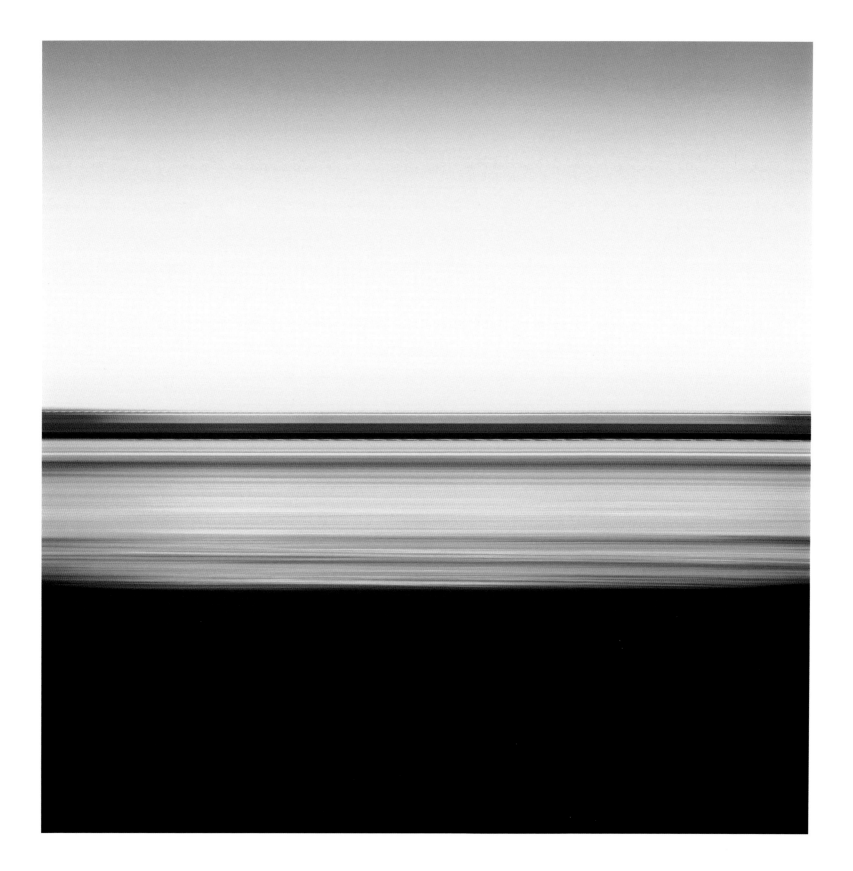

57 *Miami Beach I* USA 2007

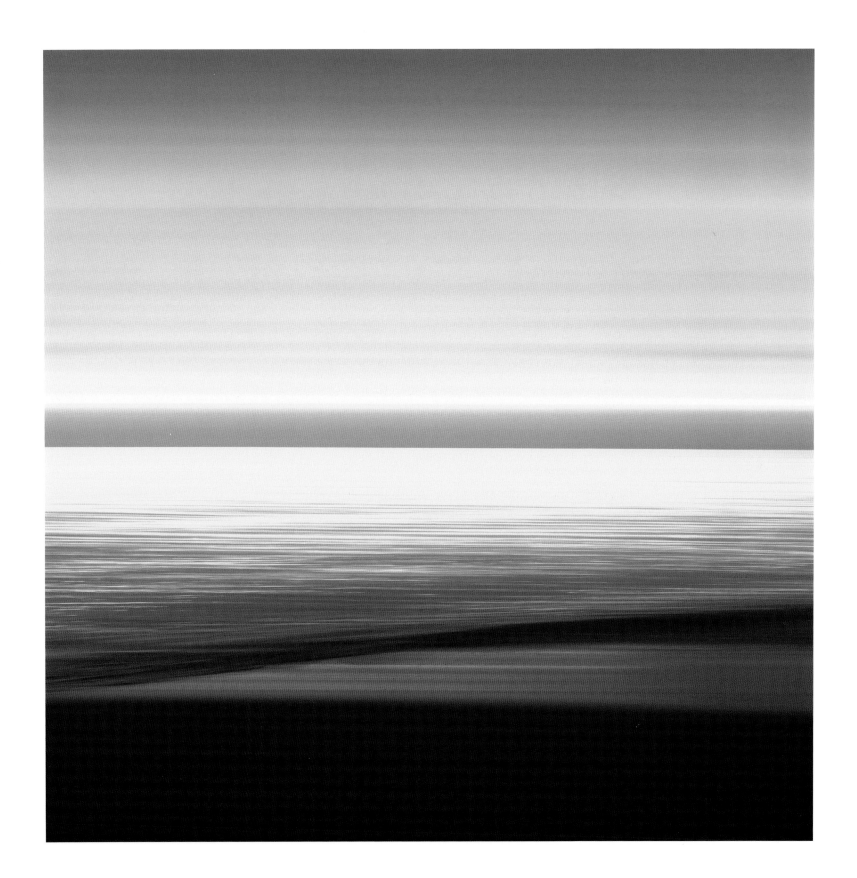

58 *Miami Beach II* USA 2007

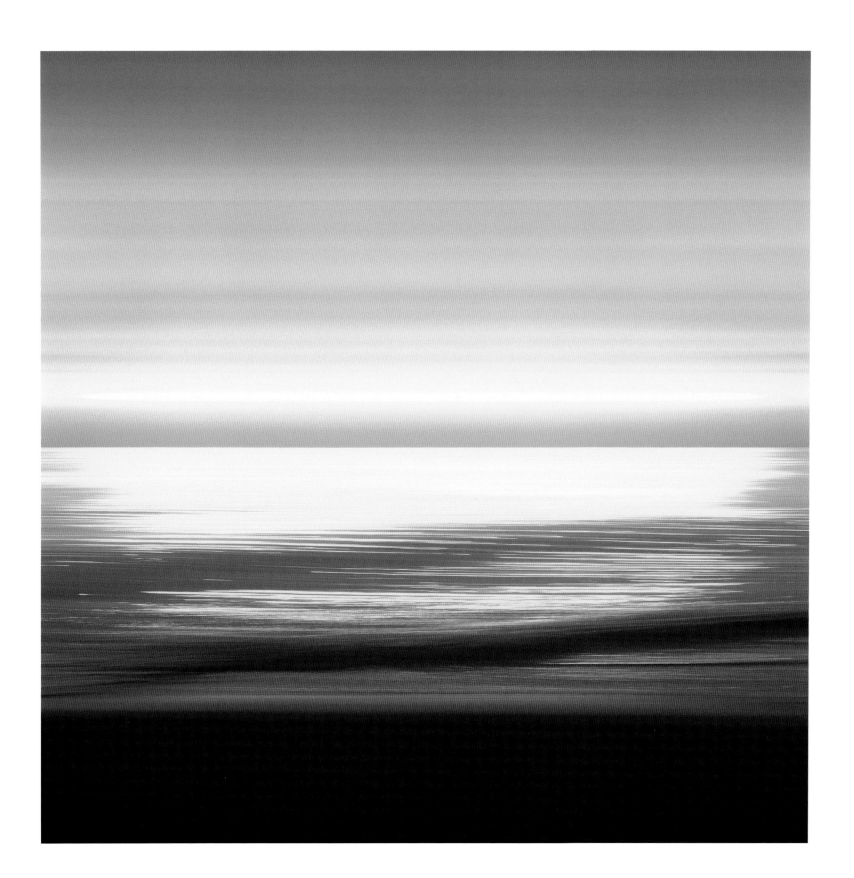

59 *Coral Reef II* Barbados 2005

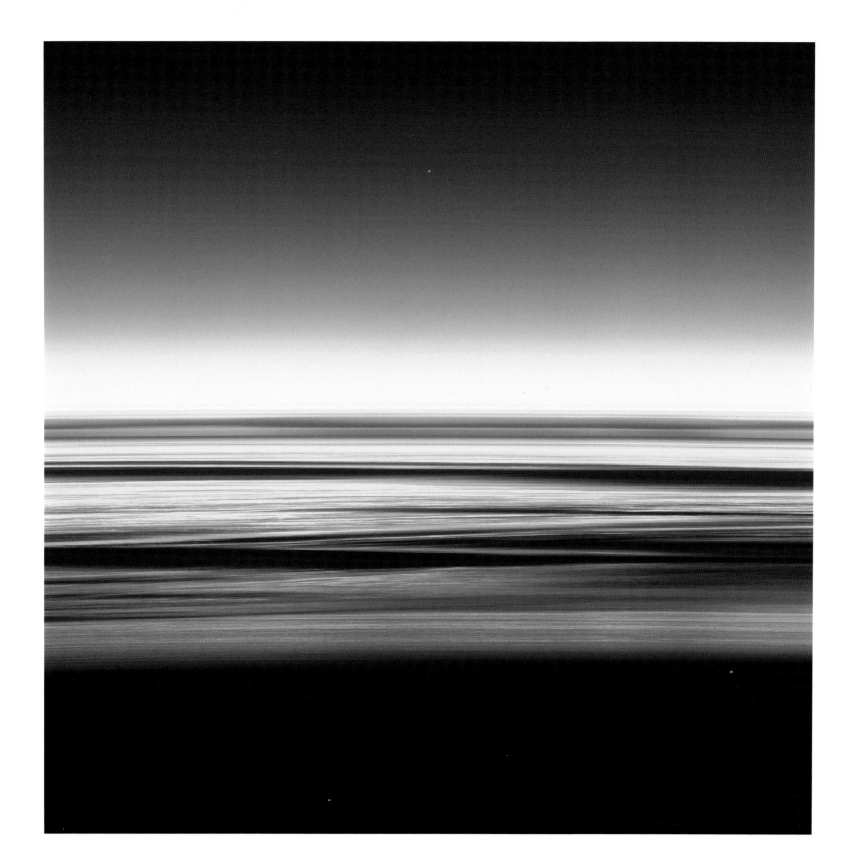

60 *Coral Reef I* Barbados 2005

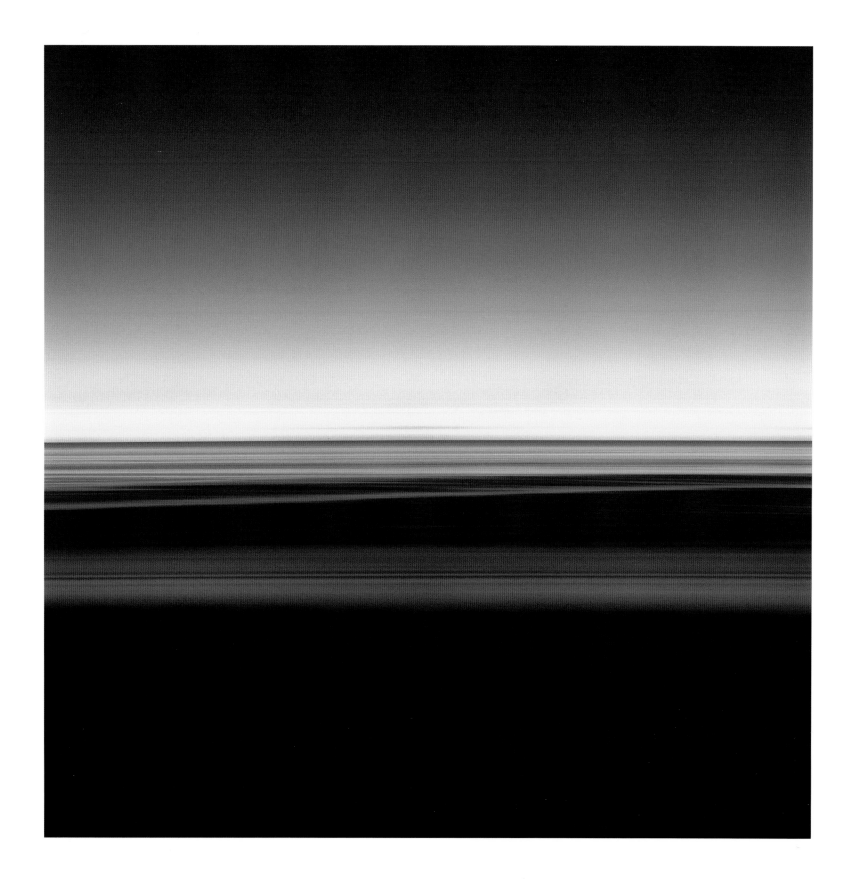

61 *Sunset II* Mauritius 2006

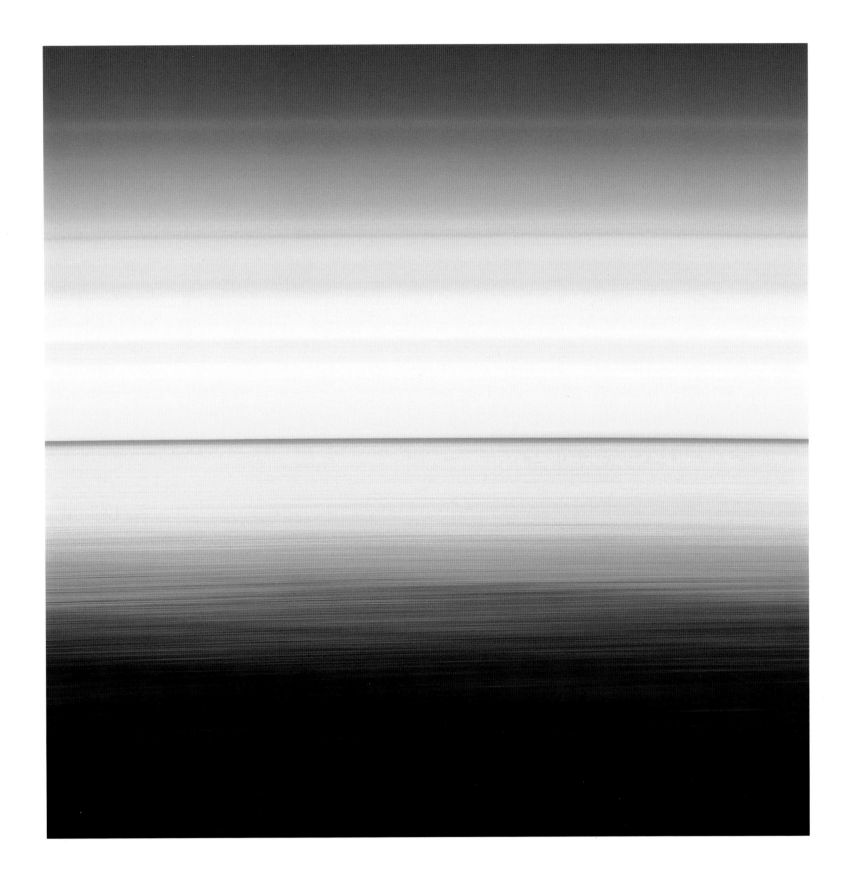

62 *Sunset I* Mauritius 2006

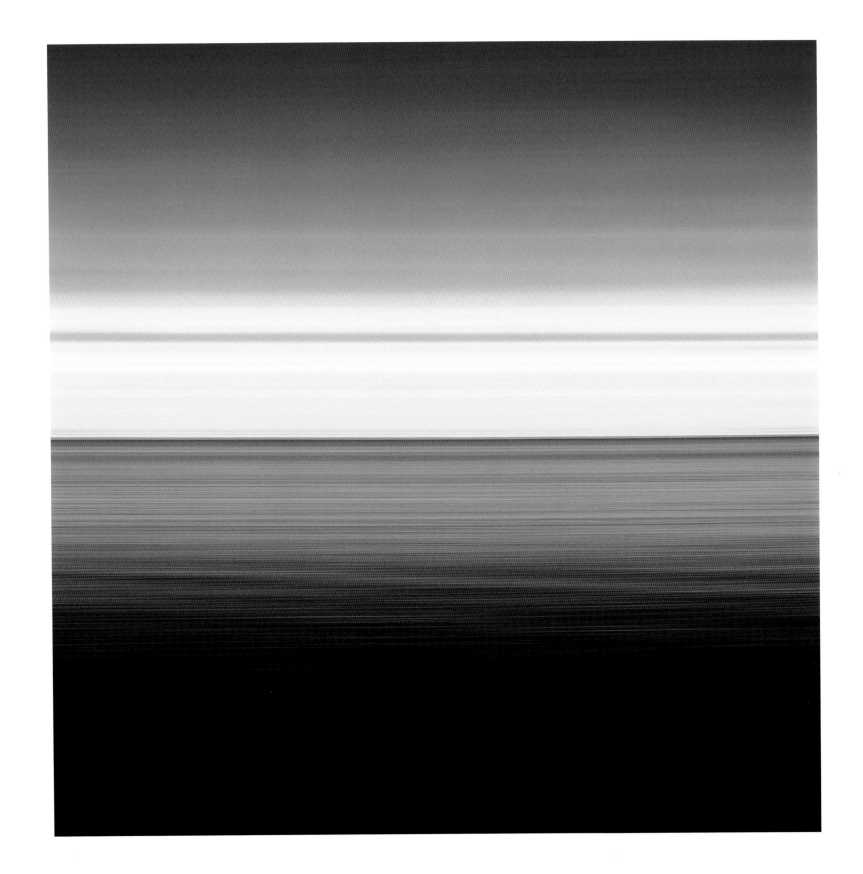

63 *Sunset VII* Mauritius 2006

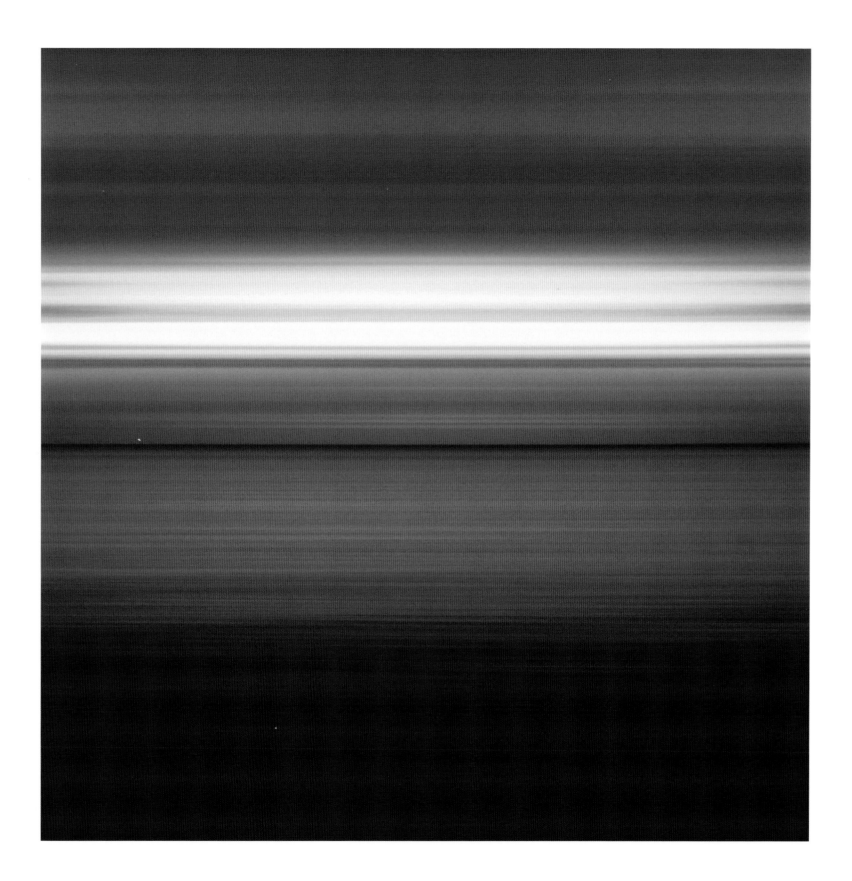

64 *Sunset v* Mauritius 2006

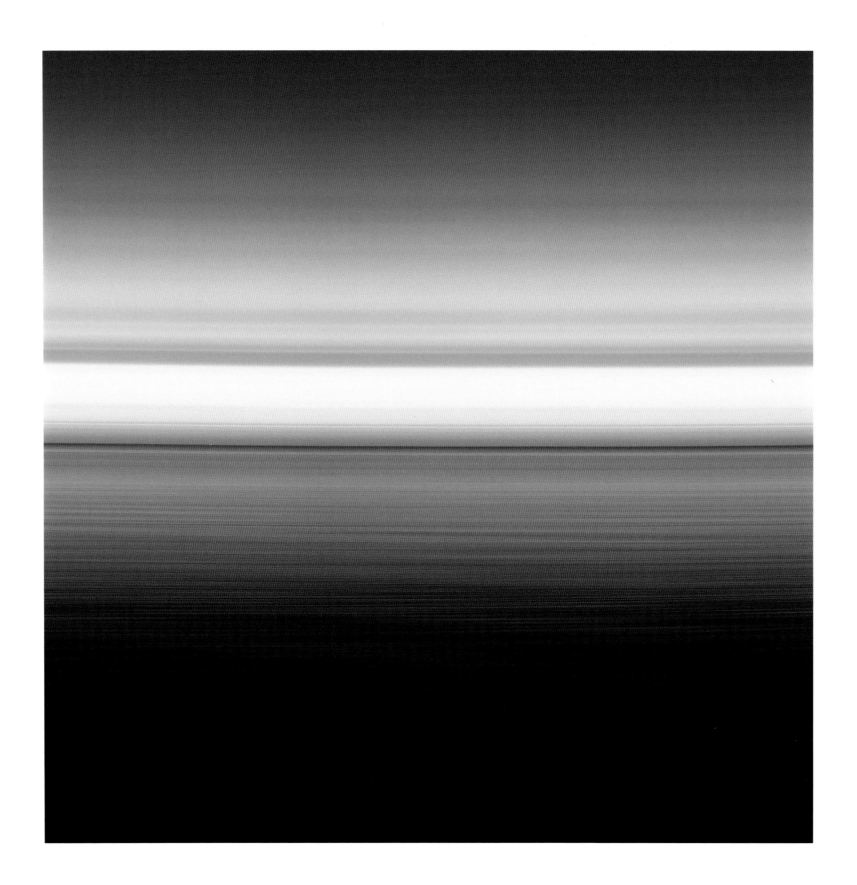

65 *Sunset x* Mauritius 2006

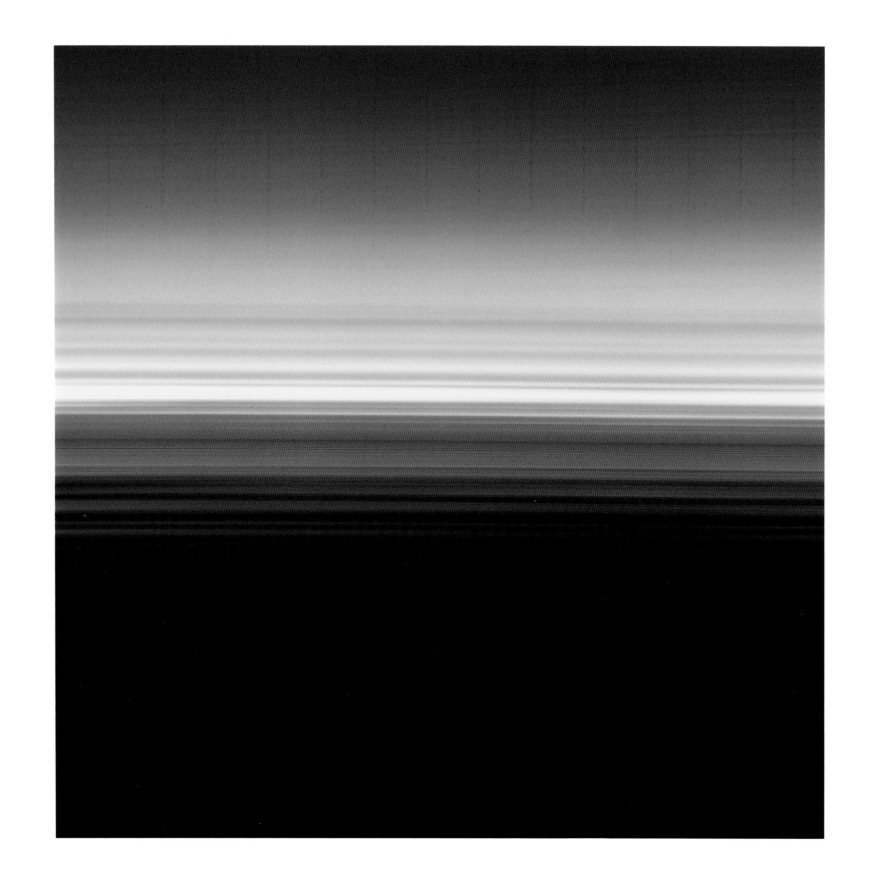

66 *Sunset XII* Mauritius 2006

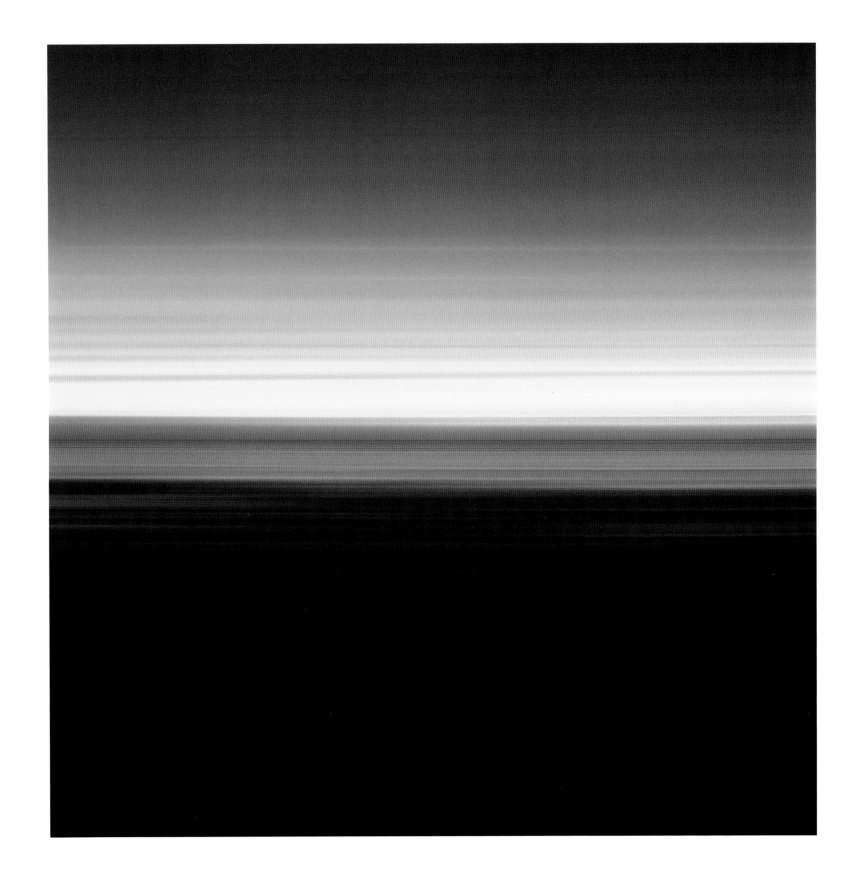

67 *Sunset VIII* Mauritius 2006

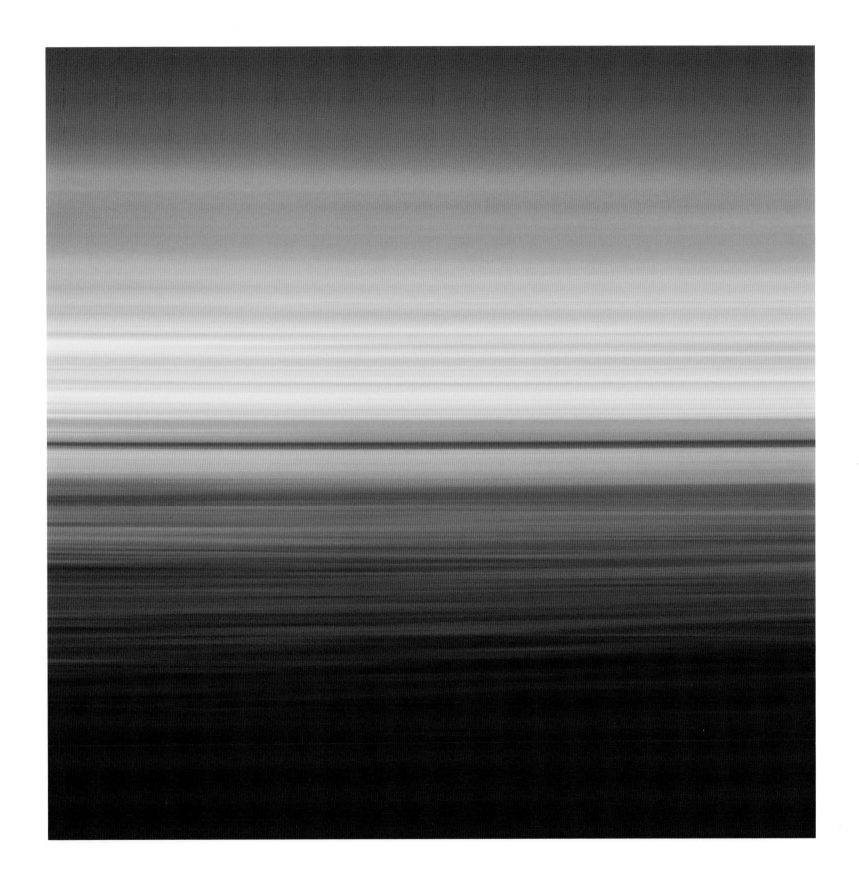

68 *Sunset VI* Mauritius 2006

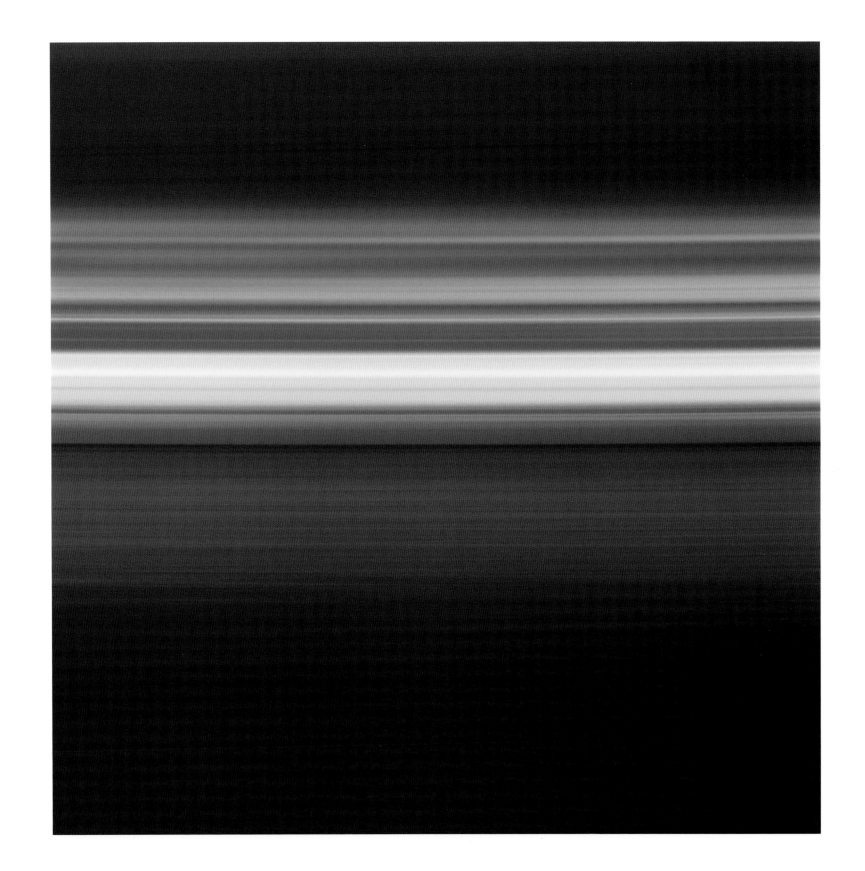

69 *Sunset XI* Mauritius 2006

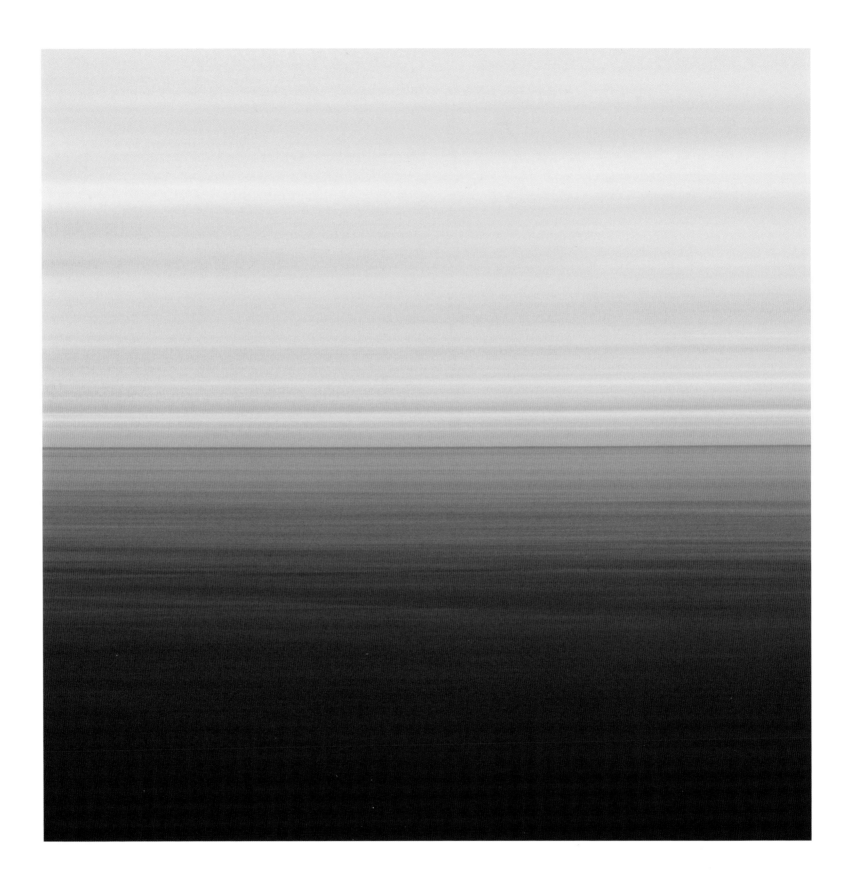

70 *Parking* Las Vegas, USA 2005

71 *Peppermill* Las Vegas, USA 2005

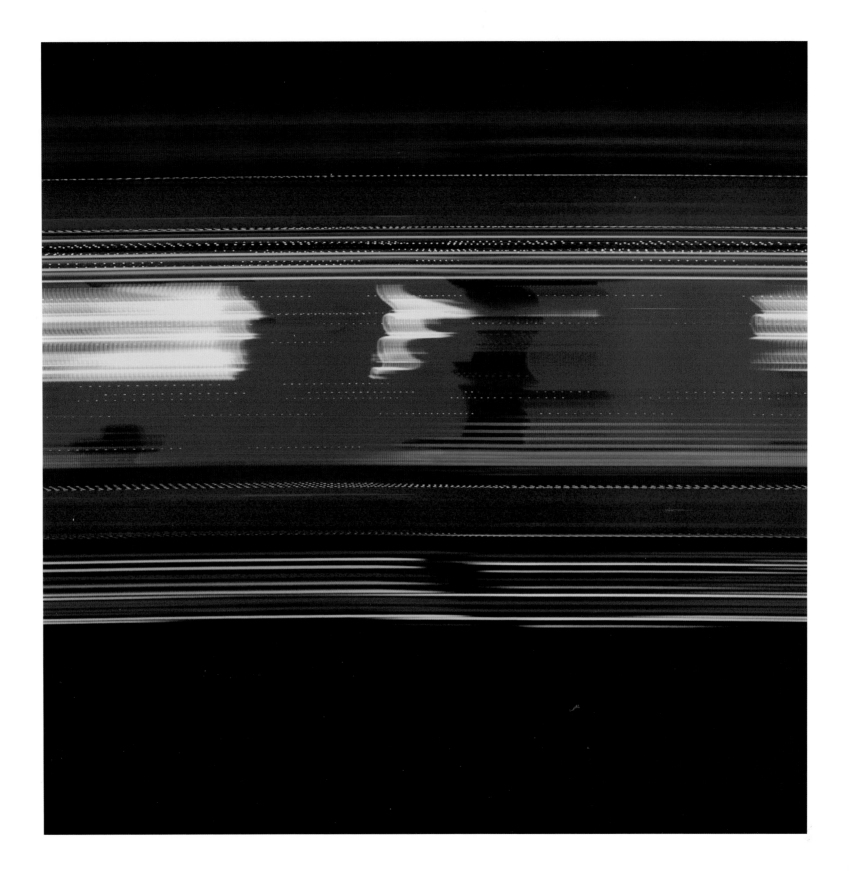

Hotel II Las Vegas, USA 2005

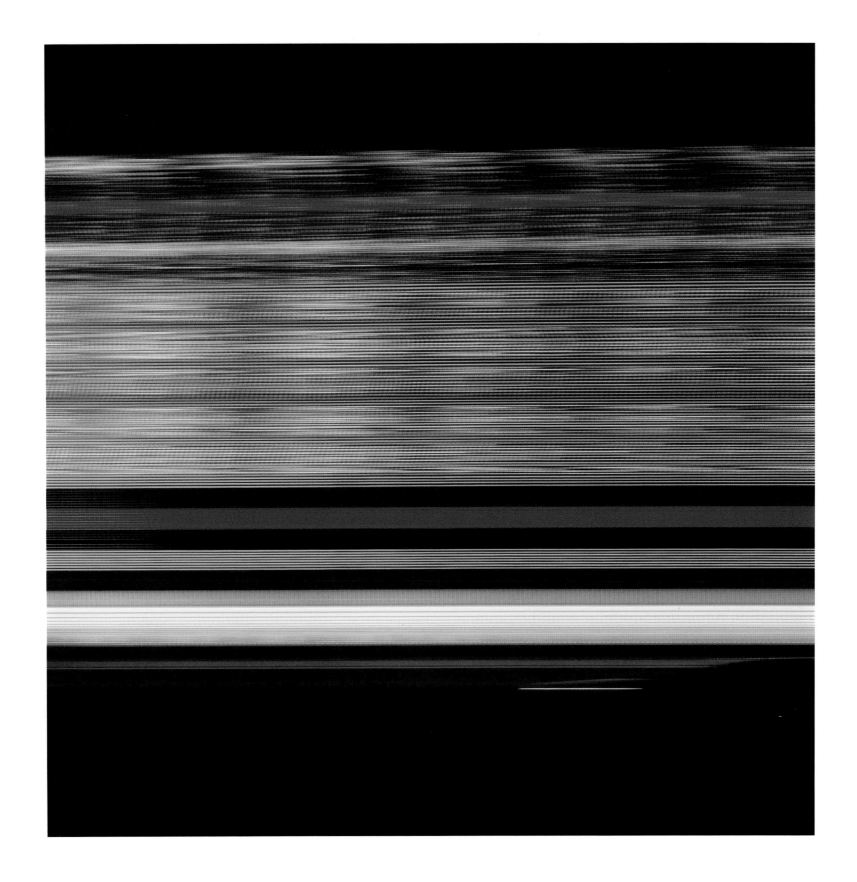

73 *Hotel I* Las Vegas, USA 2005

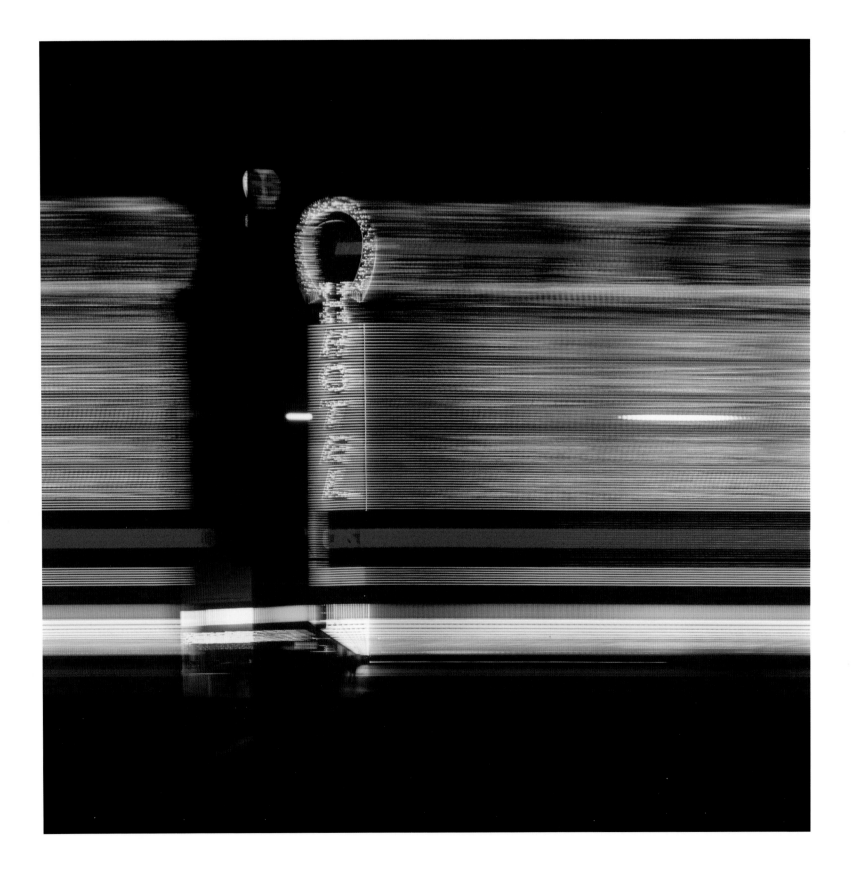

74 *Cowboy* Las Vegas, USA 2005

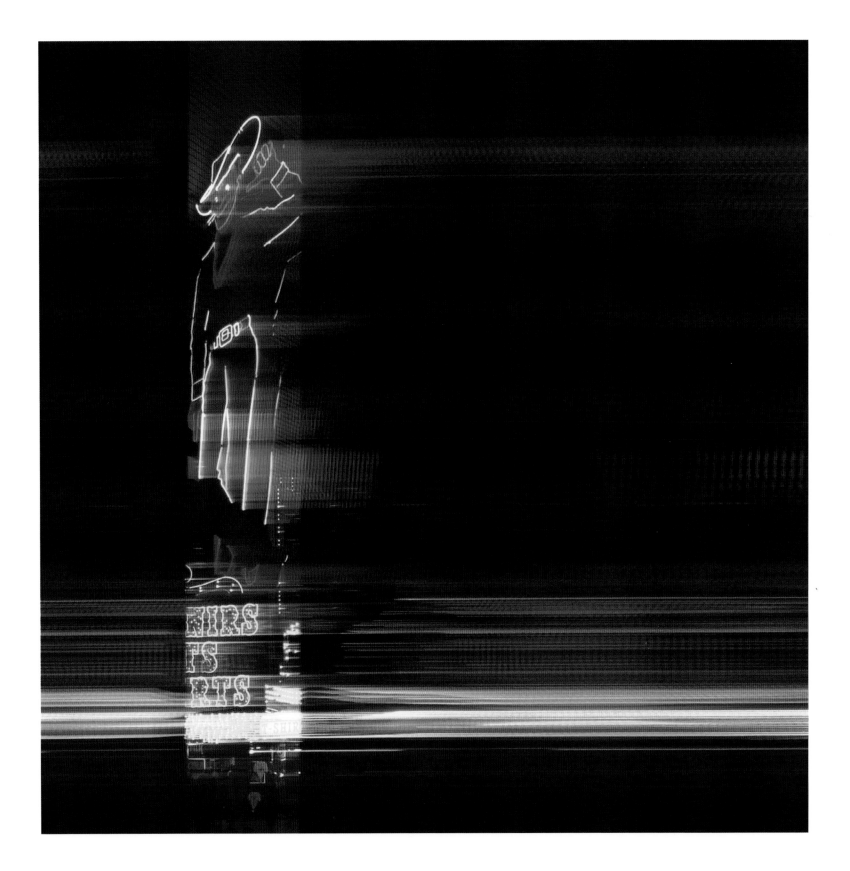

75 *Taxi* Las Vegas, USA 2005

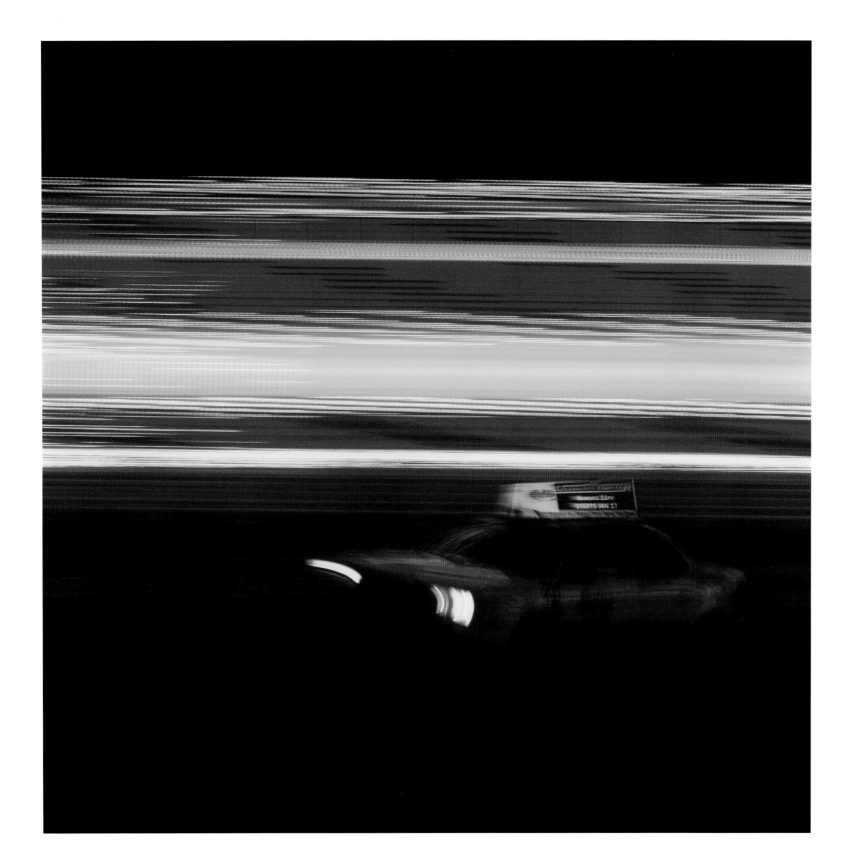

Motel Las Vegas, USA 2005

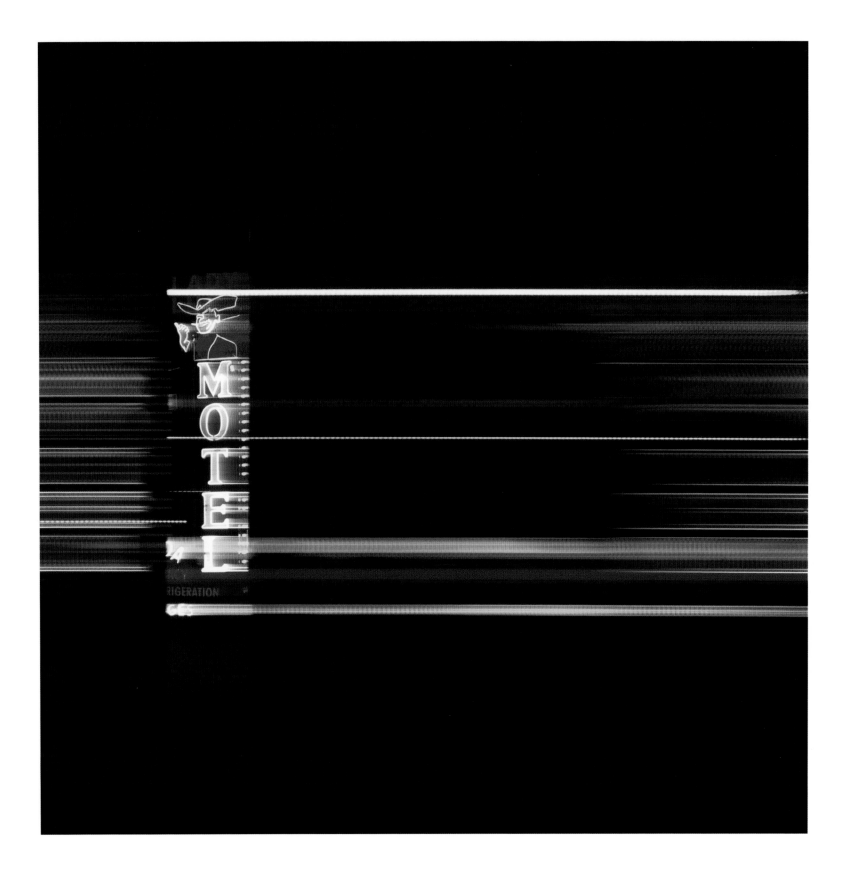

77 *El Cortez Hotel* Las Vegas, USA 2005

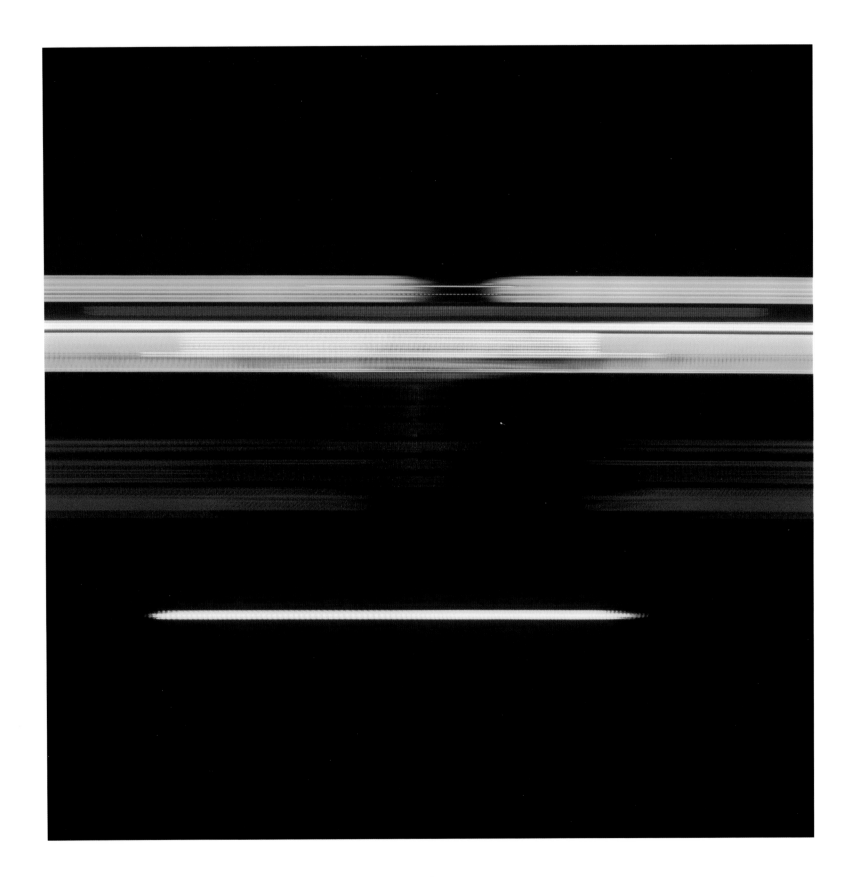

78 *Holiday Inn* Las Vegas, USA 2005

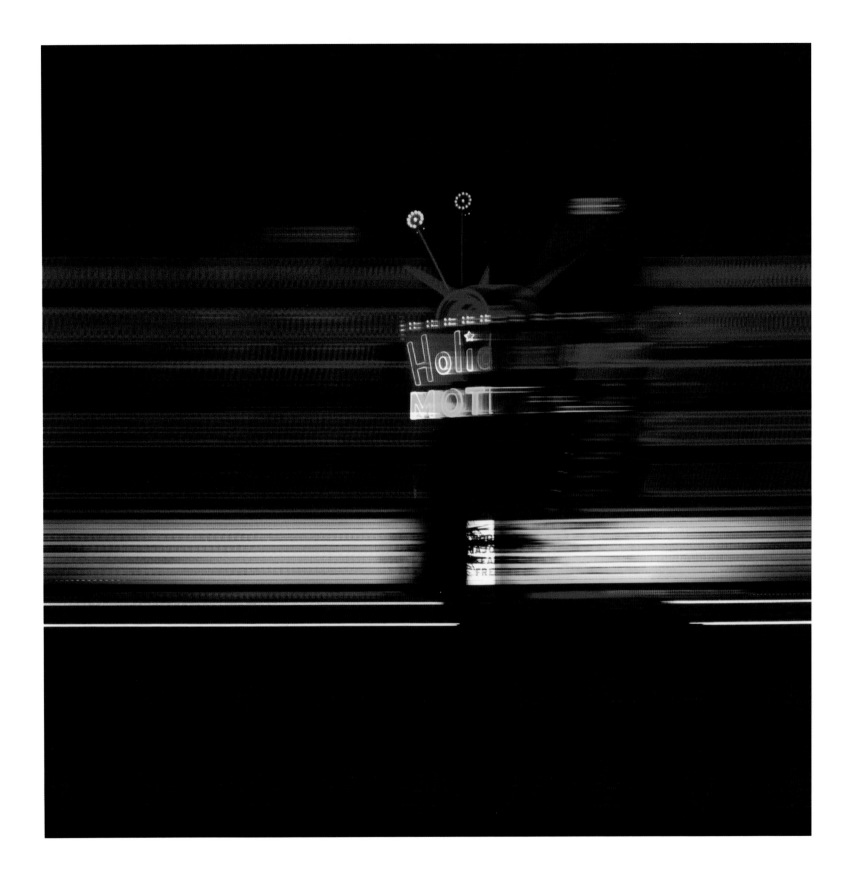

79 *The World Famous Chapel of the Bells* Las Vegas, USA 2005

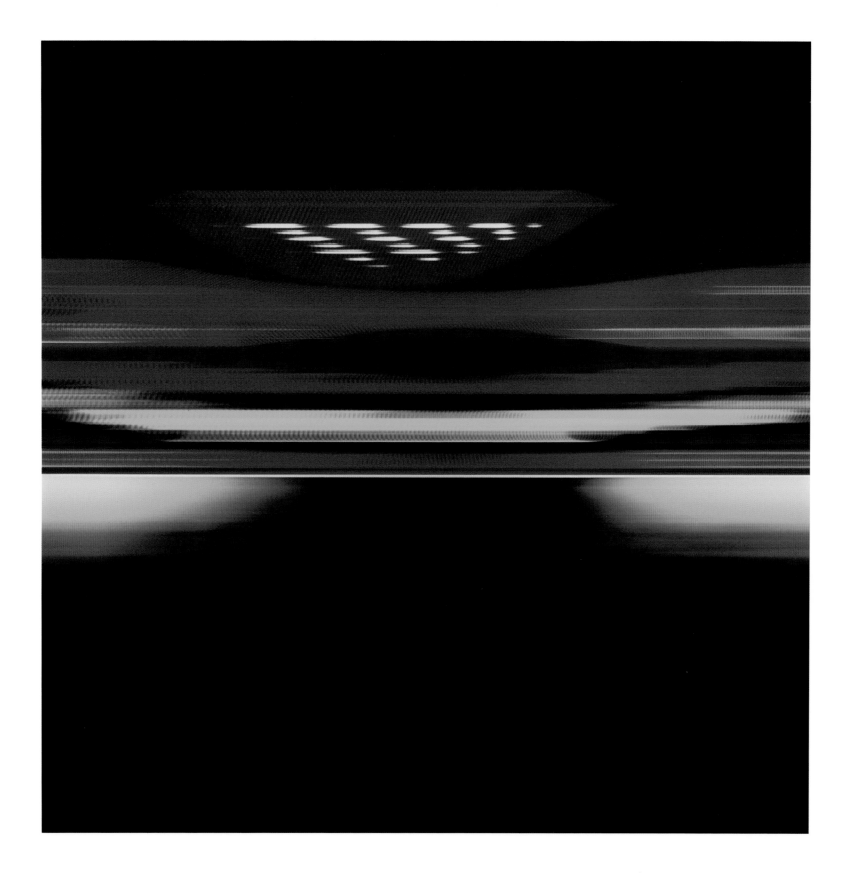

Downtown I Las Vegas, USA 2005

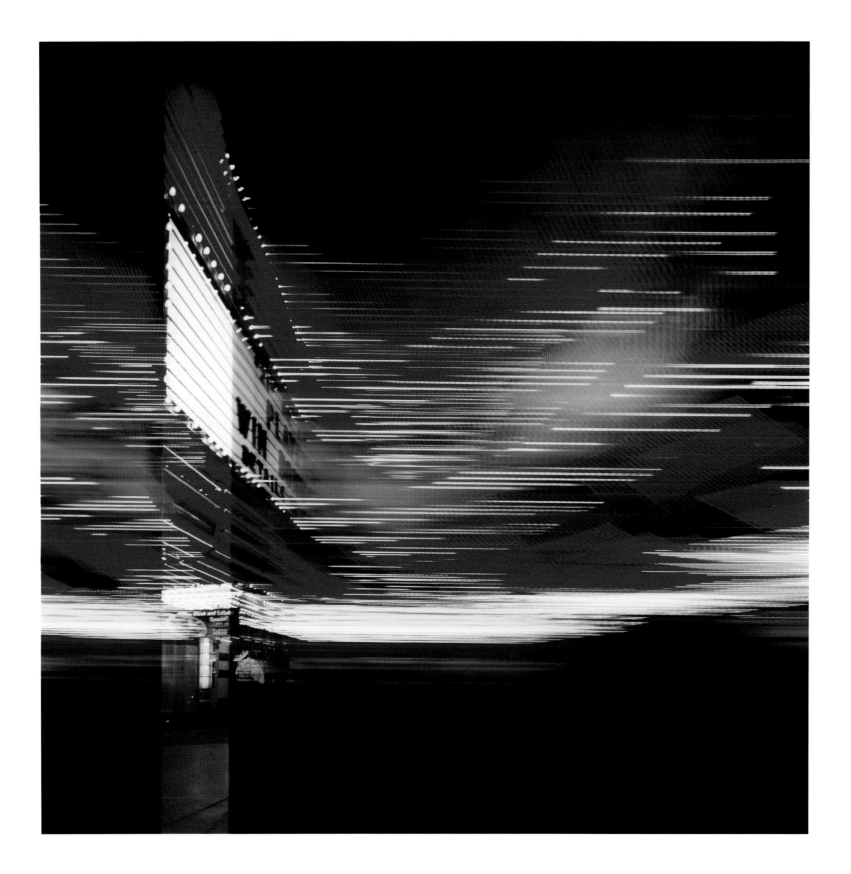

81 *Downtown II* Las Vegas, USA 2005

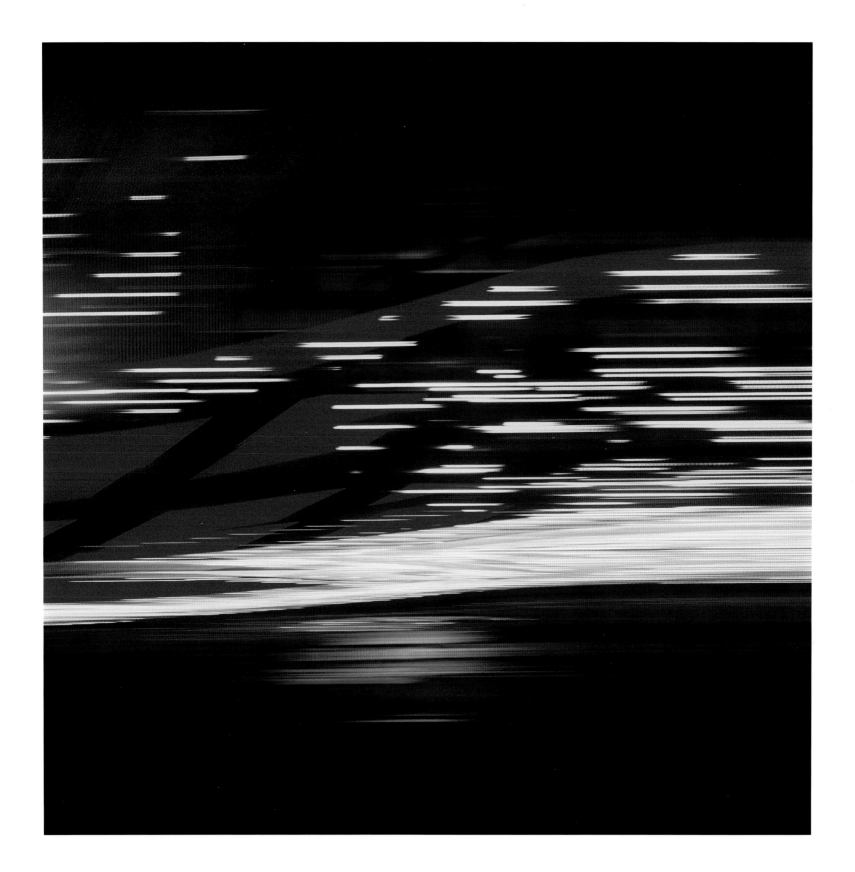

82 *New York, New York* Las Vegas, USA 2005

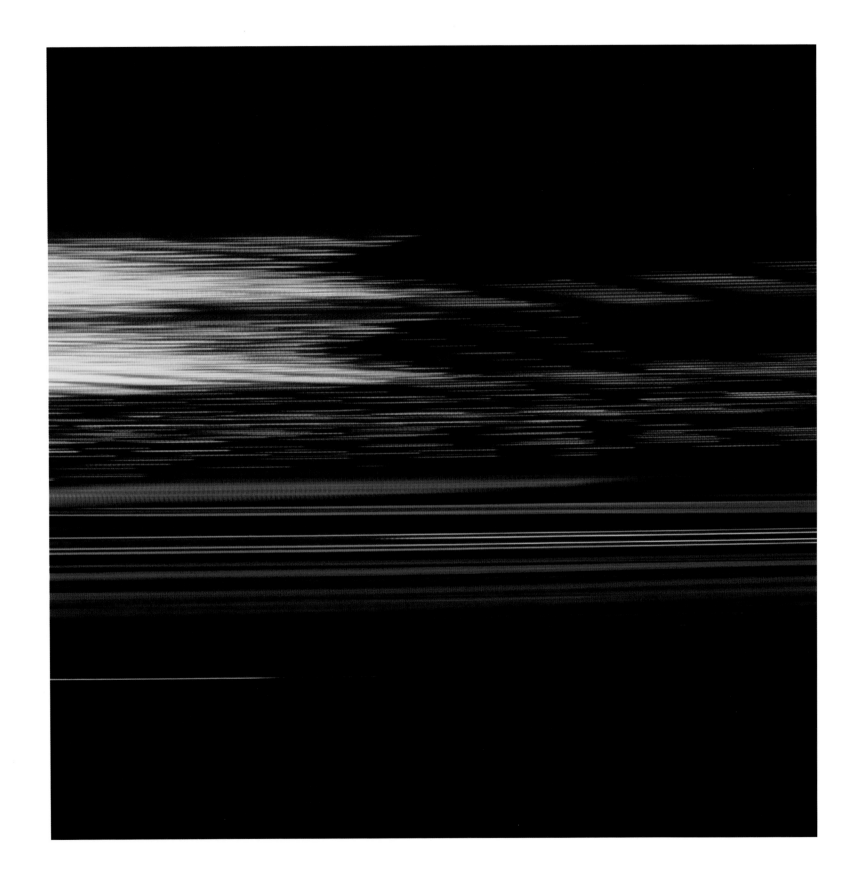

The Strip Las Vegas, USA 2005

84 *Loose $ Slots* Las Vegas, USA 2005

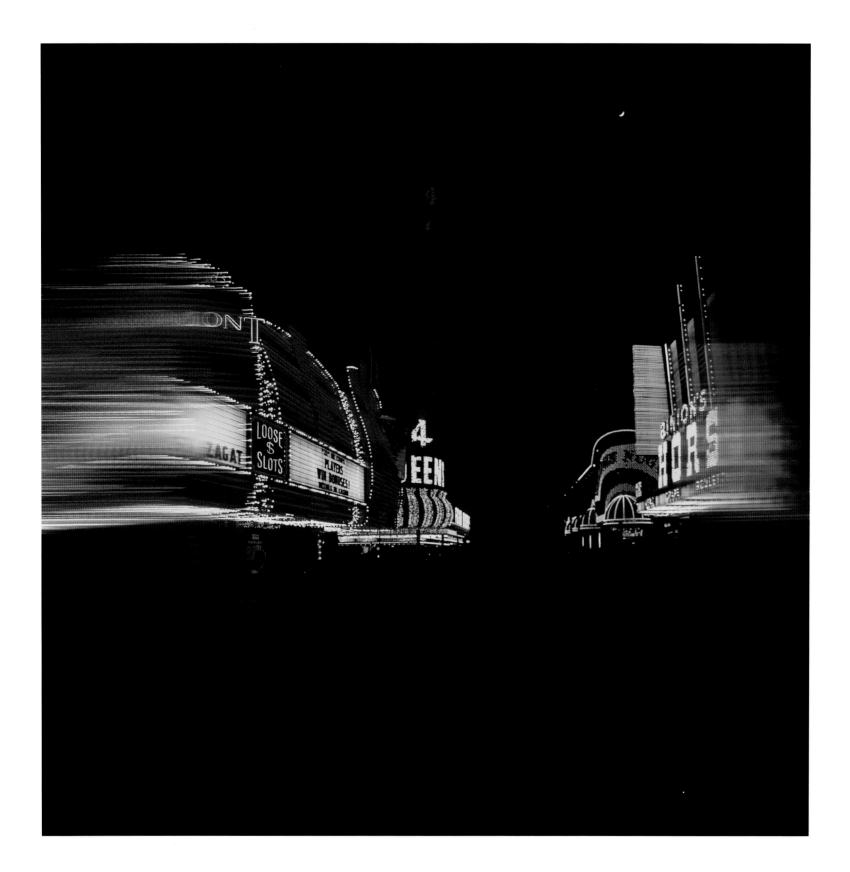

85 *Shanghai I* China 2006

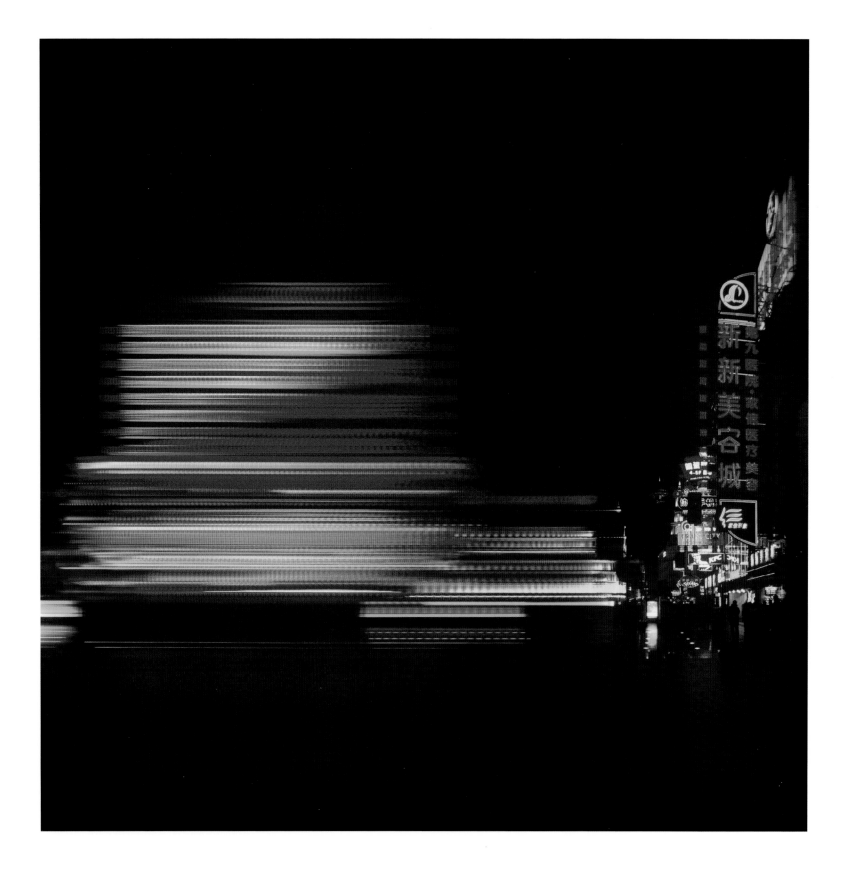

Shanghai IV China 2006

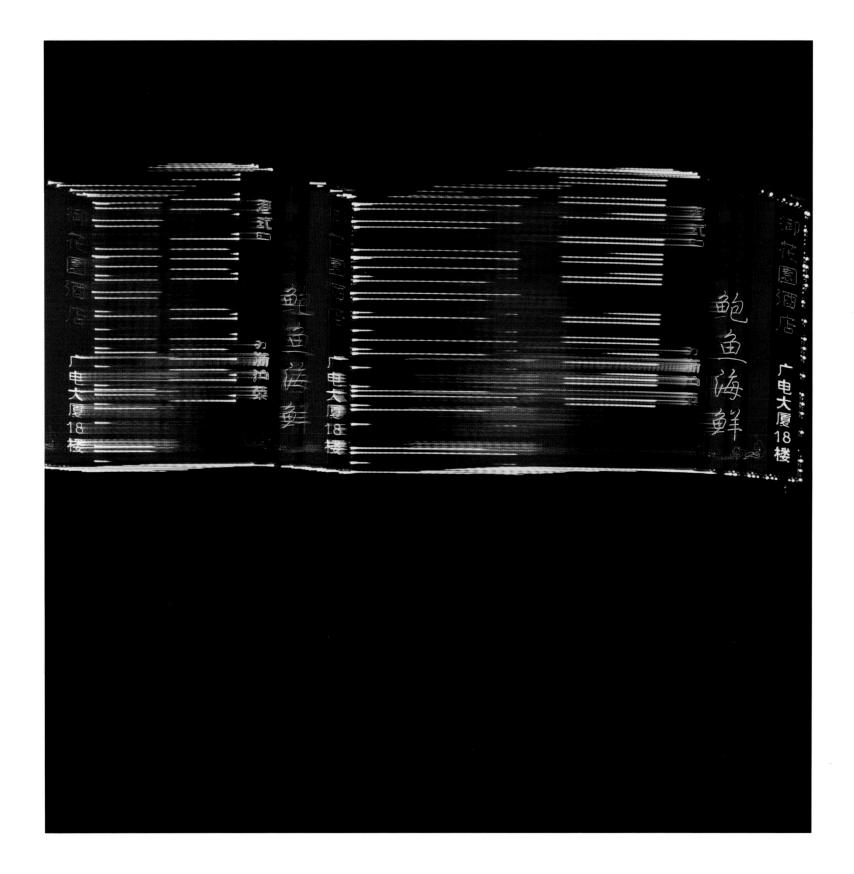

Shanghai II China 2006

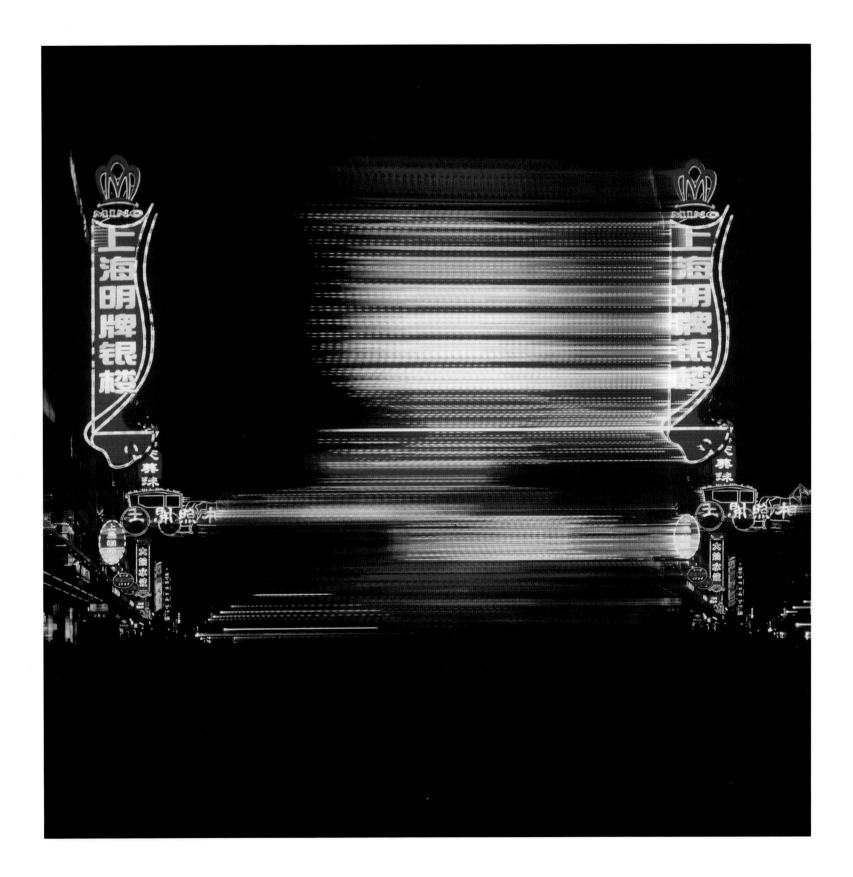

Shanghai III China 2006

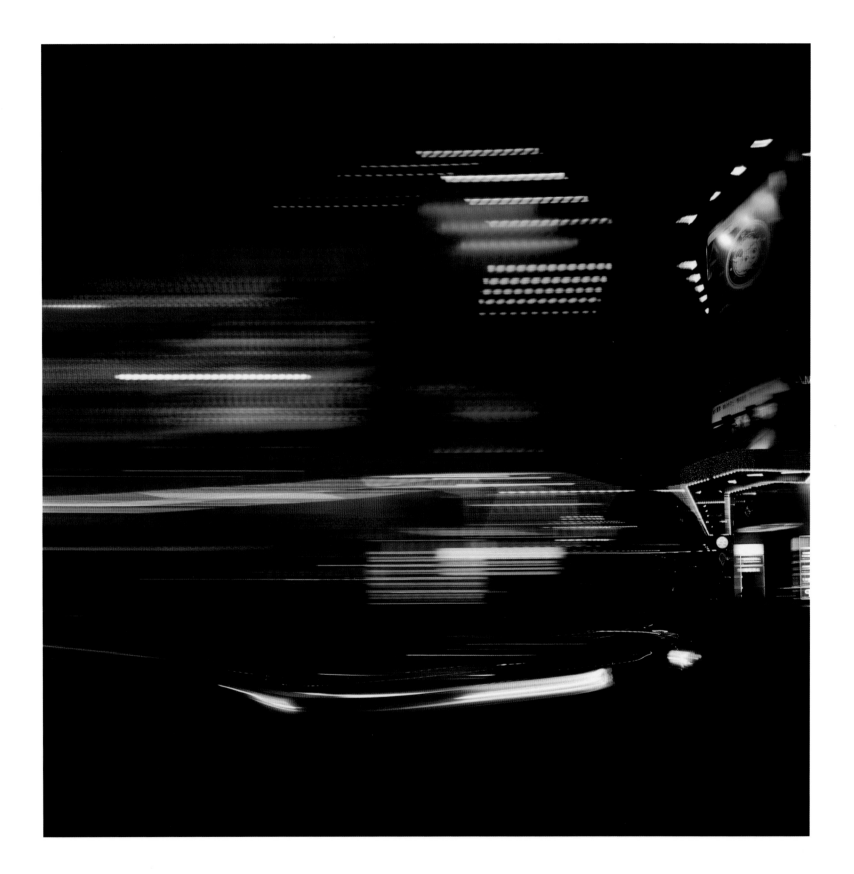

89 *Piccadilly Circus* London, England 2008

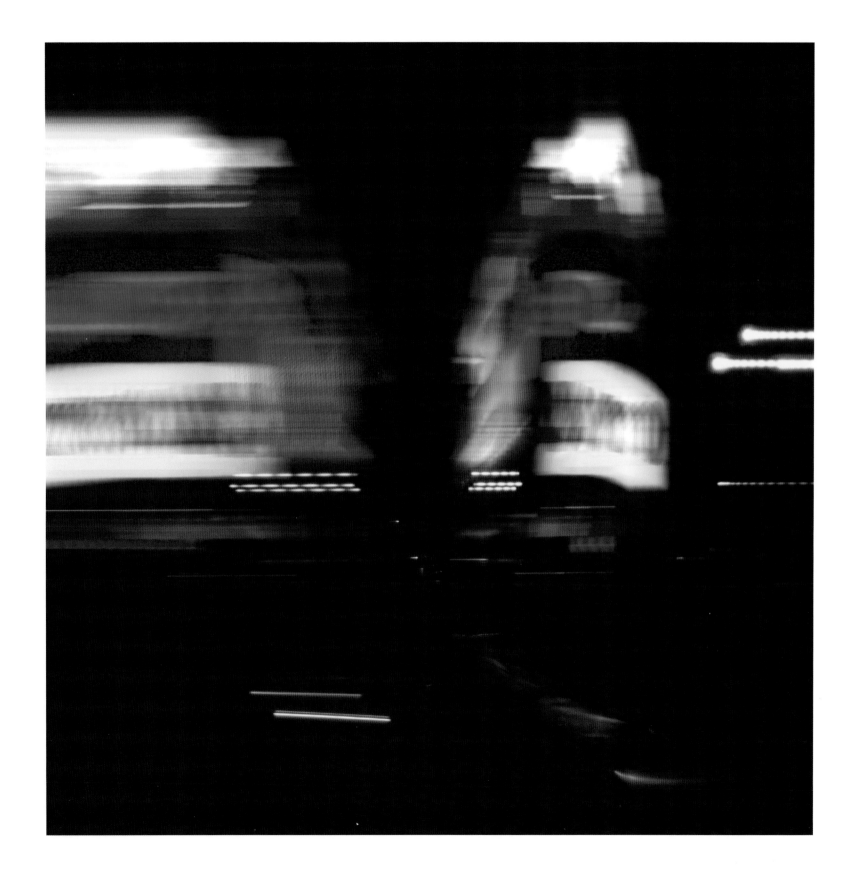

90 *Hong Kong III* China 2006

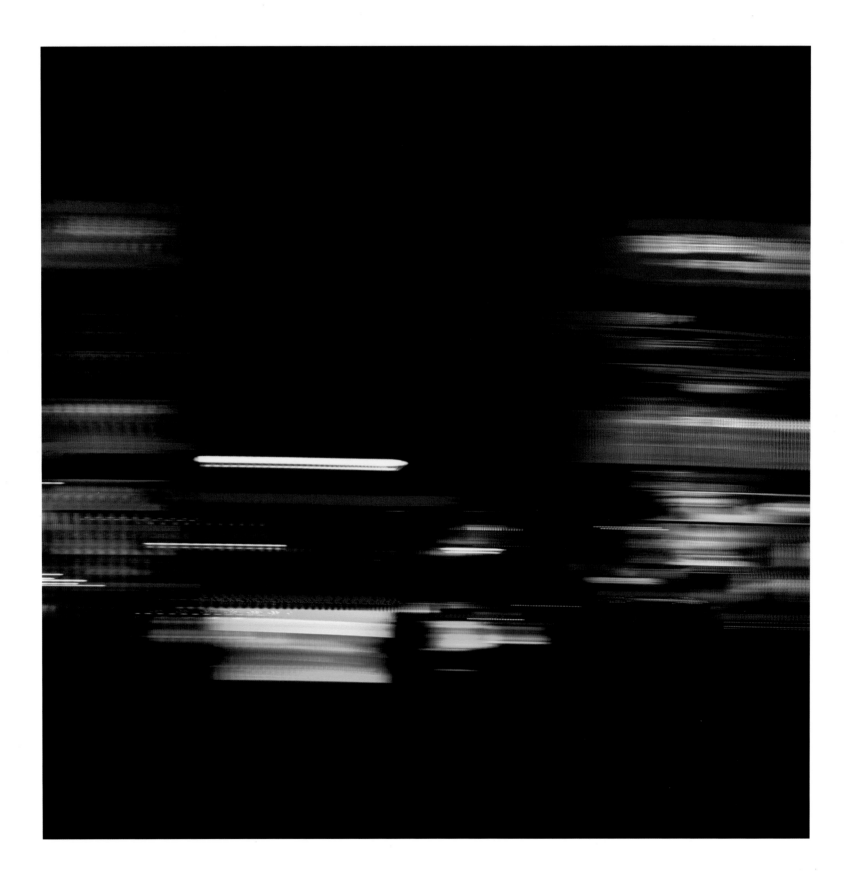

91 *Hong Kong II* China 2006

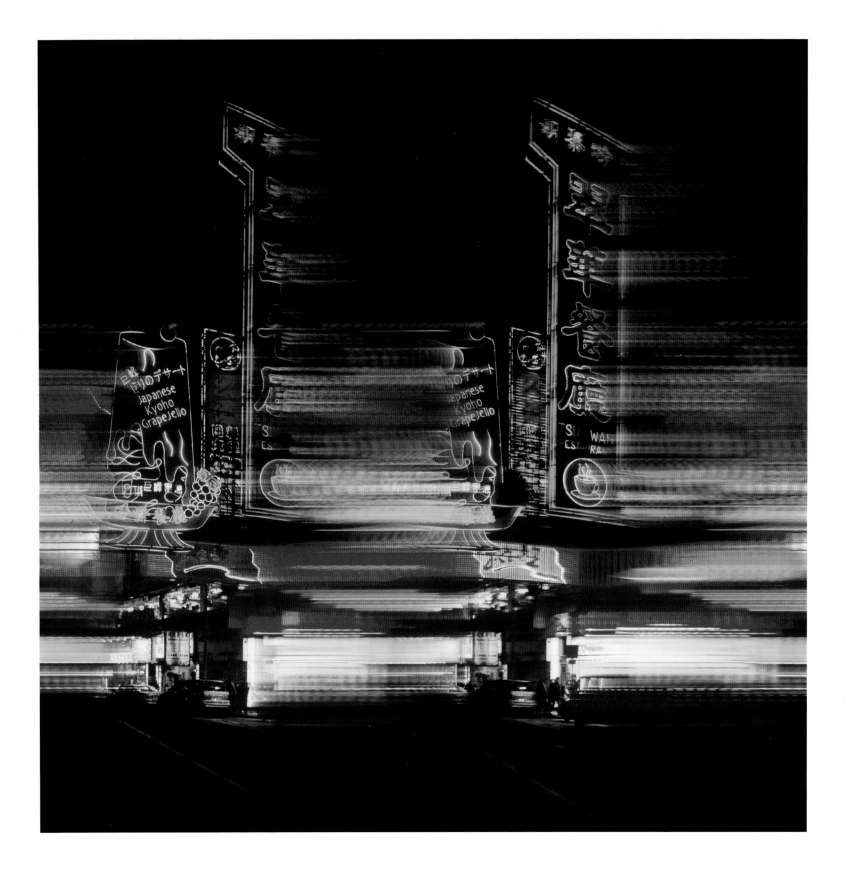

92 *Hong Kong* I China 2006

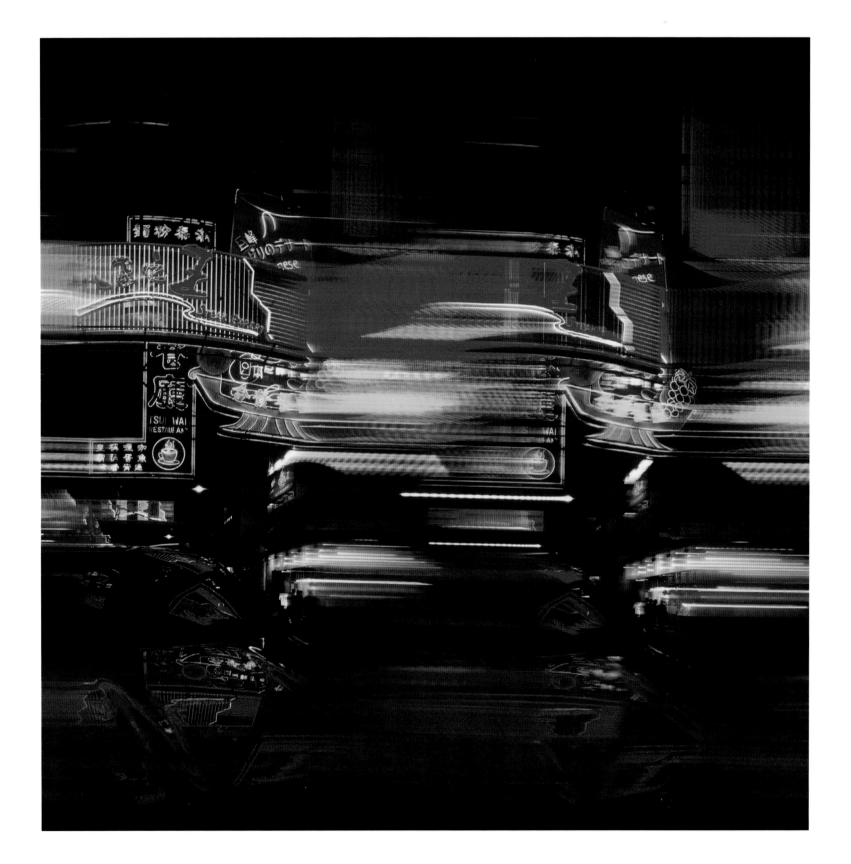

93 *Hong Kong IV* China 2006

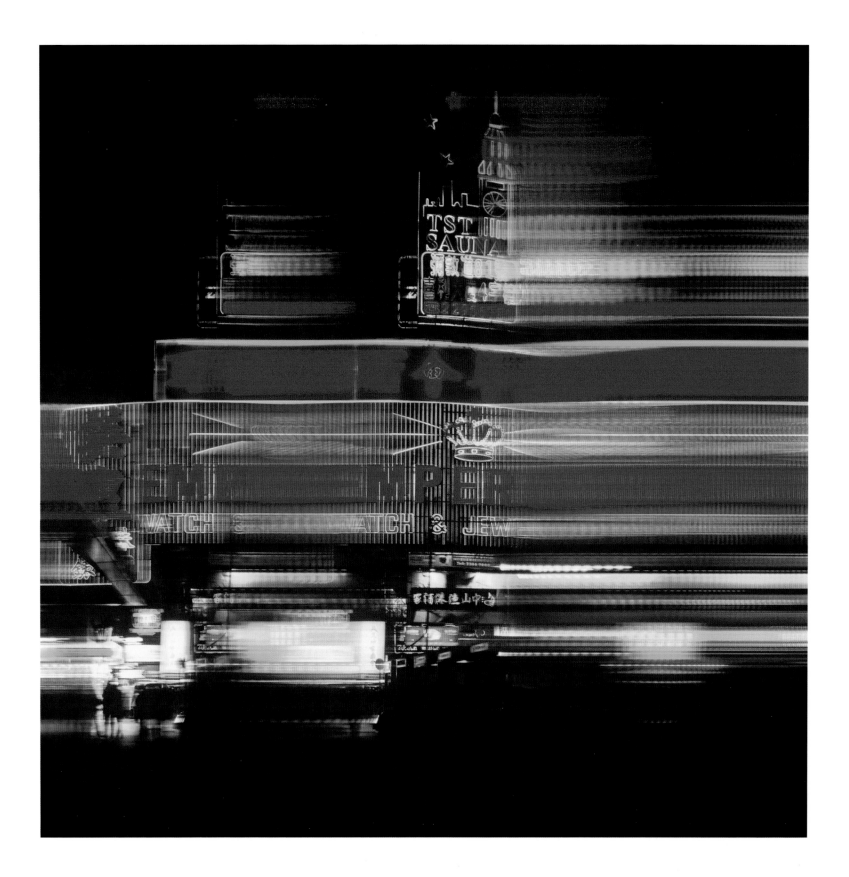

94 *Tokyo II* Japan 2006

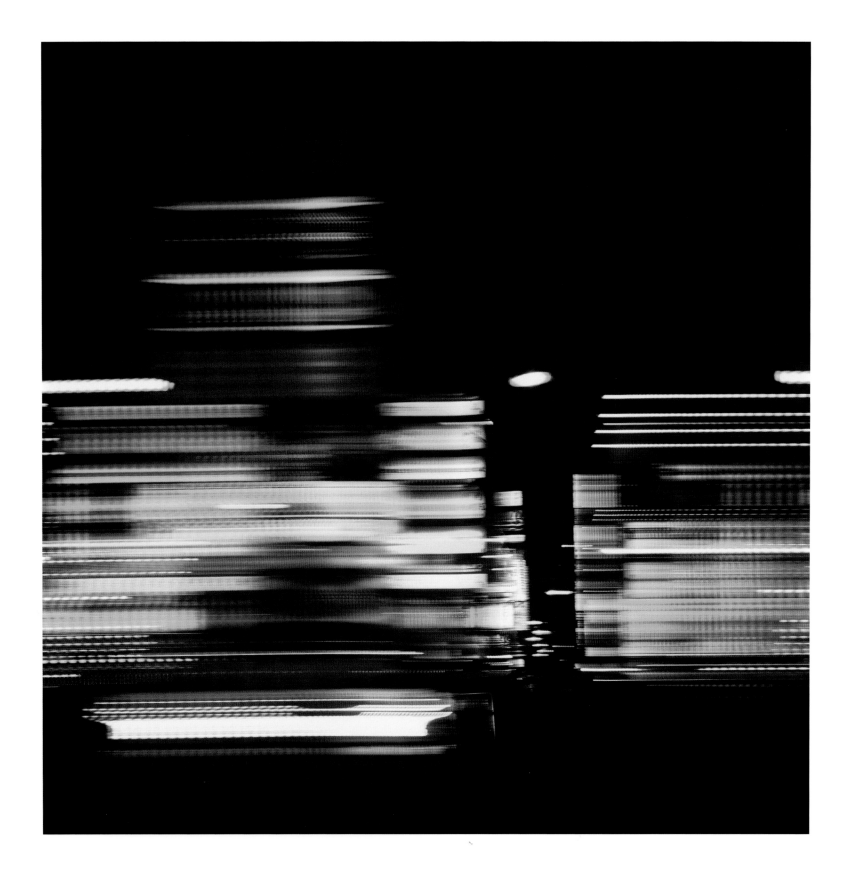

95 *Tokyo I* Japan 2006

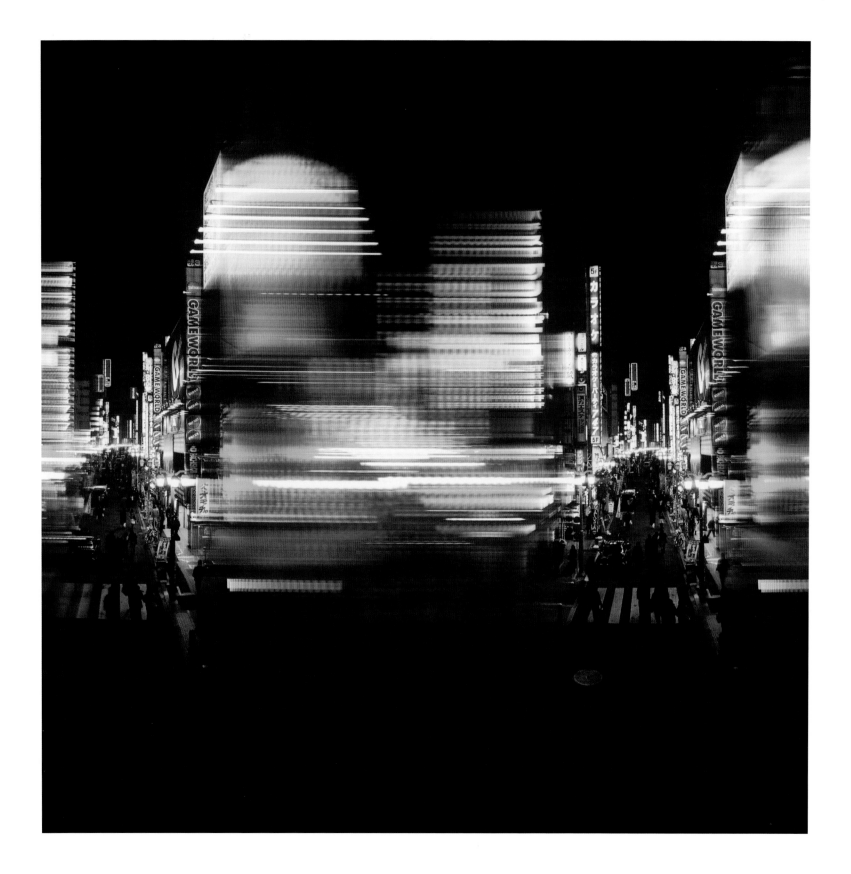

96 *Tokyo IV* Japan 2006

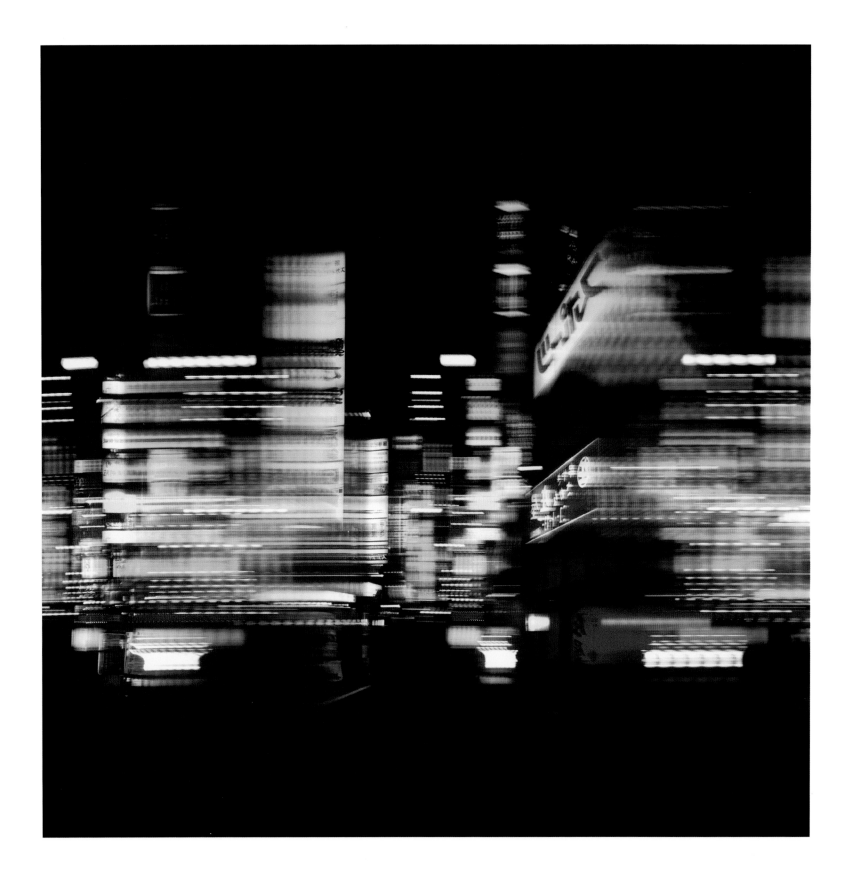

97 *Tokyo III* Japan 2006

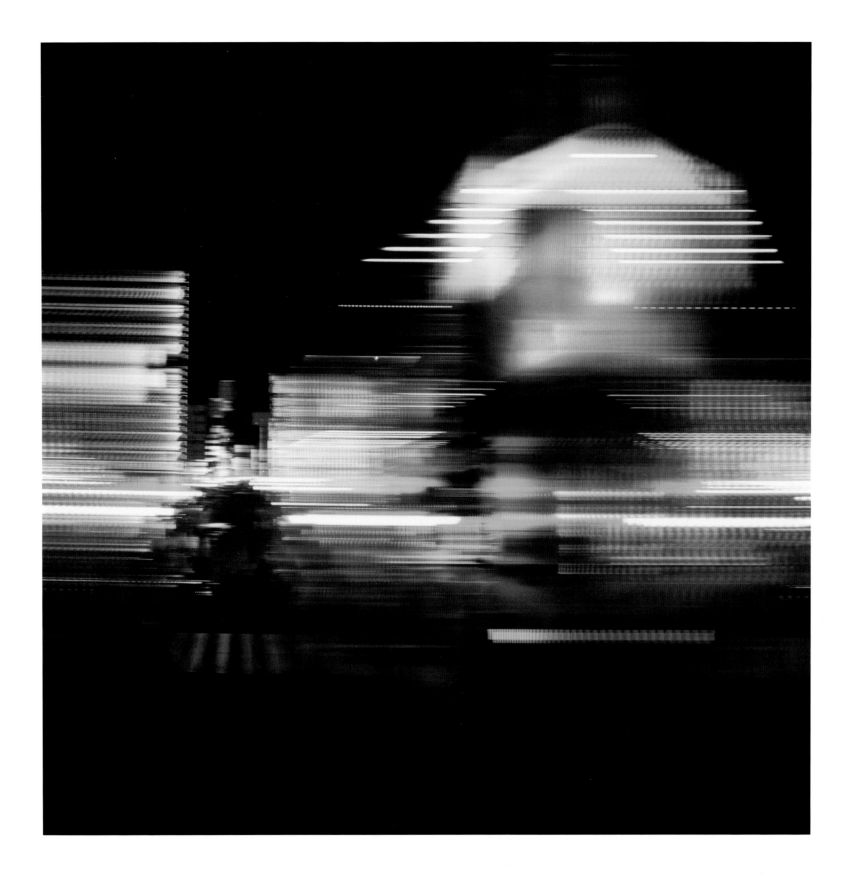

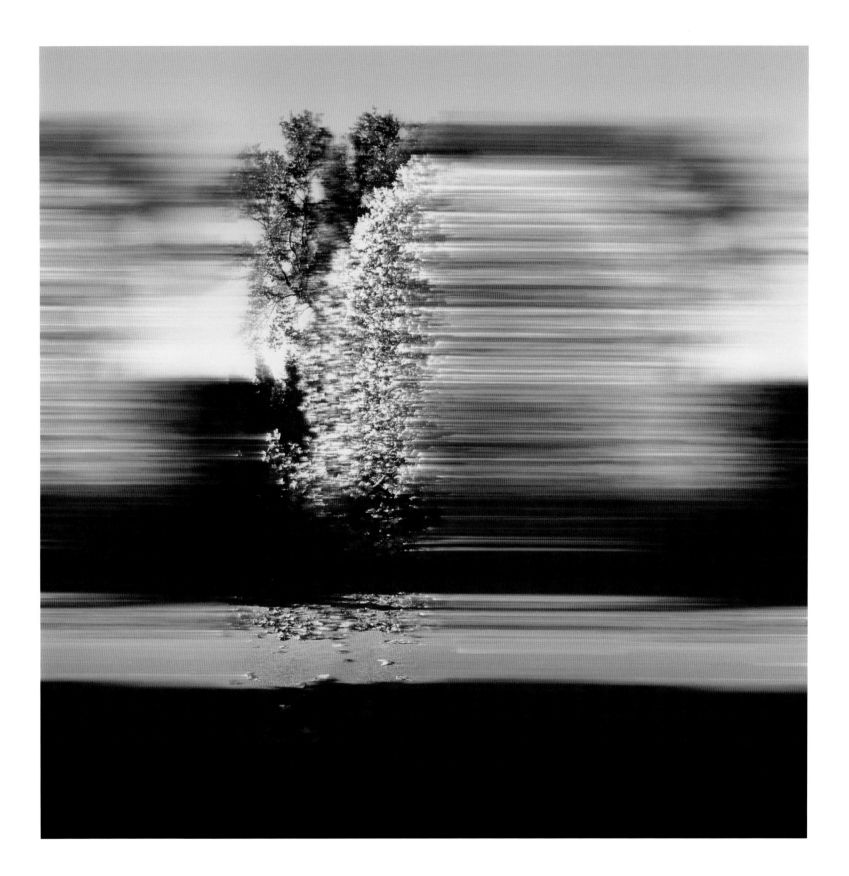

Westonbirt Arboretum III Gloucestershire, England 2006

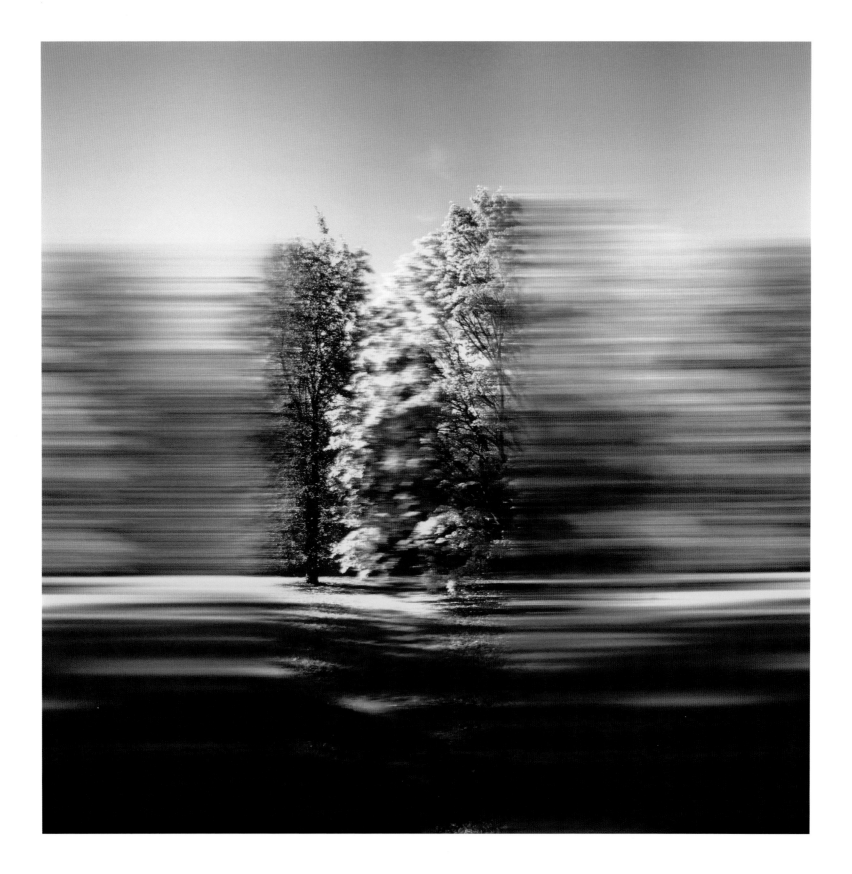

100 *Westonbirt Arboretum I* Gloucestershire, England 2006

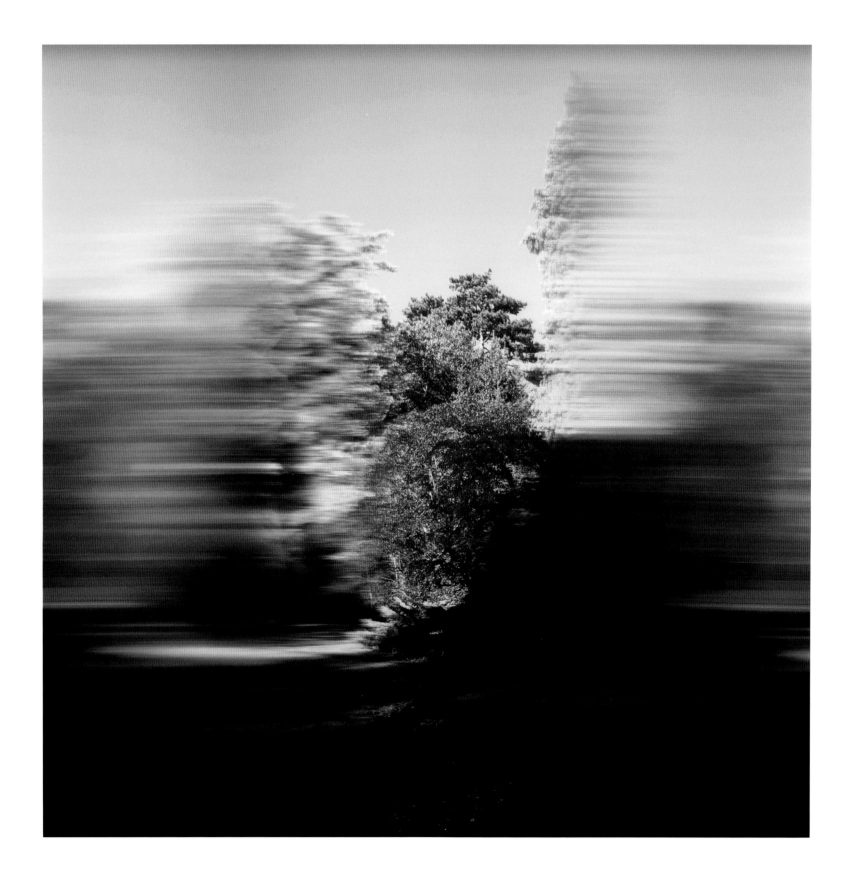

101 *Westonbirt Arboretum II* Gloucestershire, England 2006

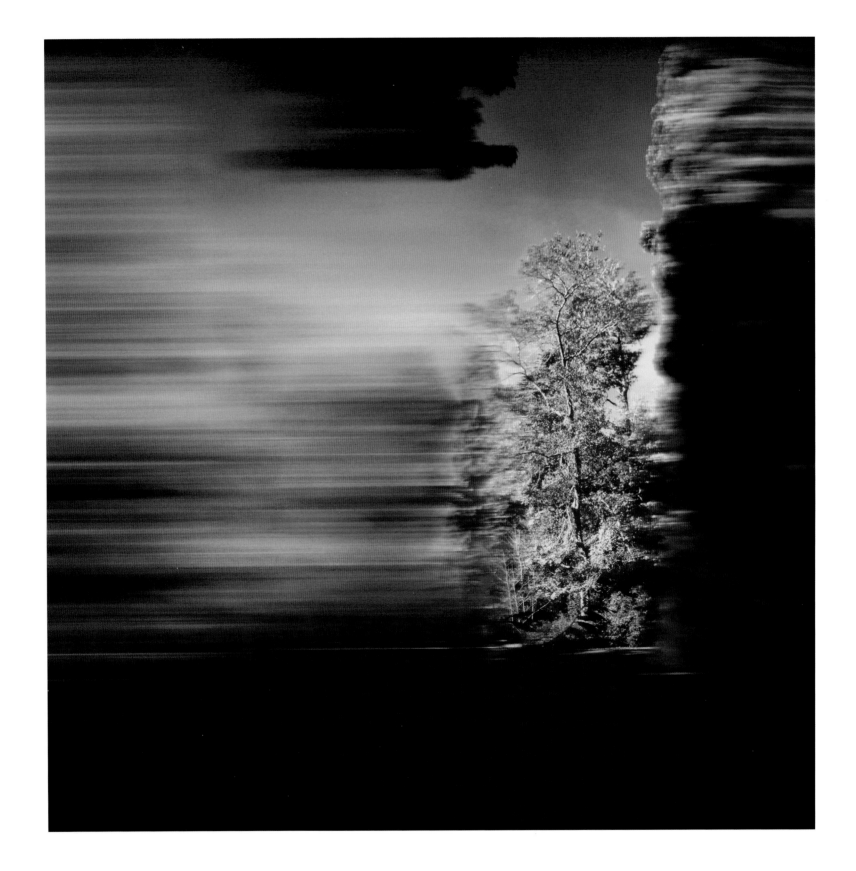

102 *Zandvoort* Holland 2007

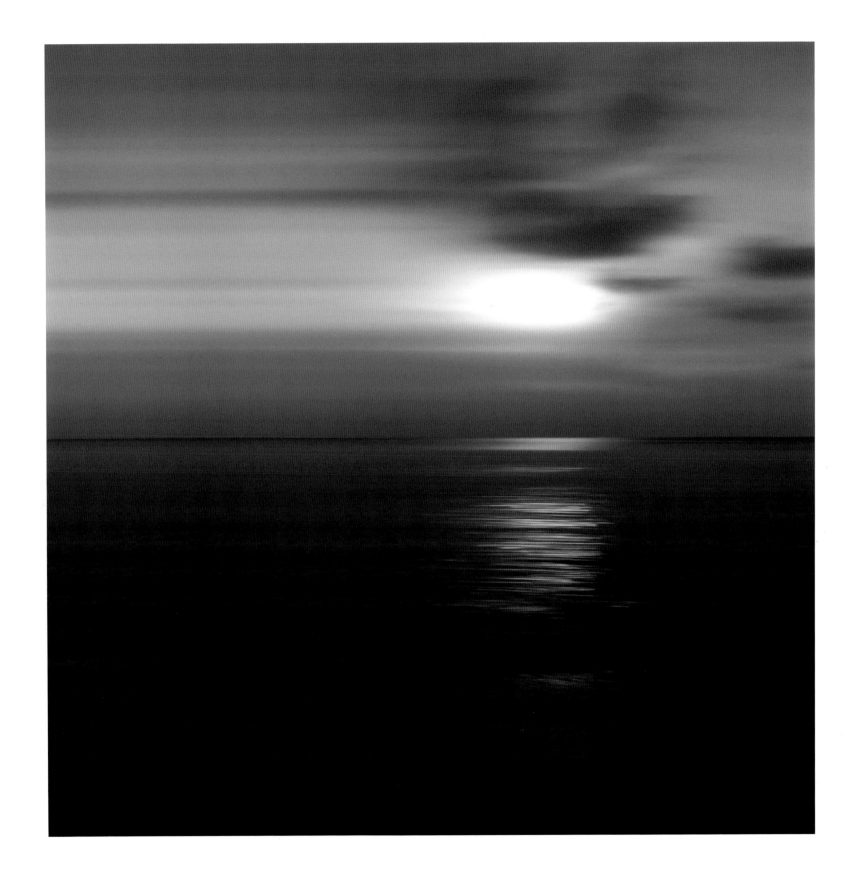

103 *Warden's Point* Kent, England 2005

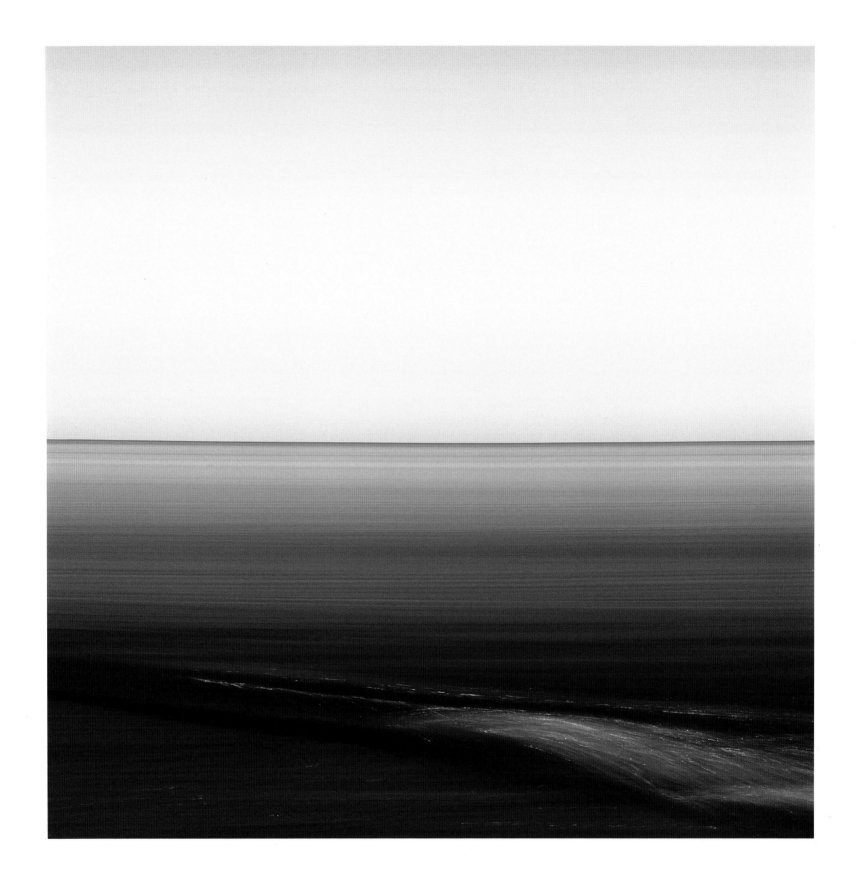

104 *North Foreland I* Kent, England 2003

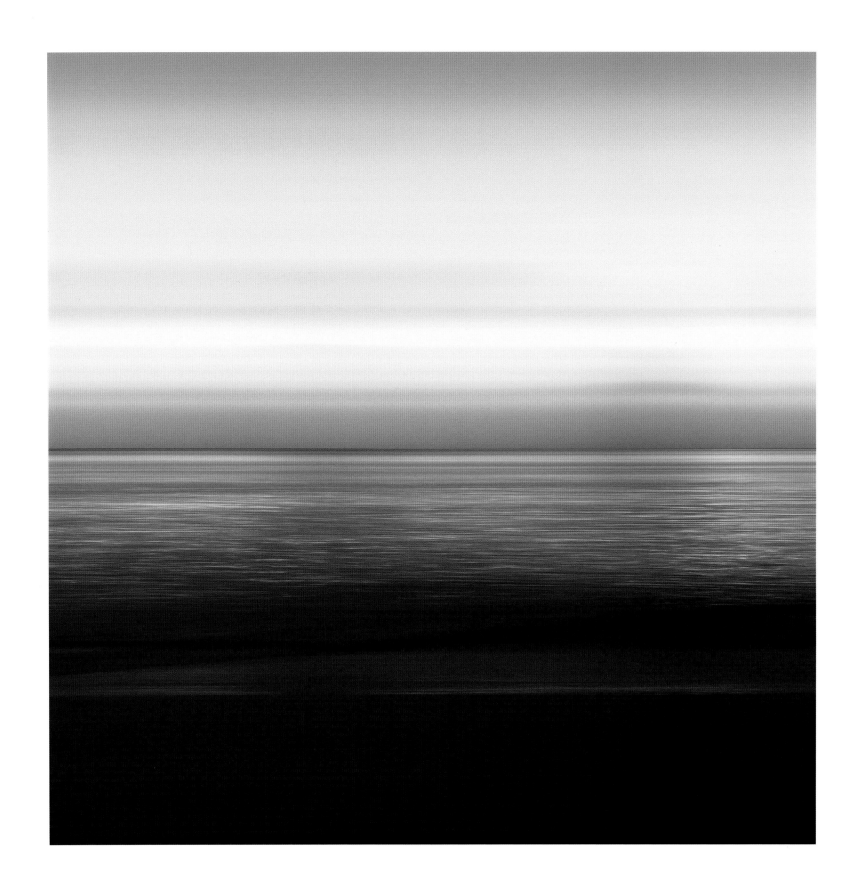

105 *North Foreland* II Kent, England 2003

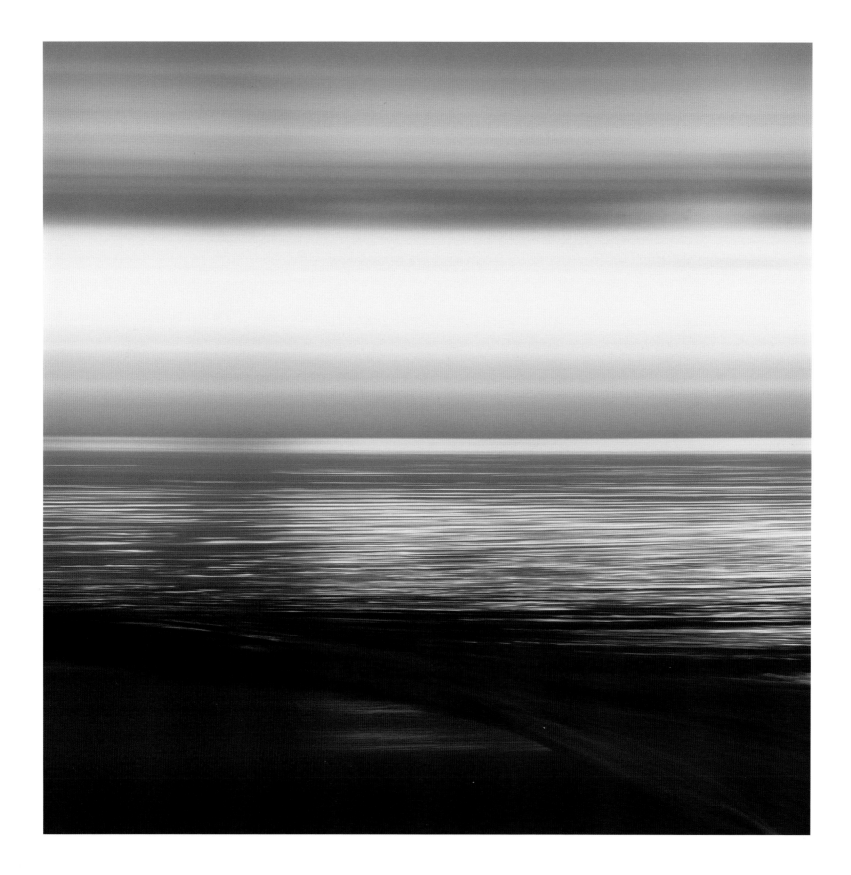

106 *Flamborough Head* East Yorkshire, England 2003

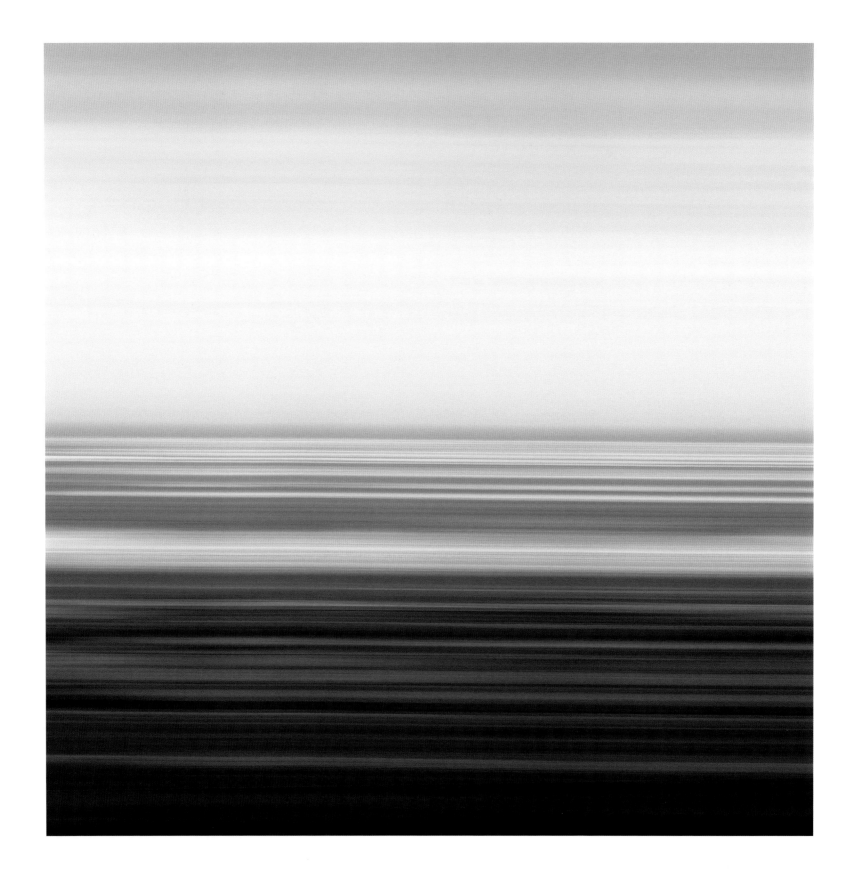

107 *Salt Whistle Bay* The Grenadines 2007

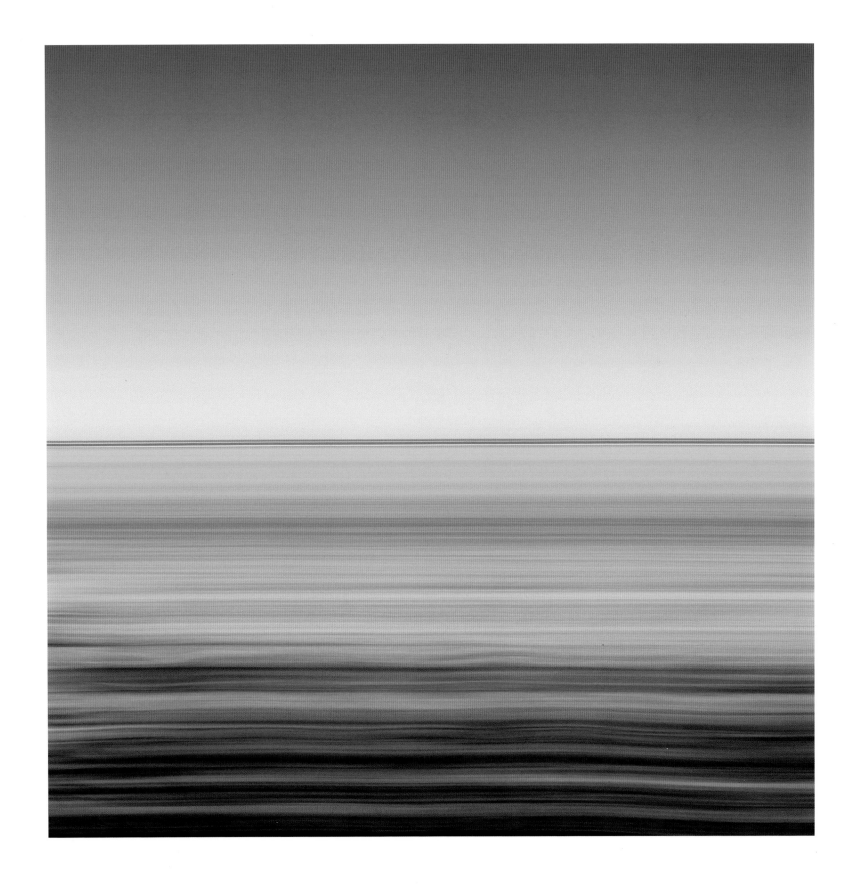

108 *Cala Luna* Sardinia 2007

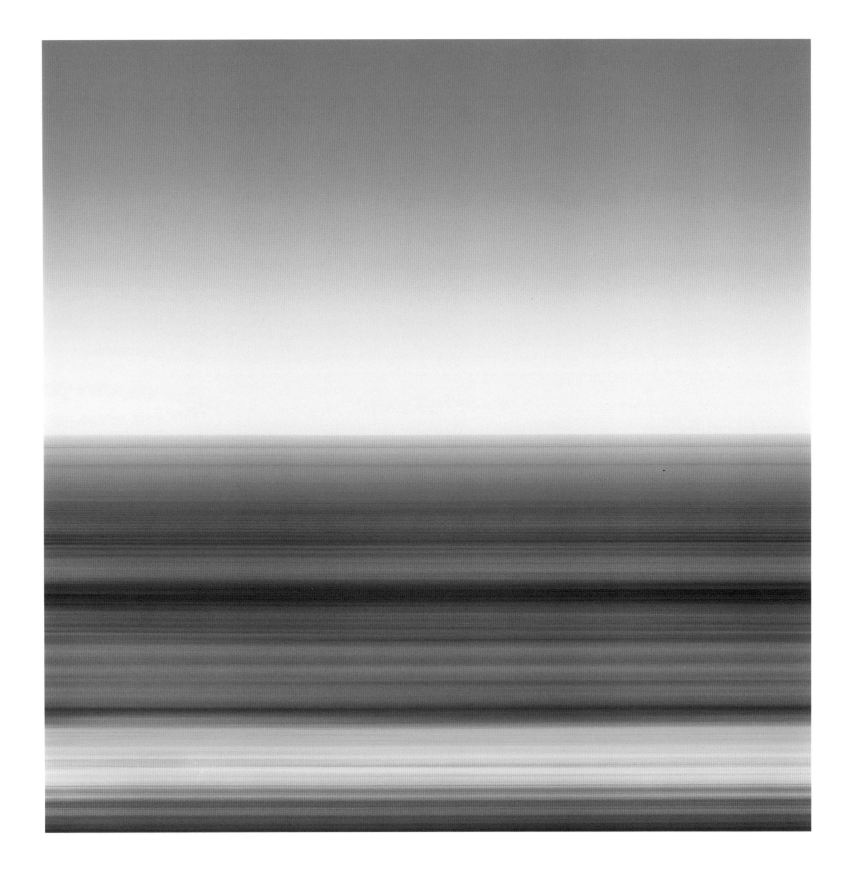

109 *Cala Fuili I* Sardinia 2007

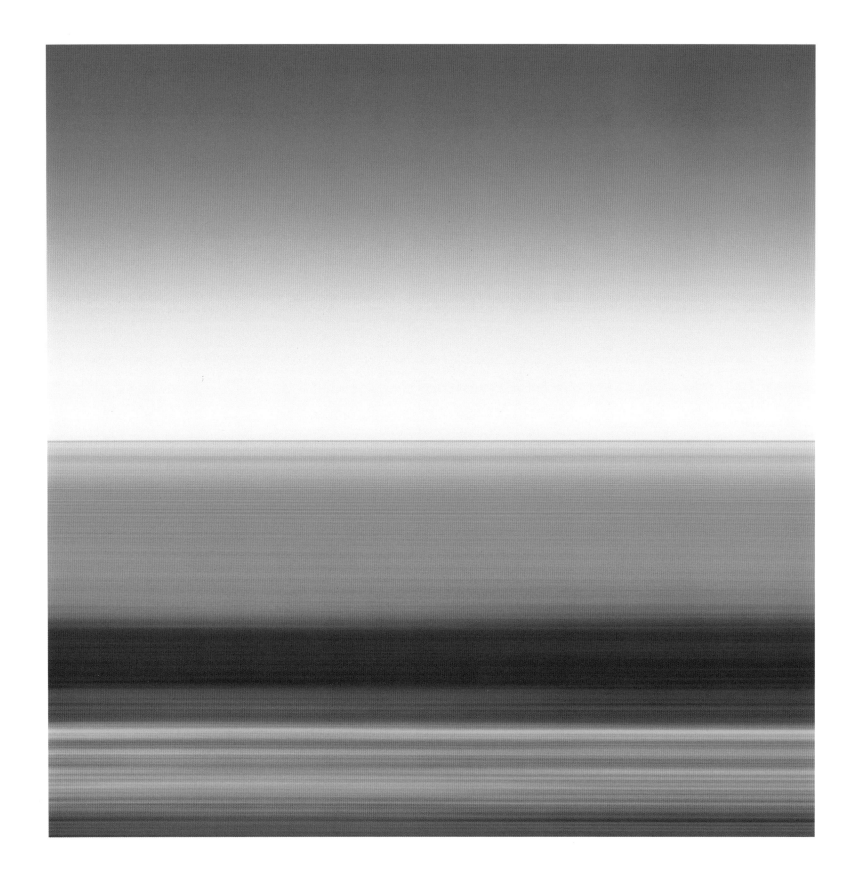

110 *Cala Fuili II* Sardinia 2007

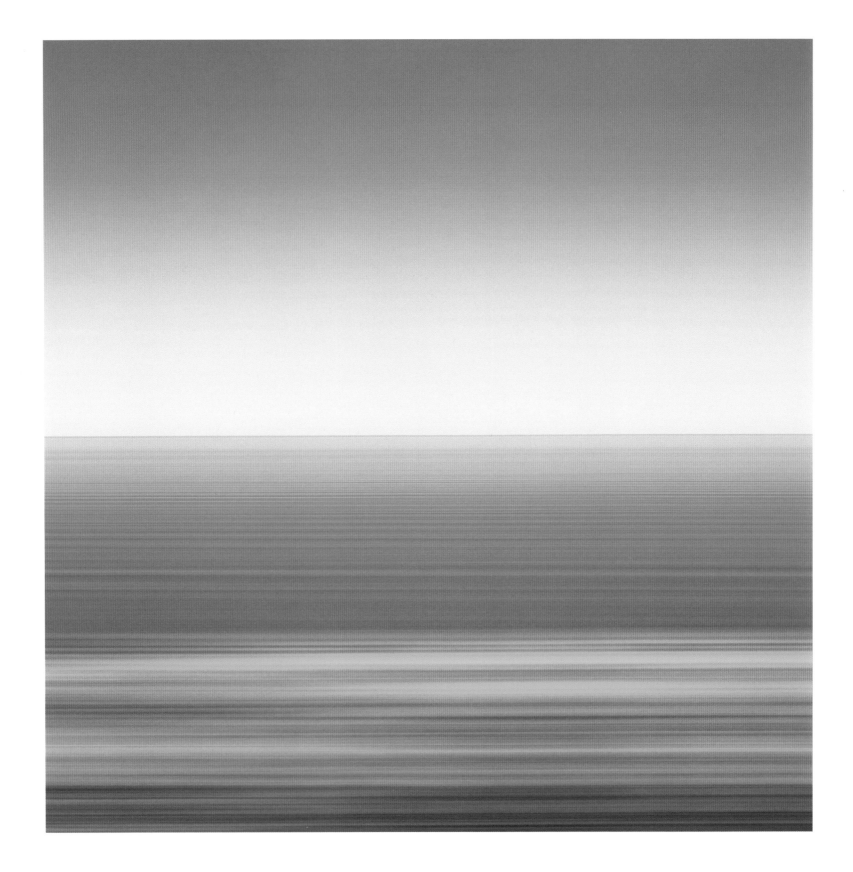

111 *Botanic Gardens* Barbados 2005

112 *Durness* Sutherland, Scotland 2003

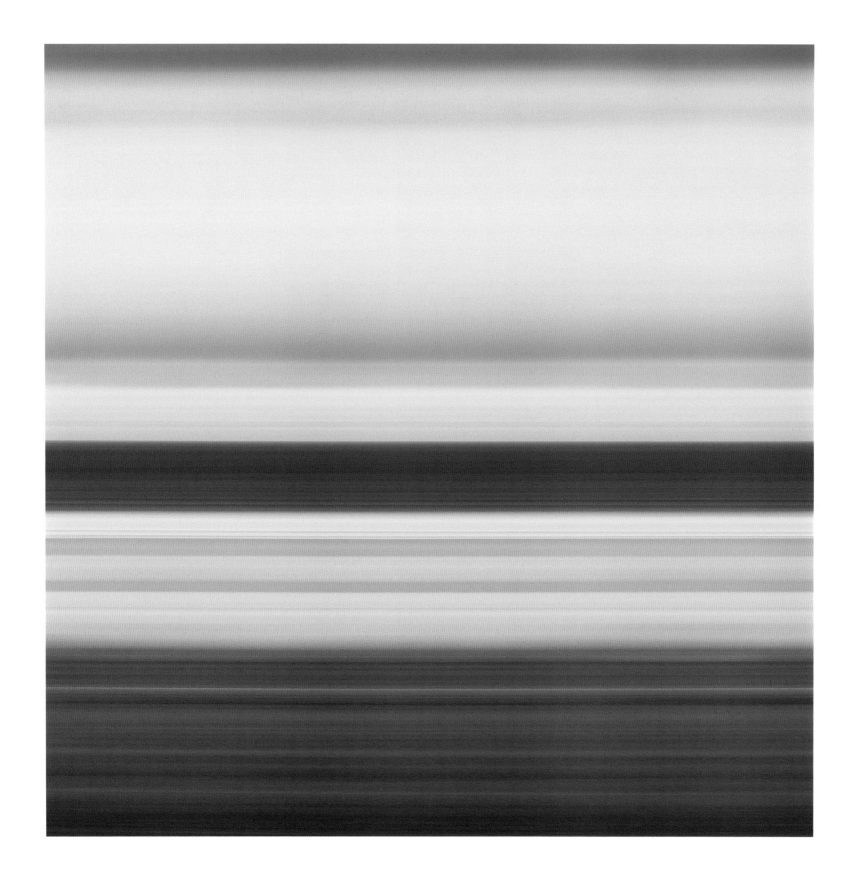

113 *Filey Bay* North Yorkshire, England 2007

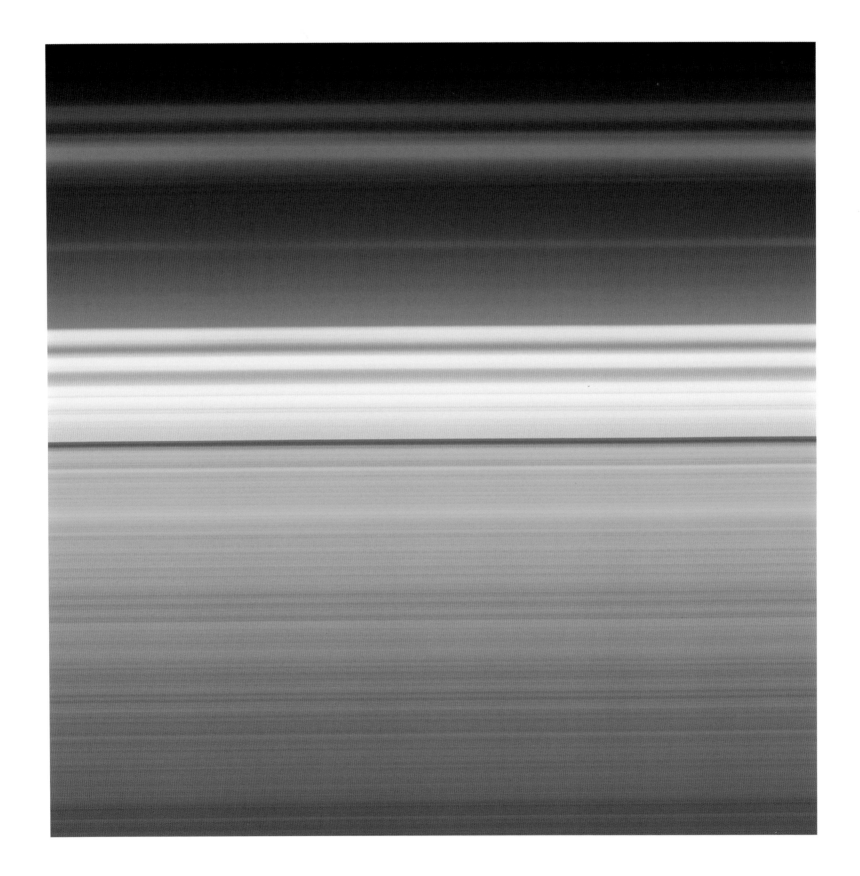

114 *Lenk* Switzerland 2007

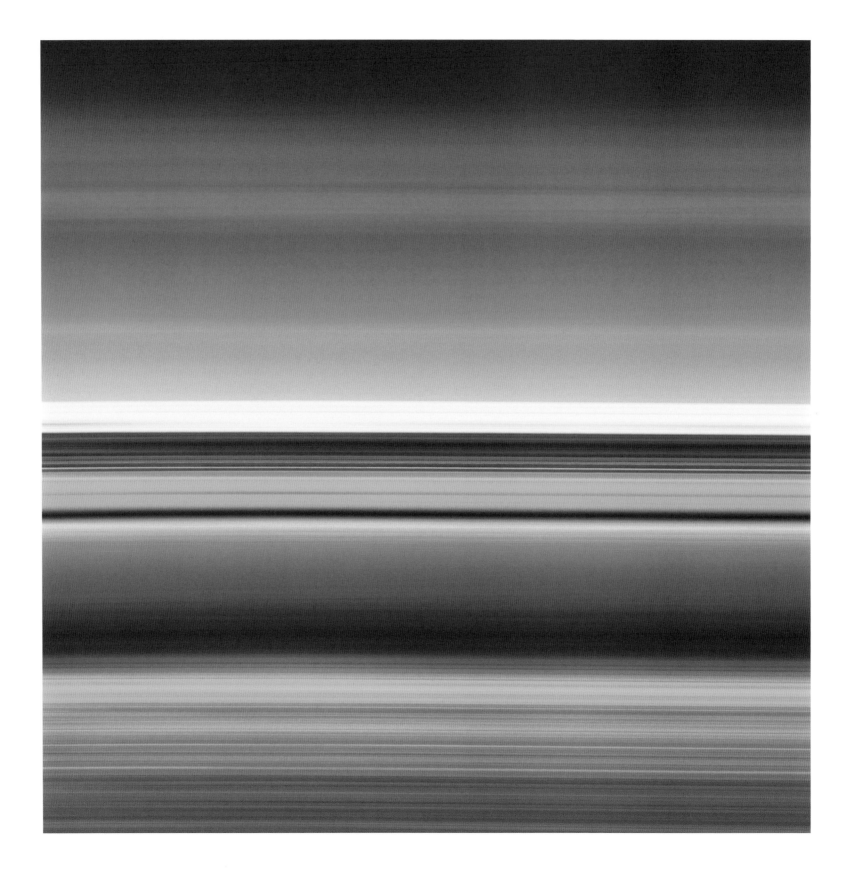

115 *Rutland Water* England 2007

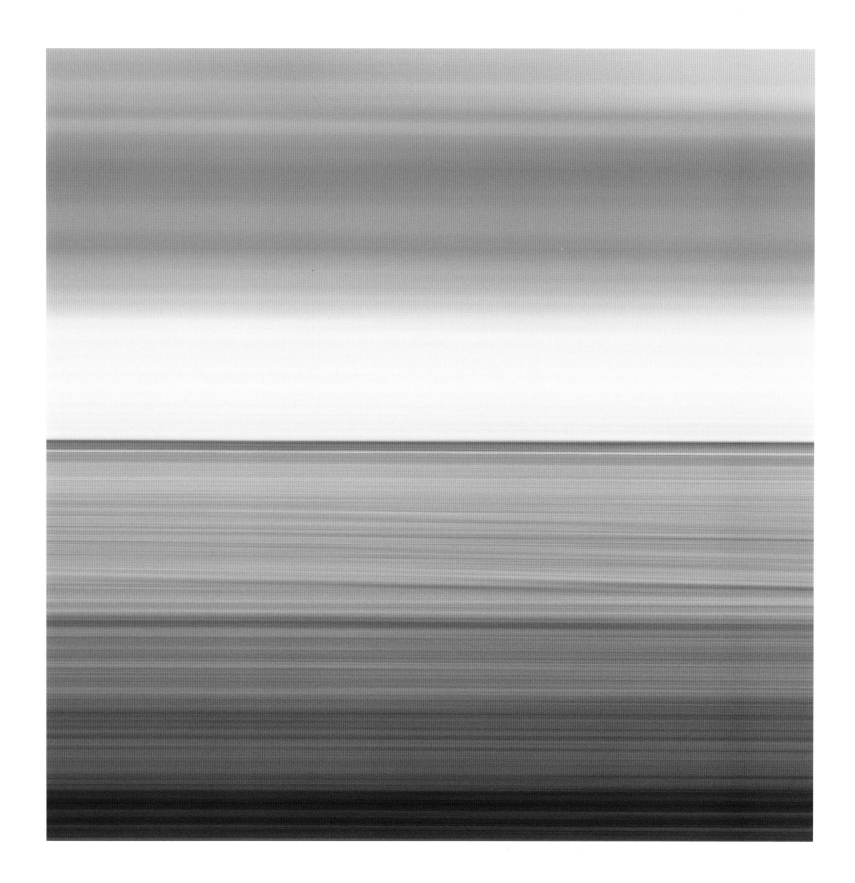

116 *Buldoo* Highland, Scotland 2003

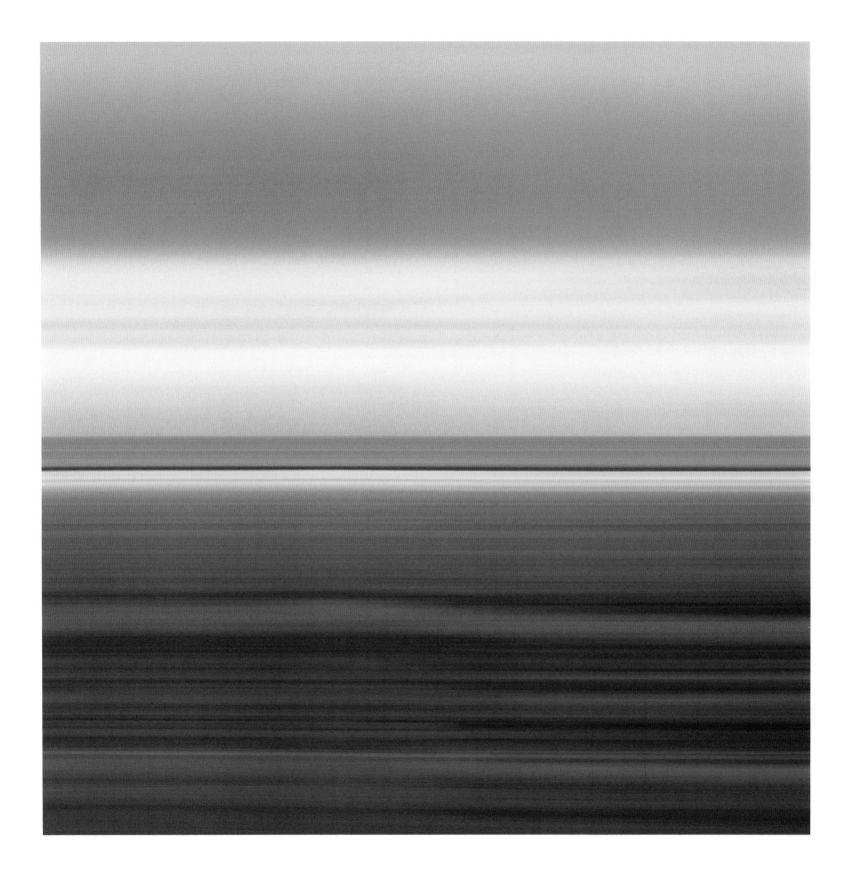

117 *Lavender Field II* North Yorkshire, England 2007

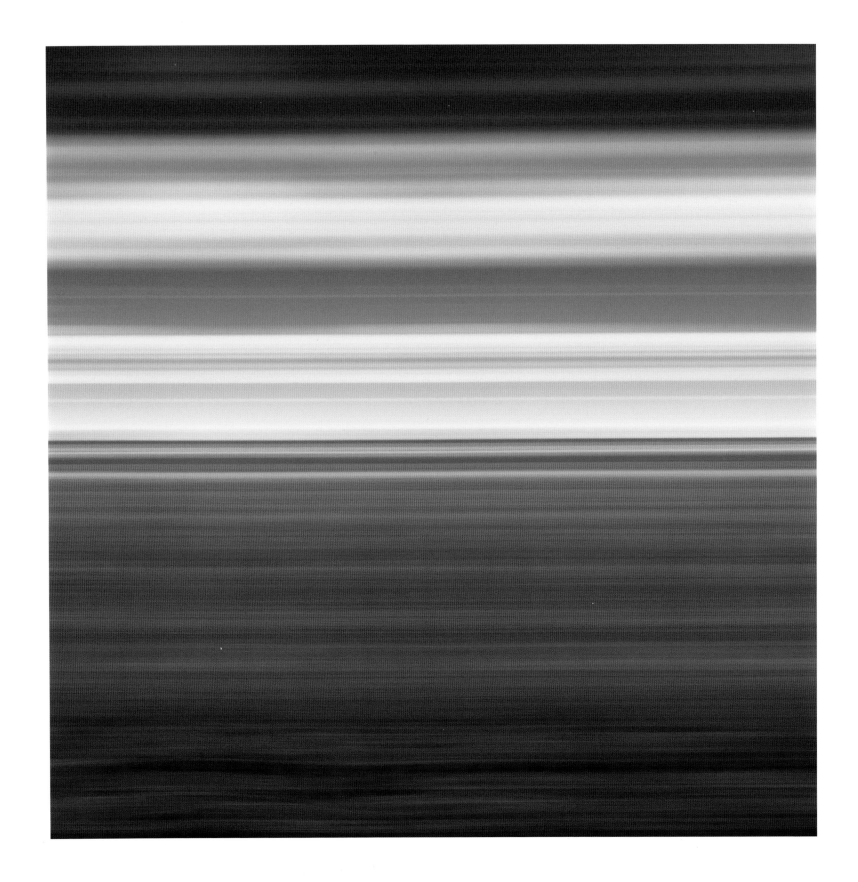

118 *Lavender Field I* North Yorkshire, England 2007

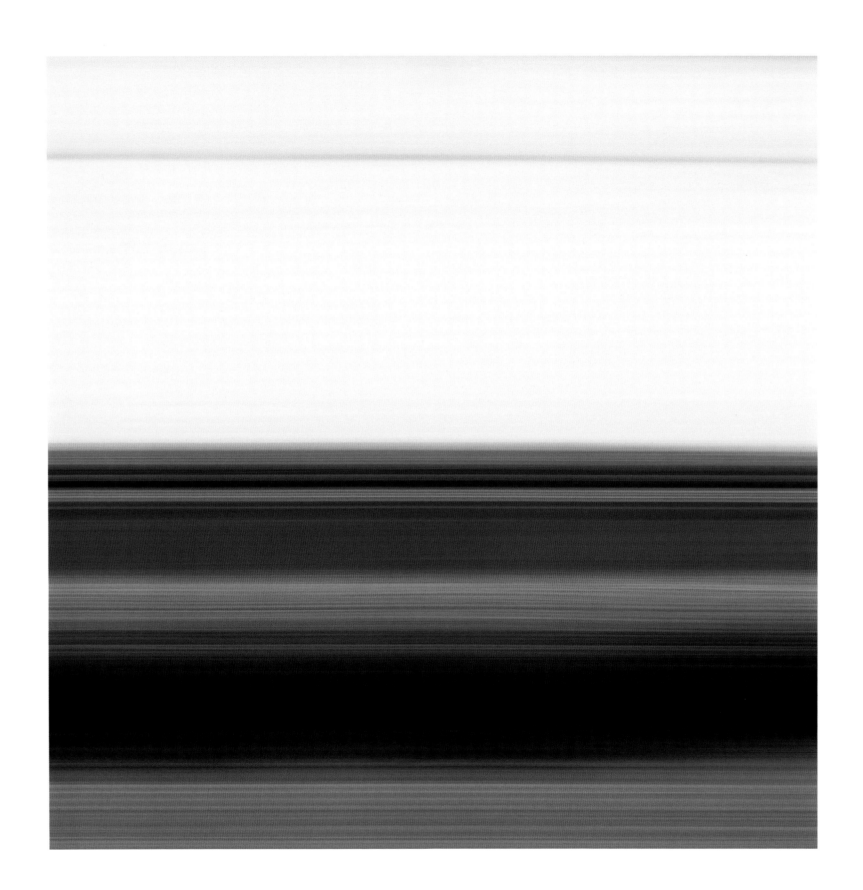

119 *Sea Wall Walk* Isla Mujeres, Mexico 2007

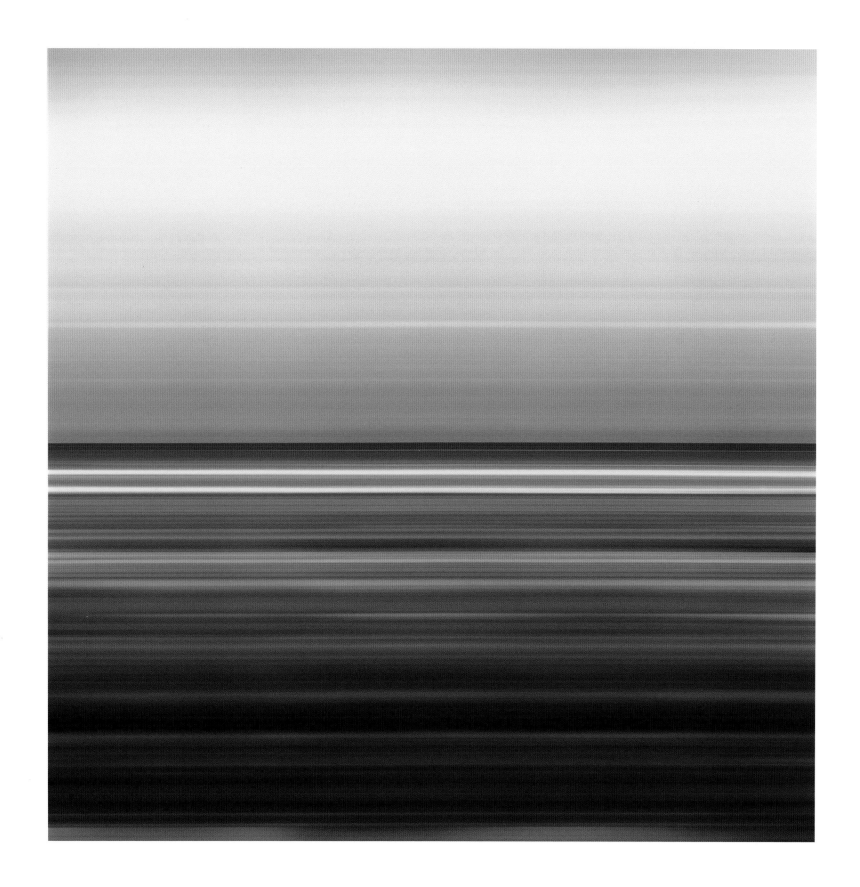

120 *Fast Castle Head* East Lothian, Scotland 2003

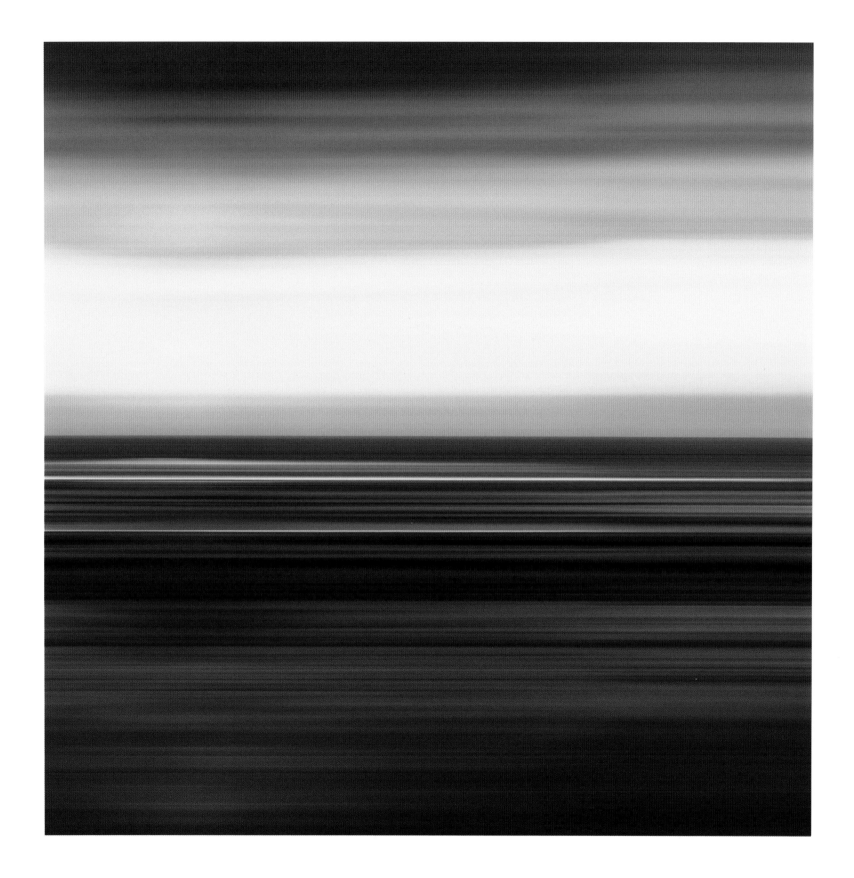

121 *Palm Island* The Grenadines 2007

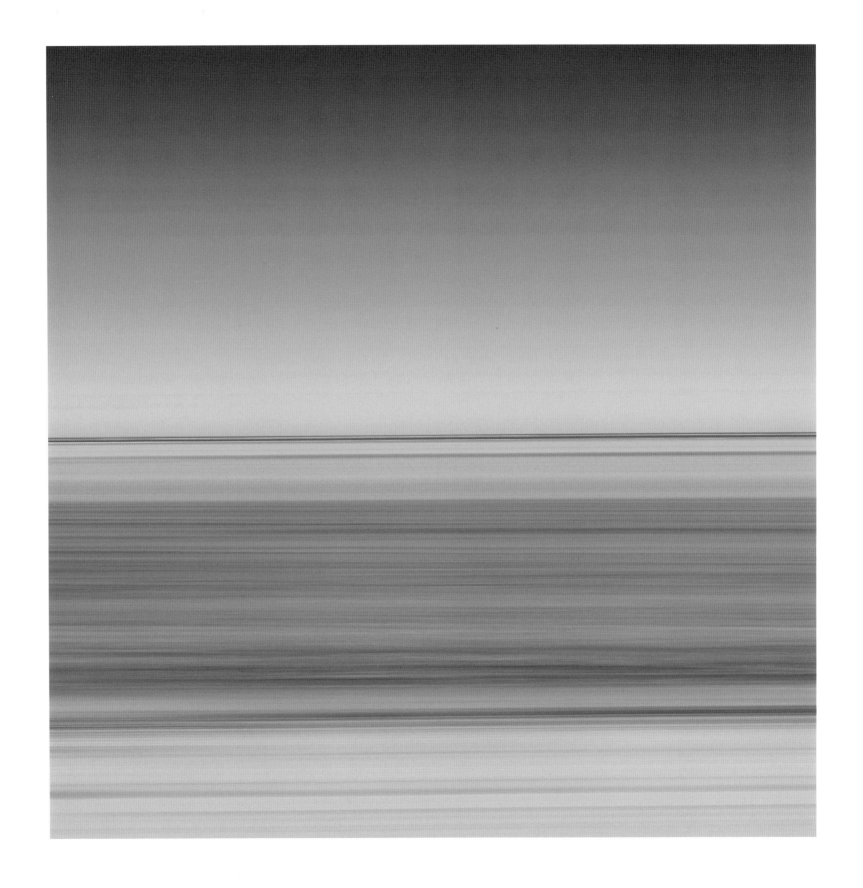

122 *Mesali Island I* Tanzania 2003

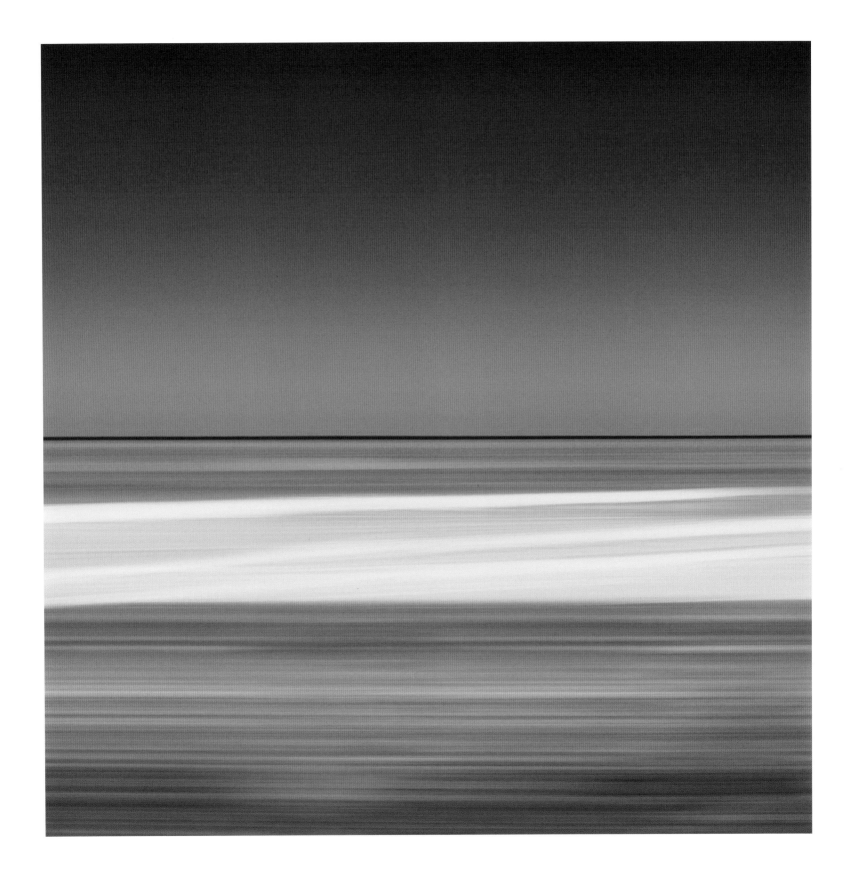

123 *Cala Sisine* Sardinia 2007

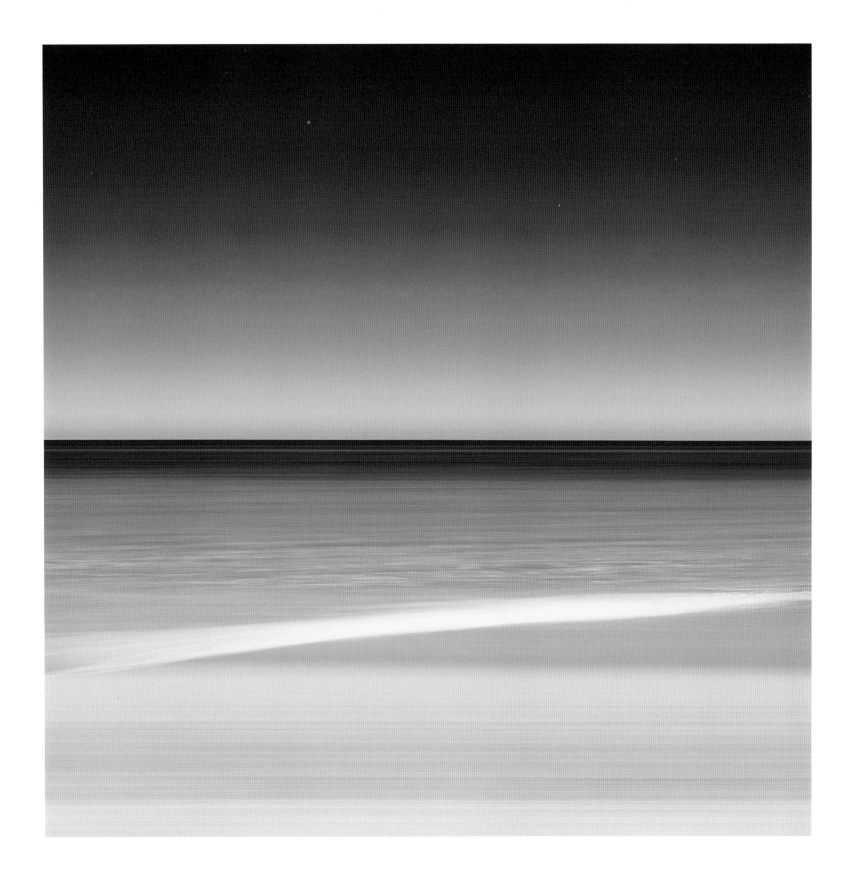

124 *Mujeres Bay* Mexico 2007

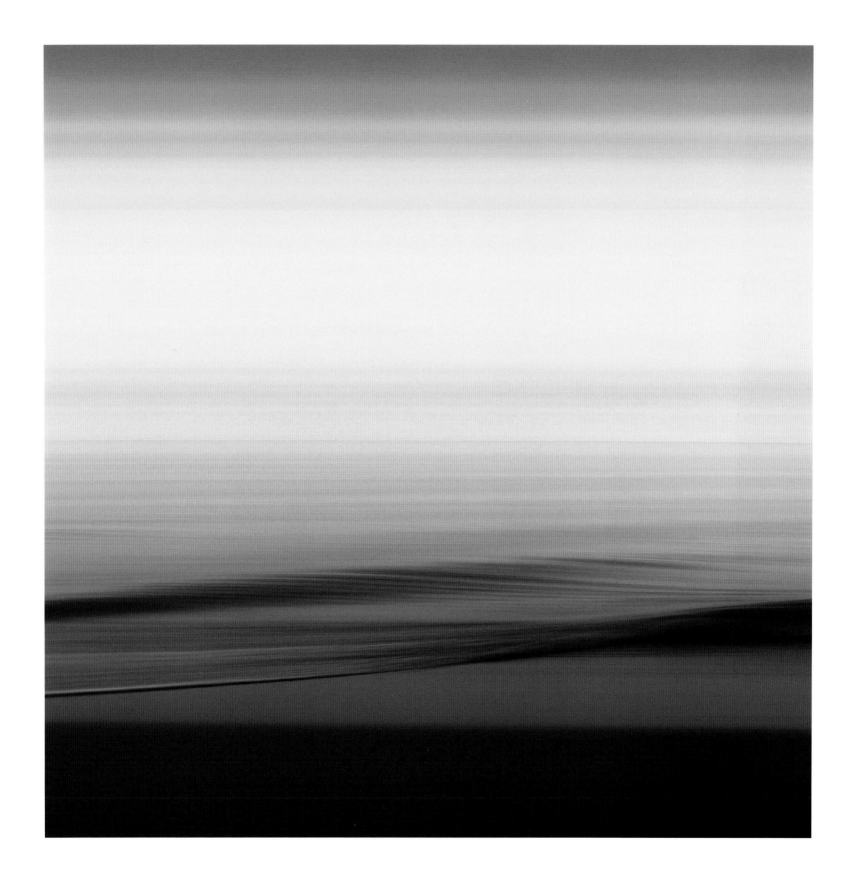

125 *Half Moon Bay* Mexico 2007

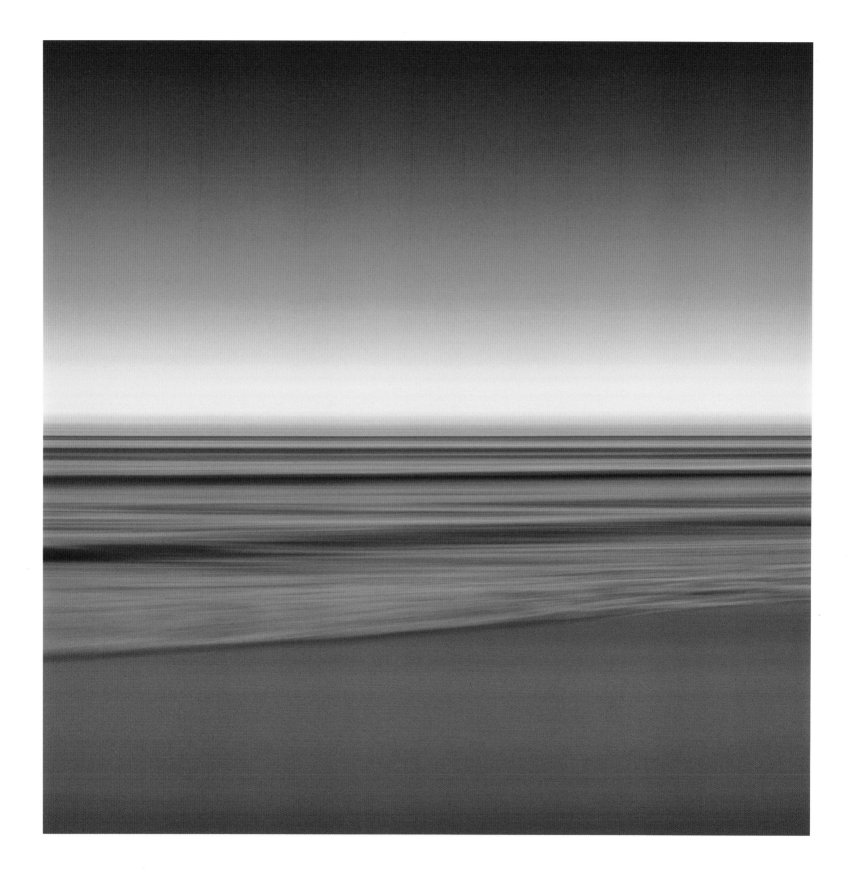

126 *Tulum* Mexico 2007

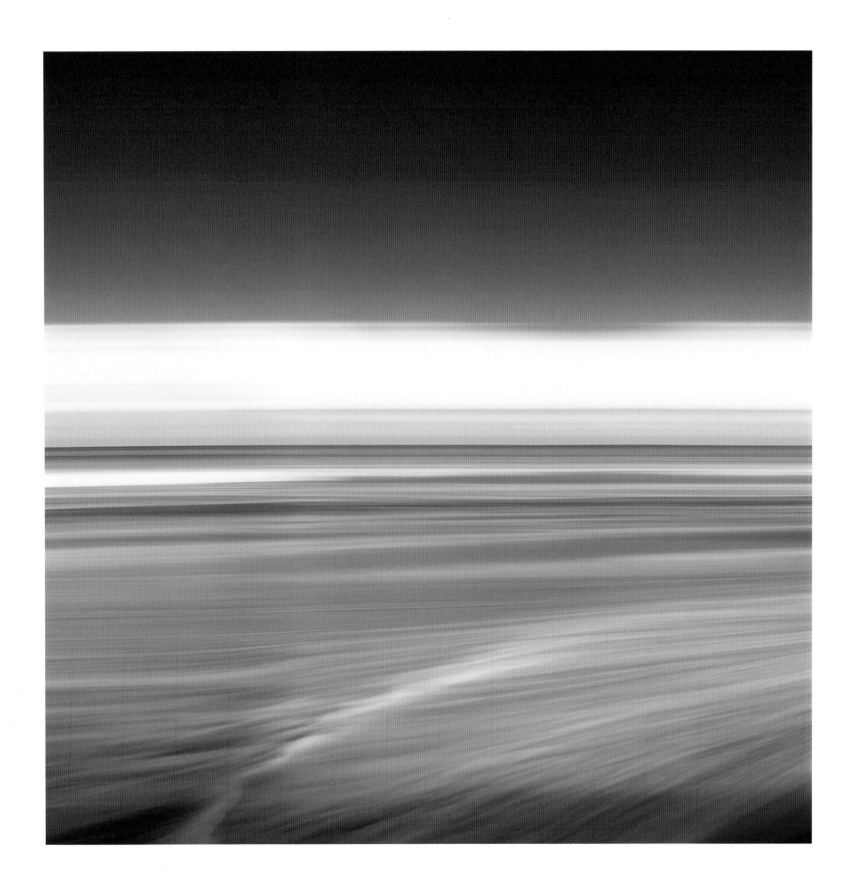

127 *Tortugas* Mexico 2007

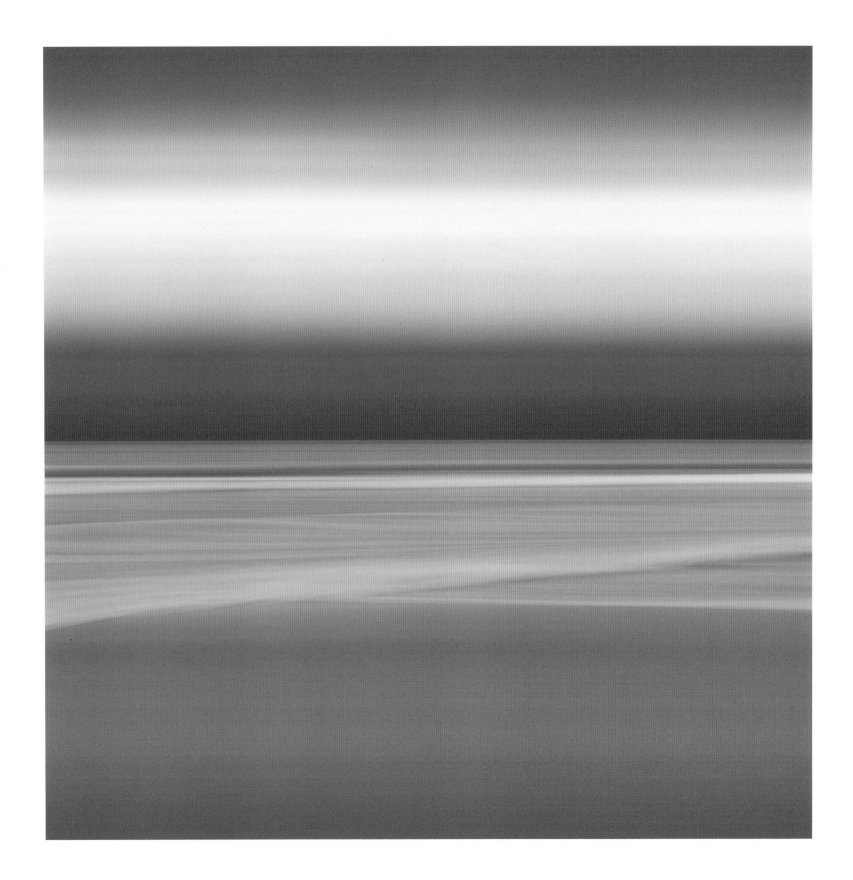

128 *Puerto Aventuras Beach* Mexico 2007

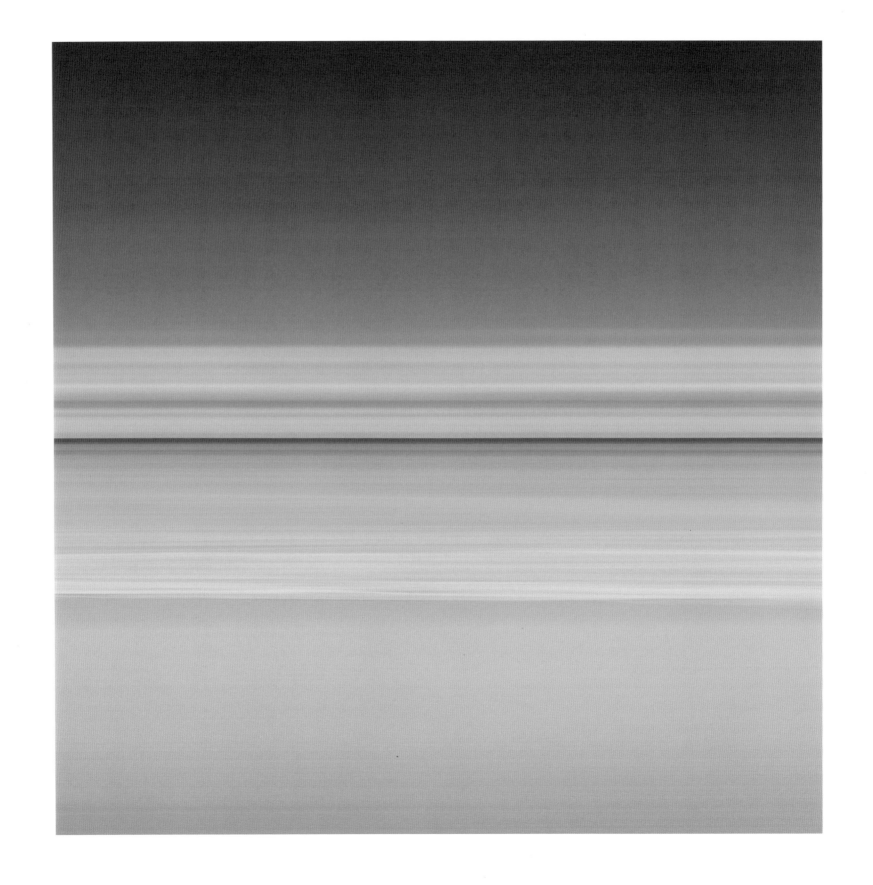

129 *Bottom Bay III* Barbados 2005

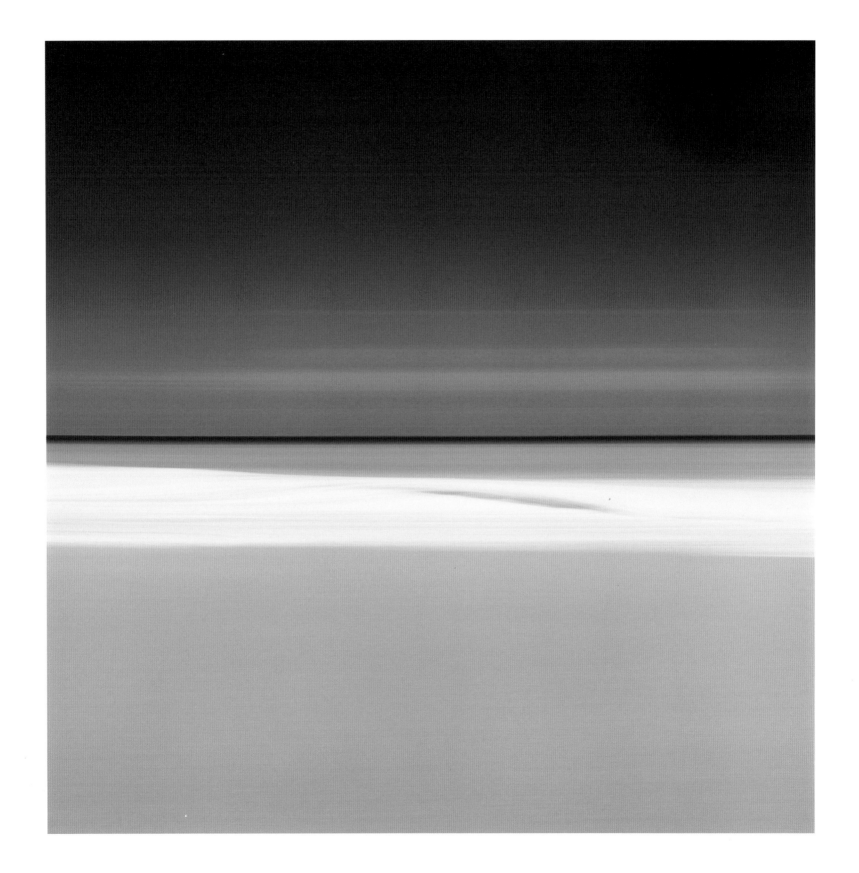

130 *Bottom Bay I* Barbados 2005

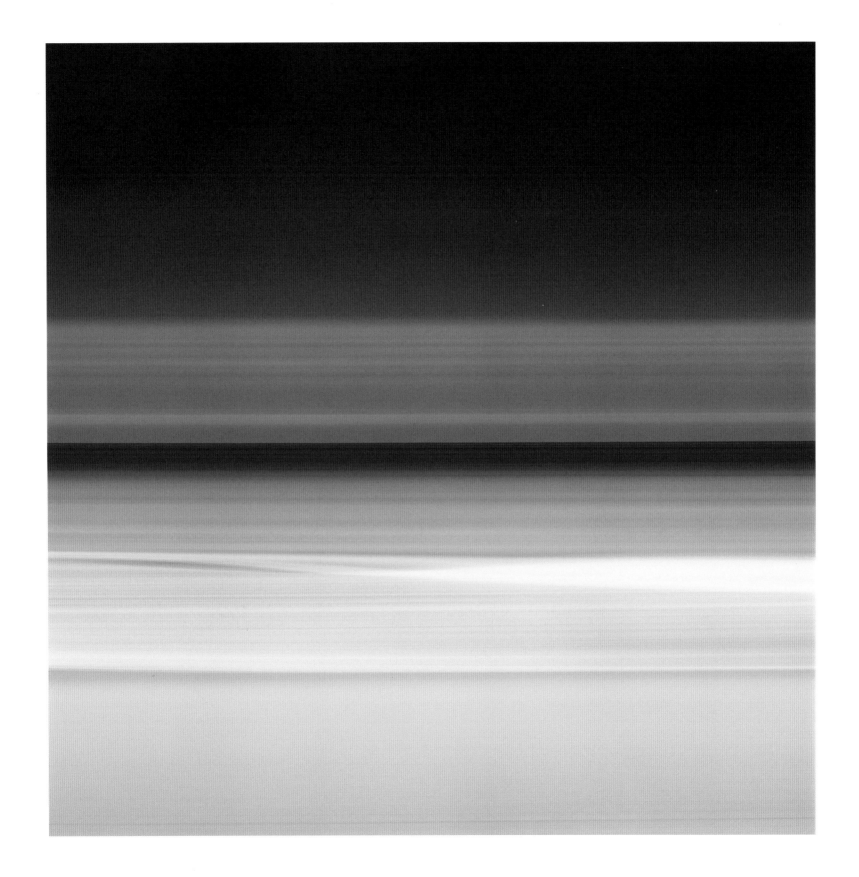

131 *Bottom Bay II* II Barbados 2005

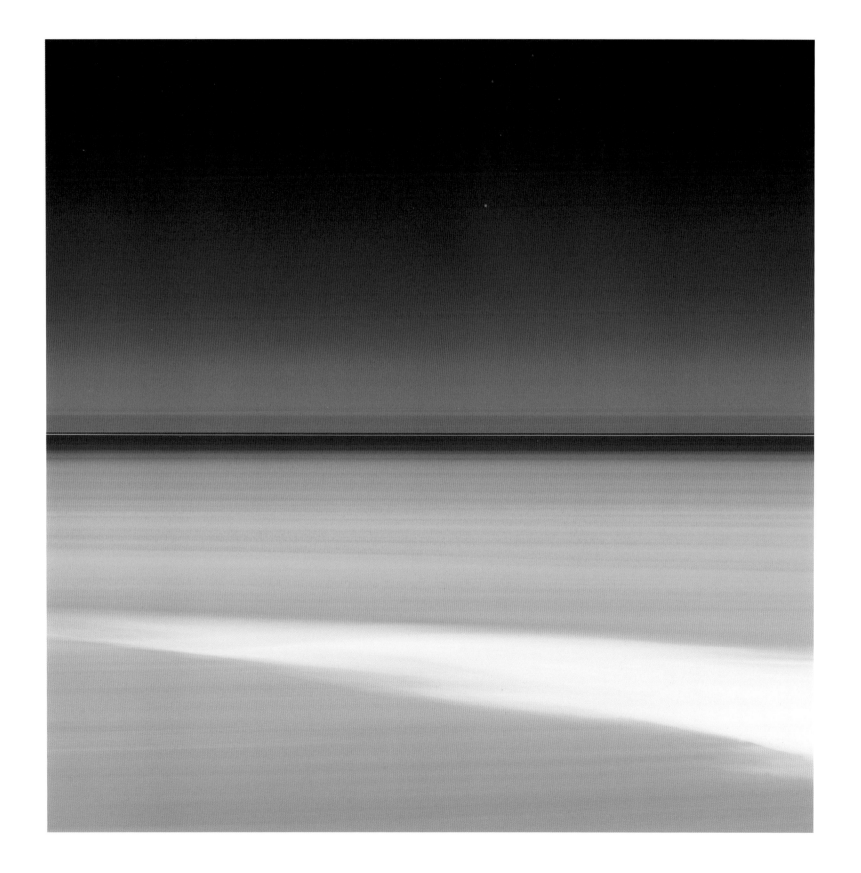

132 *Sandy Lane* Barbados 2005

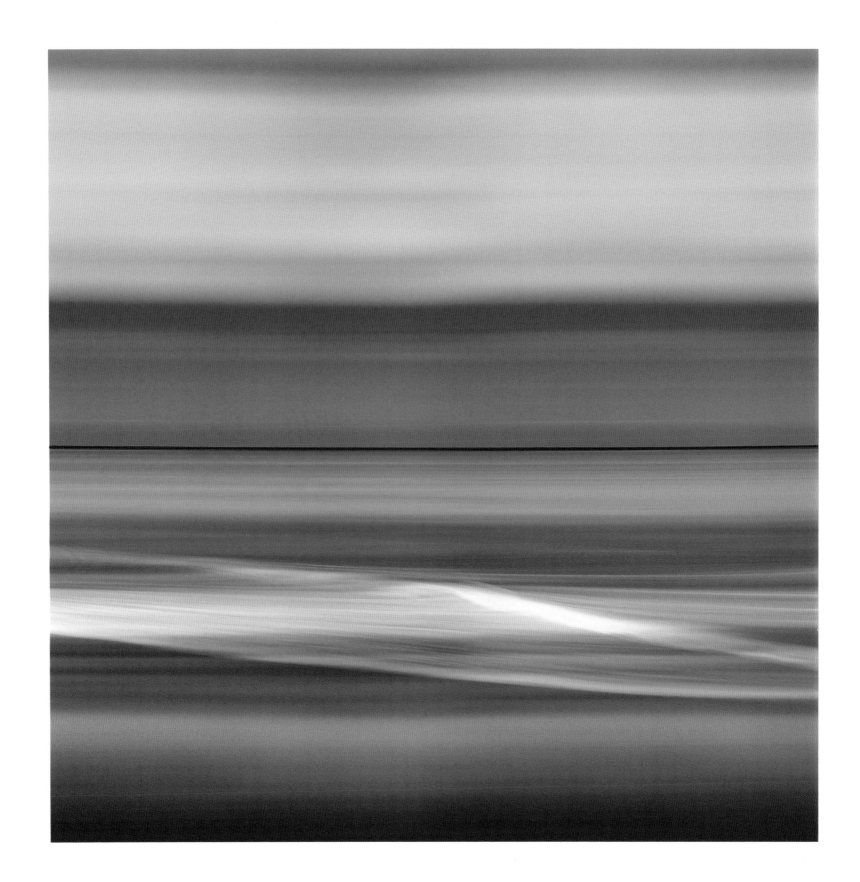

133 *Mesali Island II* Tanzania 2003

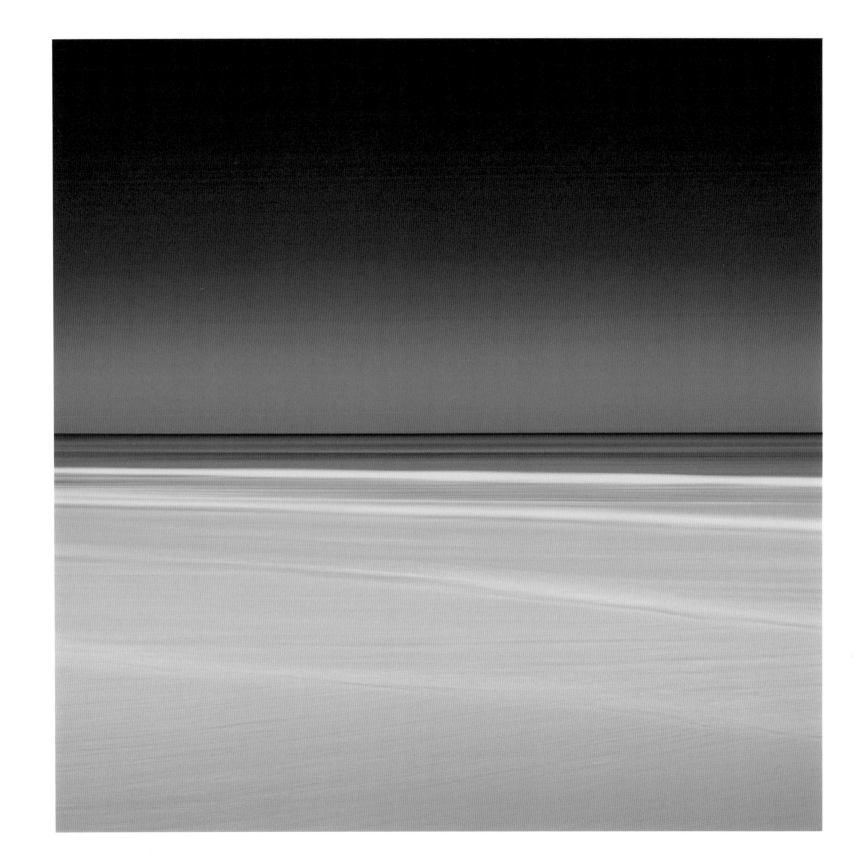

134 *Tankah Beach* Mexico 2007

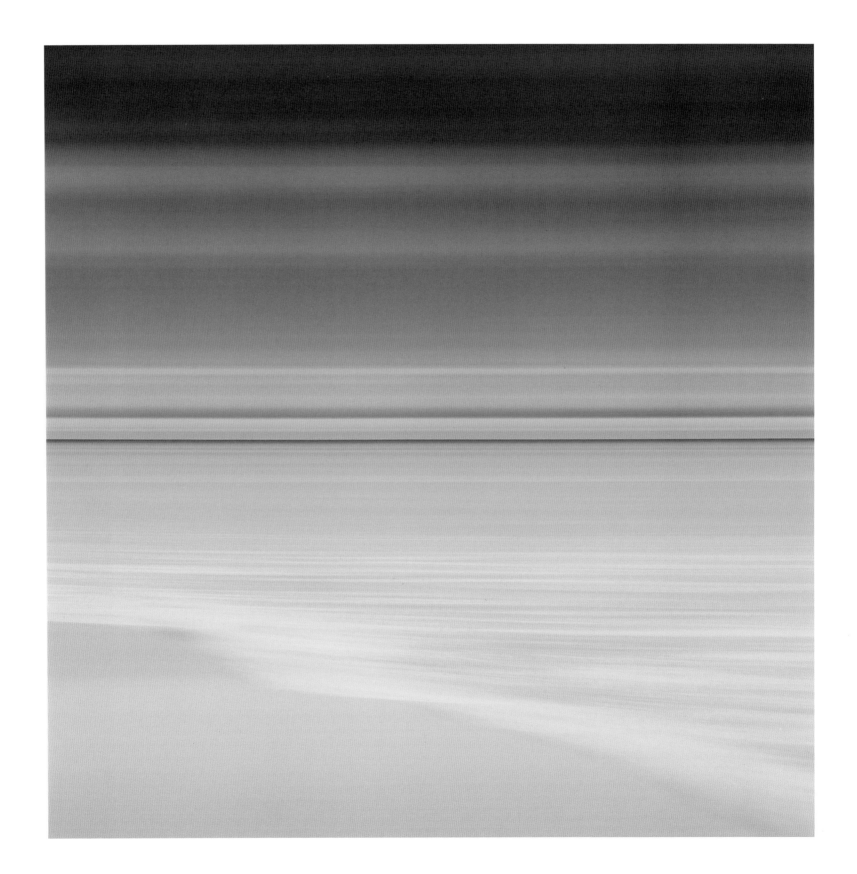

135 *Tobago Cays II* The Grenadines 2007

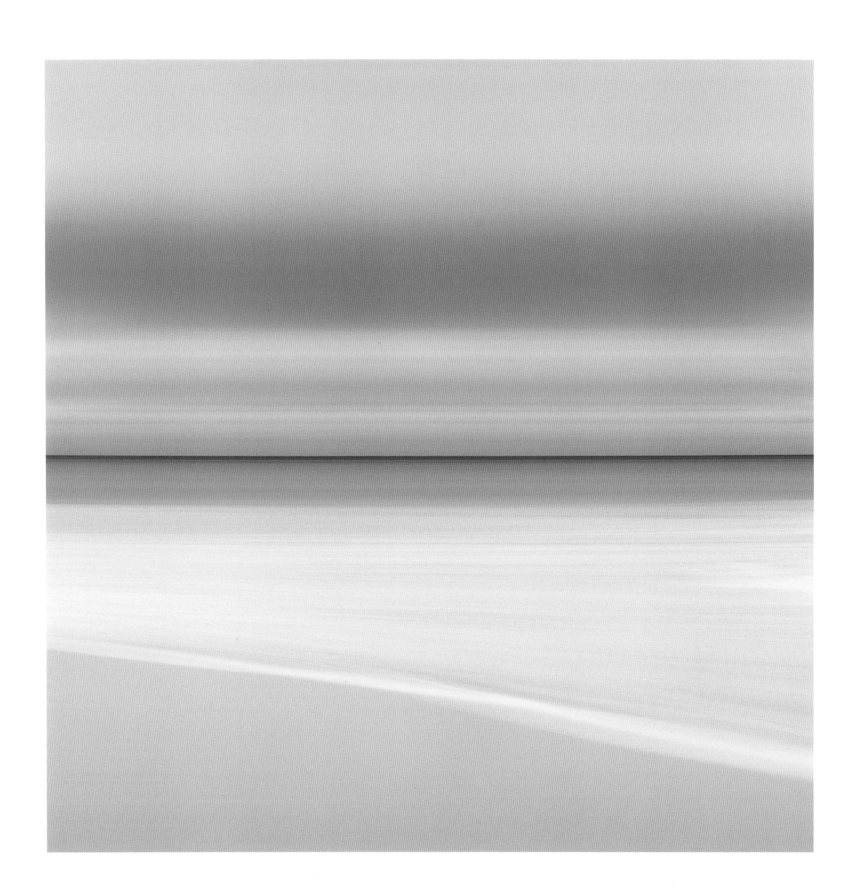

136 *Tobago Cays III* The Grenadines 2007

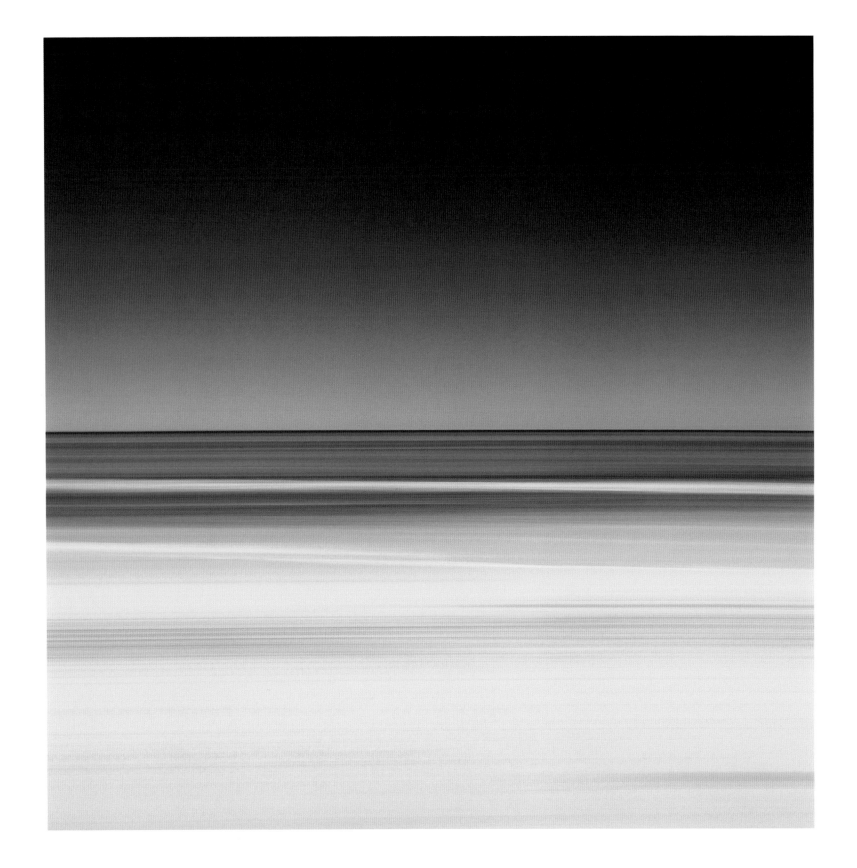

137 *Tobago Cays I* The Grenadines 2007

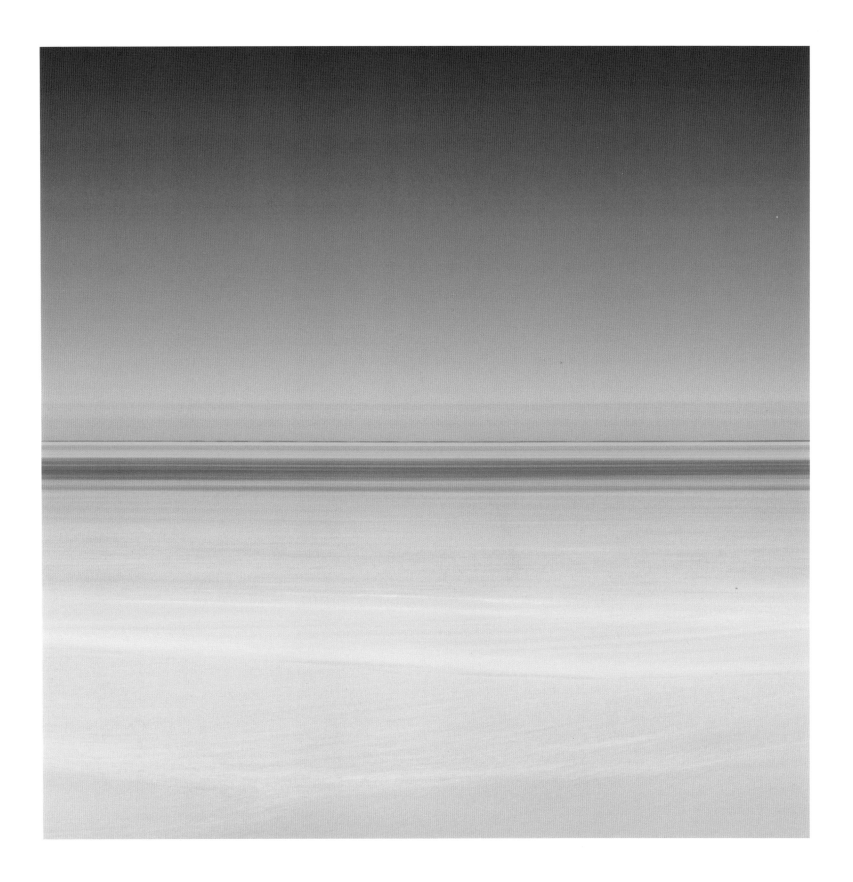

138 *Petit St. Vincent* The Grenadines 2007

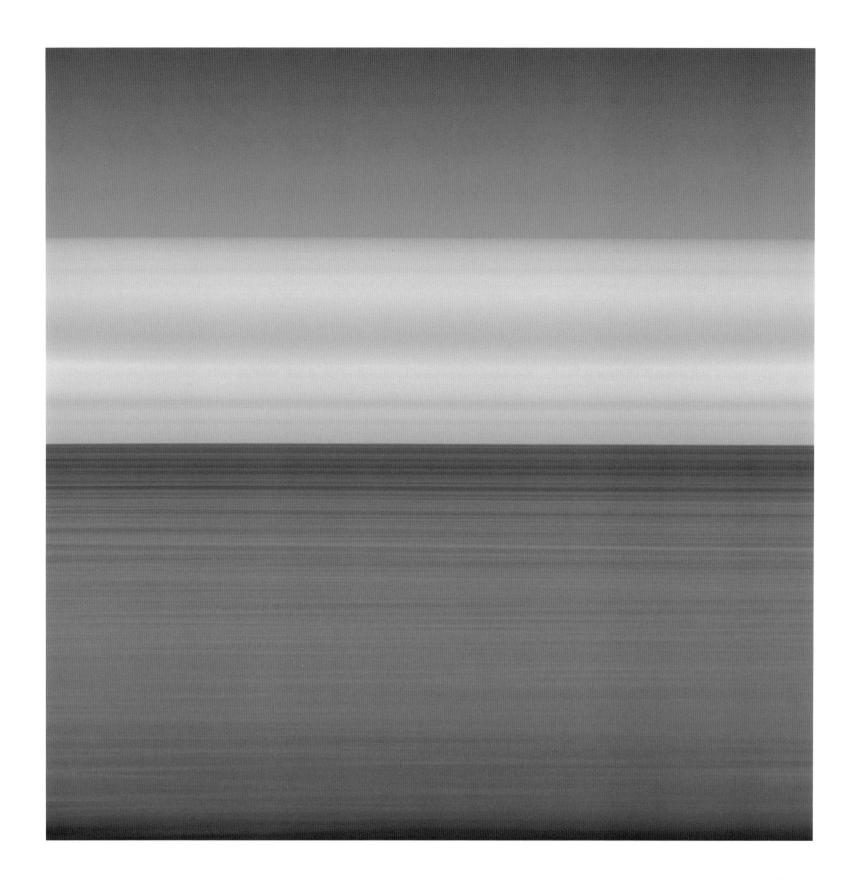

139 *Xpu-ha Beach* Mexico 2007

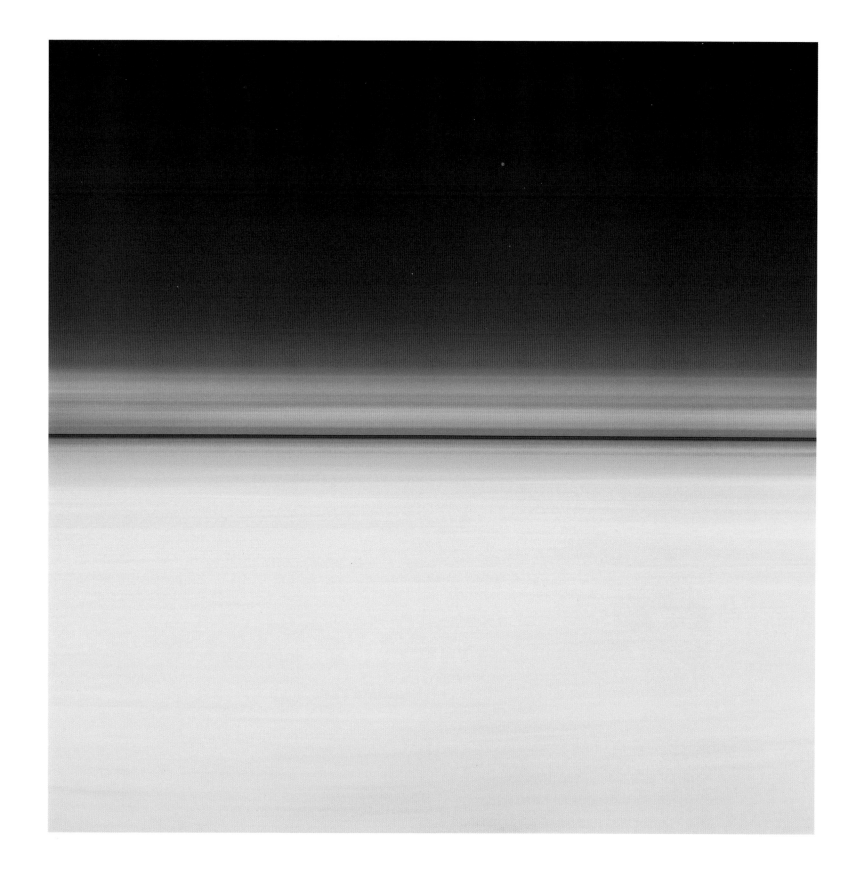

140 *Infinity Pool* Sardinia 2007

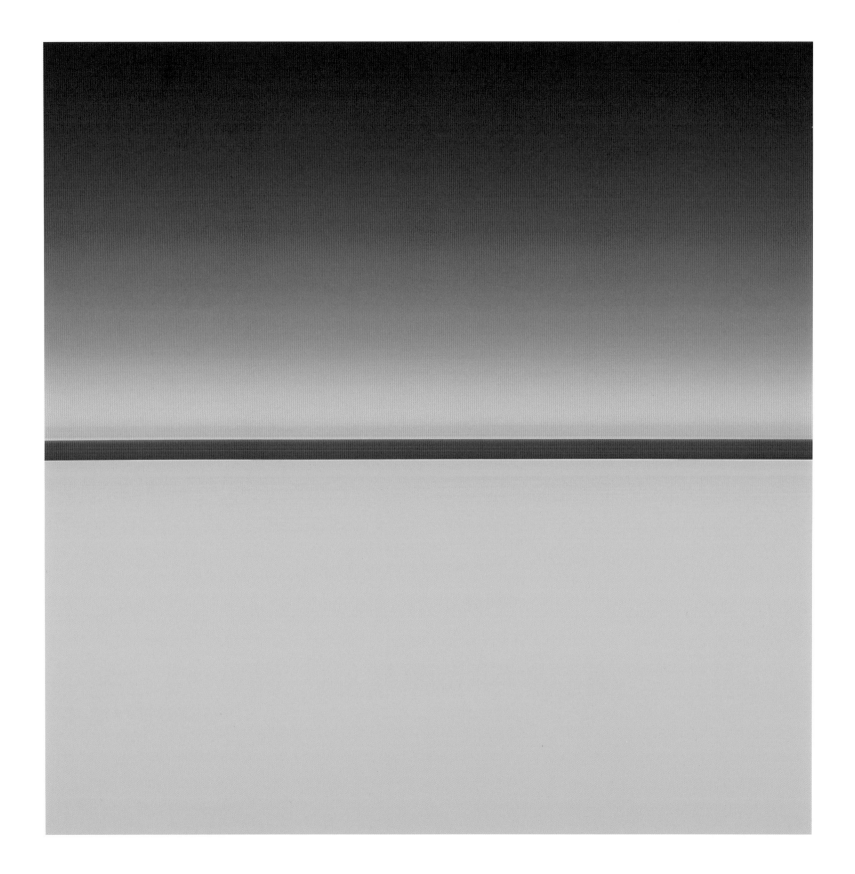

Catalogue All photographs are 24 × 24 in / 61 × 61 cm (framed) Cibachrome prints in an edition of 12 with two artist's proofs

1 *Hotel du Cap* Cap d'Antibes, France 2007

2 *Fundu Lagoon* Pemba Island, Tanzania 2003

3 *Coral Reef III* Barbados 2007

4 *Nice* France 2007

5 *Valle della Luna II* Capo Testa, Sardinia 2007

6 *Valle della Luna I* Capo Testa, Sardinia 2007

7 *Cala Granara I* Sardinia 2007

8 *Cala Granara II* Sardinia 2007

9 *Spargi Island I* Sardinia 2007

10 *Spargi Island II* Sardinia 2007

11 *Spargi Island III* Sardinia 2007

12 *Spargi Island IV* Sardinia 2007

13 *Rena Bianca* Sardinia 2007

14 *Brancaster Beach* Norfolk, England 2003

15 *Promenade des Anglais* Nice, France 2007

16 *Holy Island* England 2003

17 *Soliman Bay* Mexico 2007

18 *Mesali Island III* Tanzania 2003

19 *Cancun Public Beach* Mexico 2007

20 *Xpu-ha Beach [with red boat]* Mexico 2007

21 *Chac Mool II* Mexico 2007

22 *Chac Mool I* Mexico 2007

23 *Tulip Fields VI* Holland 2004

24 *Tulip Fields VIII* Holland 2004

25 *Tulip Fields XXIV* Holland 2006

26 *Tulip Fields XVIII* Holland 2006

27 *Tulip Fields XXV* Holland 2006

28 *Tulip Fields X* Holland 2004

29 *Tulip Fields III* Holland 2004

30 *Tulip Fields XVII* Holland 2006

31 *Tulip Fields XIII* Holland 2004

32 *Tulip Fields XXX* Holland 2007

33 *Tulip Fields IV* Holland 2004

34 *Tulip Fields XXVII* Holland 2007

35 *Tulip Fields XXXI* Holland 2007

36 *Tulip Fields XI* Holland 2004

37 *Tulip Fields XXIX* Holland 2007

38 *Tulip Fields XIV* Holland 2006

39 *Tulip Fields XIX* Holland 2006

40 *Tulip Fields VII* Holland 2004

41 *Tulip Fields II* Holland 2004

42 *Tulip Fields XII* Holland 2004

43 *Tulip Fields XXI* Holland 2006

44 *Tulip Fields XXIII* Holland 2006

45 *Tulip Fields I* Holland 2004

46 *Tulip Fields IX* Holland 2004

47 *Tulip Fields XXII* Holland 2006

48 *Tulip Fields XXVIII* Holland 2007

49 *Tulip Fields XV* Holland 2006

50 *Tulip Fields XX* Holland 2006

51 *Tulip Fields XXVI* Holland 2006

52 *Tulip Fields XVI* Holland 2006

53 *Tulip Fields V* Holland 2004

54 *Sunset IX* Mauritius 2006

55 *Sunset IV* Mauritius 2006

56 *Sunset III* Mauritius 2006

113 *Filey Bay* North Yorkshire, England 2007

114 *Lenk* Switzerland 2007

115 *Rutland Water* England 2007

116 *Buldoo* Highland, Scotland 2003

117 *Lavender Field II*
North Yorkshire, England 2007

118 *Lavender Field I*
North Yorkshire, England 2007

119 *Sea Wall Walk* Isla Mujeres, Mexico 2007

120 *Fast Castle Head* East Lothian, Scotland 2003

121 *Palm Island* The Grenadines 2007

122 *Mesali Island I* Tanzania 2007

123 *Cala Sisine* Sardinia 2007

124 *Mujeres Bay* Mexico 2007

125 *Half Moon Bay* Mexico 2007

126 *Tulum* Mexico 2007

127 *Tortugas* Mexico 2007

128 *Puerto Aventuras Beach* Mexico 2007

129 *Bottom Bay III* Barbados 2005

130 *Bottom Bay I* Barbados 2005

131 *Bottom Bay II* Barbados 2005

132 *Sandy Lane* Barbados 2005

133 *Mesali Island II* Tanzania 2007

134 *Tankah Beach* Mexico 2007

135 *Tobago Cays II* The Grenadines 2007

136 *Tobago Cays III* The Grenadines 2007

137 *Tobago Cays I* The Grenadines 2007

138 *Petit St. Vincent* The Grenadines 2007

139 *Xpu-ha Beach* Mexico 2007

140 *Infinity Pool* Sardinia 2007

Colophon

Published in an edition of 2,500 copies by

Rob Carter
Studio 7, 30 Warple Way, London W3 7SP
020 8749 1133 rob@robandnick.com www.travellingstill.com

With support from Ascot Underwriting Ltd. www.ascotuw.com
Special thanks to Eleanor Forster

ISBN 978-0-9558195-0-6

Copyright © Rob Carter 2008

Printed in Italy by G. Canale & C., Turin
Print production by Adam Shaw Associates

Designed by Tim Barnes, chicken ℞ www.herechickychicky.com